MASTER OF MASTERS

About the Author

David Cretzan, son of Josef Cretzan, was also a glass blower in Waterford Glass for twenty years, from 1985 to 2005. He is now an Occupational Health and Safety Consultant and founder of Cretzan Health and Safety Management based in Waterford, where he lives with his wife Lorraine and four children, Karl, Claudia, Alex and Nicole.

MASTER OF MASTERS

The Life of Josef Cretzan

David Cretzan

The Liffey Press

Published by
The Liffey Press Ltd
'Clareville'
307 Clontarf Road
Dublin D03 PO46, Ireland
www.theliffeypress.com

© 2022 David Cretzan

A catalogue record of this book is
available from the British Library.

ISBN 978-1-7397892-4-4

Printed in Bulgaria by Pulsio Print.

Contents

Acknowledgements

Perhaps naively when I made the decision to start this book, I believed it would be a solitary undertaking lasting several months. The reality was completely different. The completion of the book required the involvement of a wide range of people, some of whom I knew personally, others complete strangers I had never met before. However, each and every person from whom I sought help gave willingly of their time so that the story of my father's life could be published.

Firstly I want to thank the Embassy of Romania to Ireland, the Ambassador and the staff at the embassy who assisted me in sourcing all my father's information from the council offices in Putna, Romania. The Embassy drafted all the legal documentation that allowed me access to the official records of my father's family in Romania.

I want to thank Helga and Brian O'Donnell for professionally translating into English all the German documentation and letters contained in the book. Endless amounts of personal letters and Waterford Glass documents, in many cases difficult to read, are included in the book along with their translations. On many occasions Helga and Brian contacted libraries, museums, archives and municipal authorities in Germany on my behalf, seeking assistance in finding further documents and specific information I was searching for. I also want to acknowledge the cooperation that Helga and Brian received from individuals and organisations they dealt with in Germany in locating the documentation and information for the book.

The book could not have been completed without the information that I received from a select group of people who shared their memories and experiences of my father. I want to thank those I interviewed: Maeve Gavin, Kit Walsh, Bobby Mahon, Tony Galvin, Gerry Cullinane, Ray Cullinane, Seanie Cuddihy, Danny Waters, Sean Kelter, Max Göstl Jnr, Vincent Dunphy, Joe Williams, Henry Moloney, Dick Hannigan, Sam Jacob, Michael Murphy and, finally, John Sinnott, who sadly passed away before the book was published. Each of the interviewees shared with me their own unique experiences and stories about my father. To each and every one of you I want to thank you for sharing your memories with me.

I want to thank the Winkelmann family for the information they provided to me and my father-in-law, John Devereux, for giving me an insight into the work culture and the conditions that existed in the blowing room from the 1950s through to the 1980s.

I want to thank my father's two nieces in Germany, Gabi Roth née Cretzan, and Renate Steinhauser née Schulz, for the information and photographs that they gave to me, some of which are included in the book. In 2018 I had the pleasure of meeting my father's brother Mirtscha and his family for the first time in Germany. I would like to thank them for their contribution to the book.

Former glass cutter and historian John Martin Hearne was the first person to acknowledge the contribution that Josef Cretzan made to glass making in Waterford Crystal in his book, *Waterford Crystal: The Creation of a Global Brand, 1700 to 2009*. John gave me consistent encouragement to undertake the research for the book as he is passionate that the history of Waterford Crystal and its workers is factually and accurately recorded. I cannot thank John enough for his support while researching and completing the book.

I want to thank Dominic Carroll and Maurice Hennebry for their help in preparing my manuscript for presentation to the publisher, The Liffey Press. I want to thank David Givens at The Liffey Press for

Acknowledgements

having confidence to publish the story of my father's life, thereby allowing me to share his incredible life with all of you.

I want to thank Eamon McEneaney and the staff at the Medieval Museum in Waterford for their assistance with the launch of the book at the magnificent Medieval Museum, and also express my gratitude to the Metropolitan Mayor of Waterford City, Cllr. Jason Murphy, for agreeing to attend the book launch in his official capacity.

Lastly, to my own family. When the content of my father's personal documents were translated into English the complete story of his life was revealed. Knowing all the details of his extraordinary life my wife told to me that a book had to be written and that that responsibility lay with me. Writing the book was a time-consuming undertaking which involved multiple trips travelling across Europe, and I could not have completed this without the support of my wife Lorraine, and my children Karl, Claudia, Alex and Nicole. Huge thanks to all of my family; it could never have been done without you.

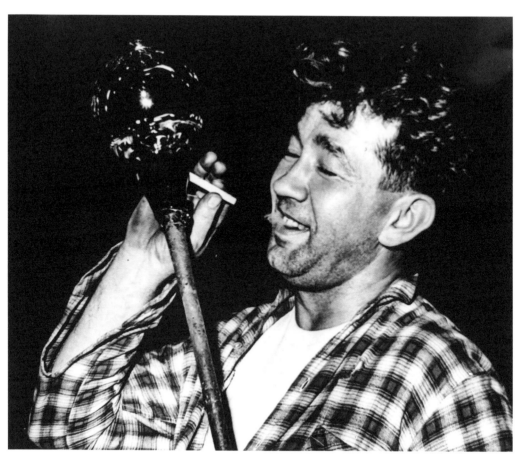

Josef Cretzan, Glass Blower

Introduction

At a time in Irish history when generations of Irishmen were forced to leave in search of employment, a small group of highly skilled European glass workers arrived in Waterford to help establish a glass factory – the world-famous Waterford Crystal. They were assimilated into local towns like Waterford and Irish life in general to varying degrees. They brought their own cultures and traditions to the community, but few knew of the struggles they had gone through before arriving in Waterford. The majority of these glass workers returned to their homelands after several years in the Waterford factory, but a small number remained in the city for the rest of their lives. One of these was Josef Cretzan, a glass blower who arrived in Waterford in 1951 when he was twenty-seven years old.

Josef's life began in Romania, where he was trained as a glass blower – a family trade for generations in Bohemia, from where his father hailed. In the early 1940s, when still only a teenager, Josef journeyed with his family across Central Europe to Germany in a bid to escape the turmoil in Romania brought about by the Second World War and the encroachment of the Russians. But in Germany he was conscripted into the army, and was sent to fight as an infantryman on the Eastern Front with Russia, then served in Rommel's Afrika Korps in Tobruk, Libya, and in Italy fought in the fierce Battle of Monte Cassino. He was wounded on three occasions, and was awarded the Iron Cross (Second Class) for distinguished service as well as the Front Line Combat medal and the Wounded Soldier medal.

The post-war division of Germany into four separate zones – British, Russian, French and American – resulted in Josef's separation from his father and younger siblings, who were trapped in the Russian zone. While living in the British and US zones, Josef supported his family by sending weekly parcels of food and clothes.

While working in the glass industry in Germany in the aftermath of the war, Josef established a reputation as an exceptional glass blower. But in 1950, an advertisement in a German newspaper, together with his desire for adventure, changed the direction of his life and brought him to a newly established glass factory in Waterford. For the next thirty-seven years his knowledge, experience and skills in glass blowing were fundamental in ensuring that that factory, Waterford Crystal, remained the premium hand-made crystal-production manufacturer in the world. Some of the crystal pieces he created were presented to kings, queens, presidents, princesses and princes. Today, his glass is displayed in some of the most prestigious buildings in the world, including Westminster Abbey in London and the John F. Kennedy Presidential Library and Museum in Boston.

In Waterford Josef assimilated into Irish life and culture – more so than many of the other foreign glass workers who came to work in Waterford. He enjoyed playing cards and darts in the local pubs throughout the city and county. He gave of himself not only in a professional capacity as a glass blower but also in a personal capacity. He never sought reward or recognition for his personal time, whether it was training apprentices on Sunday mornings or teaching German to several local people. He suffered personal tragedies with the premature deaths of two wives, Una Power and Kitty Buckley, but his resilience and his love for his children and for Waterford ensured that he remained in the city until his death in 1990.

Josef Cretzan's contribution to glass making in Waterford Crystal is acknowledged by former glass cutter and historian John Hearne in *Waterford Crystal: The Creation of a Global Brand, 1700–2009*, where he describes Josef as the 'Master of Masters'.

Chapter 1

Childhood in Putna

Nestled in the eastern Carpathian Mountains, the small village of Putna lies in the county of Suceava in the Bucovina region of northern Romania, just twenty kilometres from the border with Ukraine. The village is located in a narrow valley that leads to the famous Putna monastery, a place of pilgrimage and one of the most important cultural and religious centres for the Romanian Orthodox Church.

In the eighteenth century, the village of Putna had a population of around a thousand people. For most, existence was a day-to-day struggle to put food on the table, especially during the harsh winter months. Many relied on casual forestry and agricultural work, but this was irregular, weather-dependent and did not pay well – usually, agricultural workers were paid with farm produce and food. Then, in 1797, a glass factory was established in the village. Glass production in such a remote and mountainous region of northern Romania was made possible by the extensive national railway network and the country's rich store of natural resources, in particular an abundance of timber and oil.

Working as a casual labourer on the small farms in the Putna area was Cozma Crețan, born in 1868. Cozma married Ecaterina Andries, and they had at least one child, a daughter named Tecla, who was born on 8 January 1896. The meagre earnings of an agricultural worker barely provided enough food for the family and the prospects for Tecla were very limited. Still, after leaving school in her early teenage years,

she found work in a local guest house. The Putna glass factory provided a stream of glass workers to the guest house, as skilled labourers from other countries in Central Europe came to work at the factory.

One of those foreign workers was a glass painter from Kamnický Šenov, a town located in the centre of the glass making region of Bohemia in Czechoslovakia. His name was Franz Terme. Born in 1882, he was a third generation glass worker. His father, Franz Josef Terme, and grandfather, Jynaz Terme, had worked in many of the glass factories of Bohemia. Franz's mother, Anna Glaessner – also from Kamnický Šenov – was herself descended from generations of glass makers. All were Sudeten Germans.

In his hometown of Kamnický Šenov (later renamed Steinschönau due to the influence of the German glass workers there), Franz began his career as a glass painter. His steady hand, attention to detail and artistic flare were developed in the local glass school, where he learned his skills from the master glass painters. As the glass blowers produced clear and coloured glass pieces, Franz would paint them with delicate floral images, coats of arms, traditional Easter and Christmas images, or beautiful scenes featuring Bohemian forests and wildlife.

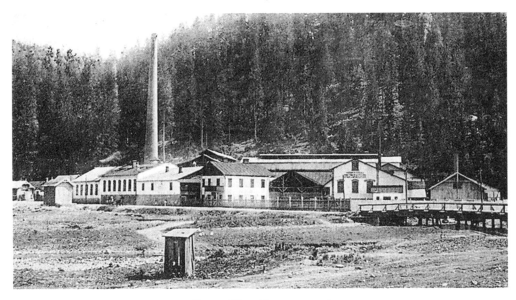

Putna Glass Factory, 1926

In the early 1900s, Franz married Auguste Weiss, and the couple had two children. However, by 1914 their relationship had broken down and, in that same year, Franz left Bohemia for the Putna glass factory. He made the 1,500-kilometre journey by train, taking several days, and on arrival in Putna was shown to his accommodation at the local guest house close to the factory. It was here that eighteen-year-old Tecla Crețan worked, and though Franz was fourteen years her senior, a romance blossomed. Tecla became pregnant, and on 25 April 1915 their first child, a boy, was born. He was baptised Aurelian Crețan. Over the next seventeen years the couple had five more children: George, Octavian, Iosif, Christina and Mirtscha. The Crețan children learned two languages, Romanian from their mother and German from their father.

Joe's mother Tecla

The registry of births in Putna described the Crețan children as the 'illegitimate children of Tecla Crețan'. Franz was still legally married to his wife Maria in Bohemia, so it was not possible for him to marry Tecla. The Romanian Orthodox Church to which Tecla belonged had a particularly strong local presence due to the monastery in Putna, and it would not permit Franz Terme to be named as the father in church documents. As a result, the children were baptised with their mother's surname – Crețan. The phonetic pronunciation in English is Cretzan.

Franz was continuously employed as a glass painter, and his salary was multiples that of an agricultural worker's, so the family lived in relative comfort. As the older boys – Aurelian, George and Octavian

Joe's father Franz Terme

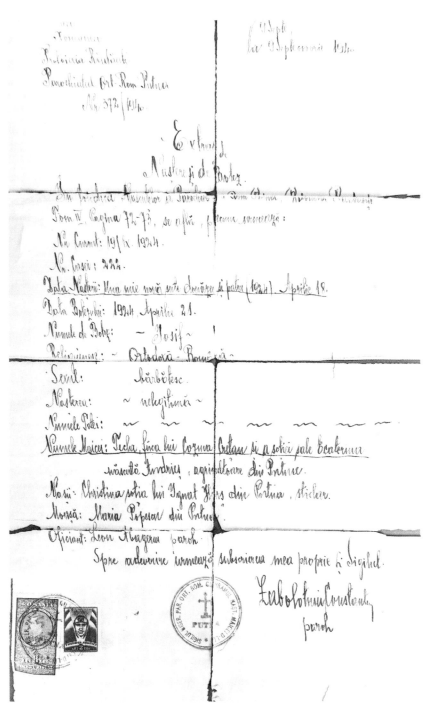

Josef Cretzan's birth certificate

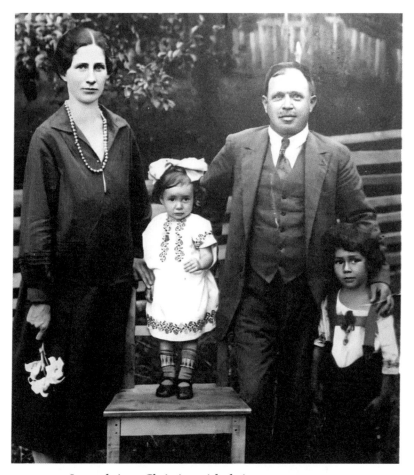

Joe and sister Christine with their parents, 1930

– approached their teenage years, they were brought to work in the glass factory with their father. The boys could not pursue their father's occupation of glass painting as it was a specialised skill that required intense training over many years, and this was not available in Romania. Franz therefore concluded that the best option for his sons was a career in glass blowing. With this skill they would earn a good income and could work in the glass industry in other parts of Europe. However, apprenticeships were ordinarily not available as experienced glass workers were brought to the factory from other glass making regions in Europe. But because of the critical importance of his work, Franz was able to arrange with the factory owner for his children to enter the factory as apprentice glass blowers, thereby preserving the

Bohemian tradition of passing the skills from one generation to the next.

Though a glass painter by trade, Franz had an in-depth knowledge of all the crafts involved in the glass industry, including glass blowing. Under their father's supervision, the young Crețan boys began blowing glass in the factory with teams of Bohemian glass blowers. On occasion, their younger brother Iosif walked to the factory to watch his older brothers blowing glass and his father painting intricate images onto glassware items. Iosif's natural curiosity and admiration for his older brothers' work led to him wanting to blow glass at the factory, so during school holidays he was brought to the factory by his father. Here, aged just eight, he gathered molten glass for the first time. He gained an understanding of the basic techniques involved in glass blowing, and this early introduction to working with molten glass would lead to his rapid development as a glass blower while still in his early teens.

When not helping at home or in the factory, the hills and mountains that surrounded Putna provided an adventurous playground for the children of the village. Fishing, hunting, swimming and camping were everyday activities, though a watchful eye had to be kept for the bears and wolves that roamed the area. Having spent his childhood in the heavily forested regions of Bohemia, Franz Terme was drawn to the hills and forests surrounding Putna, and he would lead his children there to pick edible foods, such as mushrooms and berries, and to trap birds and rabbits and other small animals that would help feed his family. Their family life seemed secure. But events beyond their control would soon have a major impact upon the region and on Franz Terme's family, and would result in the family becoming divided for ever.

On 10 May 1934, Iosif's mother Tecla died. She was thirty-eight years old. Of her six children, the eldest, Aurelian, was eighteen years old, and the youngest, Mirtscha, was a mere eighteen months old. Tecla's parents were already deceased, so Franz Terme now had six

children to care for and no wider family to support him. Although the three eldest boys – Aurelian, George and Octavian – were working as apprentice glass blowers in the factory, the three youngest children – Iosif, Christina and Mirtscha – had to be cared for at home while Franz was at work. The villagers in Putna formed a close-knit community that helped one another in times of crisis, and now they stepped in to help Franz raise the three younger children. But to reduce the burden, Franz decided to bring Iosif into the glass factory to work as a glass blower with his older brothers. So in the summer of 1934, when only ten years of age, Iosif started his apprenticeship as a glass blower at the factory in Putna. Taken by his father's hand, he walked with his older brothers the short distance from their home to the factory beside the Putna river on the outskirts of the village.

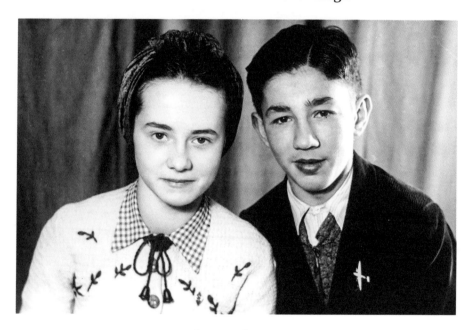

Joe and sister Christine, 1938

Chapter 2

Unrest on the Horizon

U nder the guidance of his older brothers, especially Octavian, Iosif began to develop his skill for gathering and shaping molten glass. Within a year of working in the factory his natural talent and exceptional skills were clear. At such a young age his ability to work with and control molten glass was exceptional. The master glass blowers working in the factory at that time were primarily from the Bohemia region. These Bohemian glass blowers had family traditions in glass blowing passed down through generations, and their skills and experience had been developed over centuries. It was a Bohemian tradition that where a young apprentice displayed exceptional skills in glass blowing he would be brought to work and train with the master glass blowers to further develop his talent at an early age. This tradition of intense training for selected apprentices ensured that the renowned reputation of Bohemian glass blowers would be maintained for future generations.

These Bohemian glass makers recognised Iosif's ability and identified him as boy with a huge potential for glass making. In keeping with their tradition, they selected Iosif to work with them directly so that he would be exposed to their glass making techniques on a daily basis. These masters of glass blowing were to teach him every aspect of glass making. They instructed him on the best method to prepare and skim the molten glass every morning before taking the first gather from the pot of glass. He was taught the best techniques on how to gather molten glass from the pot, the best angle to insert the blowing iron

into the molten glass and the marvering or rolling out molten glass on the blowing iron, using his thumbs and index fingers only. Each day he would work with coloured glass, forming coloured cups for glass casing, melting colour powder and fragments into hot molten glass.

Iosif was taught many other specialist glass making techniques such as fusing and double casing of clear and coloured glass, glass pouring, glass pressing, the process for reheating glass from room temperature to molten state and the fusing of glass at the correct temperatures using miniature furnaces. The hand tools that were used in glass blowing – wooden blocks, dividers and coolers – were made individually for each glass blower and Iosif was shown precisely how these tools should be made to allow him to work the molten glass with greatest effect. The detail of his training when using the wooden hand tools to cool and shape the molten glass was so detailed that he knew how dry, or how wet, the tools had to be to allow him to work the glass to achieve the desired shape and thickness. The correct use of scissors and shears for cutting molten glass was a precision skill that required great concentration to ensure that the spouts on jugs and decanters were perfectly formed with deep and sharp angles where required. All of these glass making skills were passed on to Iosif by his early teenage years, and he exceeded all expectations that were placed on him by the master glass blowers at the factory.

Throughout this period, his father Franz Terme carefully monitored Iosif's progress and, although he was not a glass blower by profession, he understood the glass making techniques from the factories that he had worked in while he lived in Bohemia. Every day he would spend time with Iosif watching how he would gather glass from the furnace and cool and shape the glass using his wooden hand tools, shears, scissors and paper coolers. Sitting on a stool beside Iosif as he worked the molten glass, Franz would hold a small wooden stick in his hand as he observed his techniques. He would strike his fingers with the stick when he wanted Iosif to work the glass hotter, while never undermining his confidence as he worked with the molten

glass. His background in glass painting required concentration, atten-
tion to detail and confidence in his own ability, and these attributes
were passed from father to son at the factory in Putna. However, the
greatest and most valuable attribute that was passed from father to
son was pride – pride in his skill as a glass blower, pride in the craft of
glass blowing, and pride in the work that he produced.

By the time Iosif had reached fifteen years of age there was noth-
ing more the Bohemian masters or his father could teach him about
glass blowing. He had developed into an exceptional glass maker with
remarkable skills who understood how to work molten glass effort-
lessly. He had become a full-time production worker at the factory
who could produce any of the pieces the Bohemian masters made. His
training period in Putna had lasted for almost five years and it was so
comprehensive in every aspect of glass making that he never required
any further training in any aspect. His combination of exceptional
natural talent and the unique training program he had received had
produced a glass maker described by the Bohemian master glass mak-
ers in Putna as the most gifted and naturally talented teenage glass
maker they had ever seen.

While Iosif's glass blowing career progressed rapidly during the
mid-1930s, there was geopolitical conflict occurring in the Bucovina
region where Putna was located. Bucovina comprised two separate
regions – southern Bucovina, which lay within the Romanian border
with the Soviet Union, and northern Bucovina, which was located
in the Soviet Union. In the 1930s, the entire Bucovina region had a
diverse ethnic population made up of Romanians, Ukrainians, Jews,
Germans and Poles. There was ethnic and civil unrest in the region
between the northern and southern regions of Bucovina. The Soviet
Union wanted to extend its power into the Romanian-controlled
southern Bucovina region, and the towns and villages closest to the
border suffered ongoing civil unrest between the feuding factions.
This volatility in the region greatly affected the day-to-day lives of the
families living in Putna; they worried for their safety and that of their

children because of their proximity to the Russian border. However, there were more significant and sinister political events developing in Europe that would have a major impact on the population of Romania: the rise of Adolf Hitler and the Nazi Party in Germany.

In 1938, under the Munich Agreement, Nazi Germany annexed Sudetenland, the Czechoslovakian border region with Germany which contained a large ethnic German population living primarily in Bohemia. It was Hitler's ambition to repatriate all ethnic Germans living in Eastern Europe back to their German homeland, and to make Germany great again following its defeat in World War One. Hitler's policy of discrimination and persecution of minority groups, including Jews, Romani and gypsy people, would find its way to Romania following the start of World War Two in 1939, and the region of Bucovina where Putna was located would not be spared.

In June 1940, under the Molotov-Ribbentrop Pact, the Romanian government was forced to cede the northern region of Bucovina to the Soviet Union. The Red Army took control of the area with the new Romanian–Soviet Union border being located only 20 kilometres north of Putna. Overnight over three million Romanians woke up in a foreign territory where their history, traditions and culture were not accepted. Under Soviet control, the region became increasingly unstable as thousands of Romanian families crossed the border from the now Soviet-controlled northern region of Bucovina into Romanian-controlled southern Bucovina without the permission of the Soviet army. With the region in turmoil the future for the glass factory in Putna became uncertain as many ethnic minorities in the region were persecuted and deported to Siberia.

At this time Hitler's ideology of *Lebensraum* (living space) was introduced and rolled out across Europe. The purpose of *Lebensraum* was to bring all ethnic Germans living in Eastern Europe back to their 'homeland', Germany. This ideology would spare Franz Terme and his children from deportation or persecution experienced by thousands of other families who lived in Romania, because he was

ethnic German and all his children were fluent German speakers. The entire German-speaking population in Bucovina was encouraged to resettle in the cities of Poland that were under German control at that time. Franz Terme now had to decide if he wanted to remain in Putna with his children or leave and start a new life in another country. Inevitably, with such uncertainty and the civil unrest across Europe caused by World War Two there was no demand for glass products and the factory at Putna shut down its furnaces and ceased production in 1940. With the closure of the glass factory there was no source of income for the family and there was no prospect of any type of work for Franz Terme as a glass-painter in the region.

On 9 February 1941, the family suffered the unexpected death of Georg Crețan. He was twenty-two years old. His death compounded the worsening situation that the family found themselves in and their future in Putna seemed bleak. Civil unrest and violence had increased dramatically in the region throughout the spring of 1941. On 1 April 1941, in the village of Fântâna Albă in Soviet-controlled northern Bucovina, a large gathering of Romanian civilians carrying white flags and religious symbols attempted to cross the border back into Romanian-controlled southern Bucovina. It was rumoured that the NKVD, the Soviet secret police, would allow the group to cross the border uninhibited. However, as the group approached the border, police opened fire killing approximately 2,000 of the unarmed Romanian civilians. The incident became known as the Fântâna Albă massacre. With the death of Georg and the deepening continual civil unrest in the region, the situation in Putna became too stressful for Franz Terme and he decided that there was no future for himself or his remaining children in Putna. He determined that the best option was to leave Romania to find a safer place for his children to live, while at the same time hoping to find employment in the glass industry again.

Throughout the 1930s Franz Terme had maintained contact with former colleagues from Bohemia who were working in the glass

industry throughout Europe. In particular, he kept in close contact with the Lorenz family. Indeed, the frequent correspondence between them often referred to opportunities for Franz to return to work as a glass painter in central Europe, in particular, to the Moser glass works in Karlsbad (Karlovy Vary) in Czechoslovakia. Franz was confident that thanks to his network of contacts in the glass industry and the specialised nature of his work he would find work again in Czechoslovakia or Germany.

Plans were put in place and arrangements made to leave permanently. All important documents and belongings were gathered, including personal letters, photographs and birth certificates. At least one piece of glass that was made in the factory by Iosif was brought with them as a reminder of his work at the Putna factory. The piece was a small glass, made in the *gentile* style of glass making. The glass which was made from a dark brown glass melt is approximately four inches in height and was hand painted by his father. This glass was made by Iosif when he was fourteen years old, and it is the earliest and only known existing example of his work from the factory in Putna.

The glass is now in the possession of Josef's younger brother Mirtscha, who lives in Limburg an der Lahn, Germany.

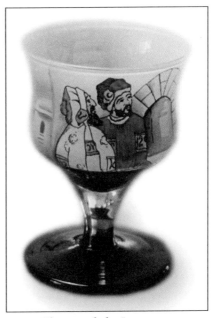

Franz Terme departed Putna in the summer of 1941 with his children Aurelian, Octavian, Iosif, Christine and Mirtscha. Central Europe was experiencing the ravages of war and Franz Terme had no idea where he was going. The family travelled initially to Lodz in Poland, where they stayed for several weeks on the outskirts of the city in a small farmhouse. Lodz was under the direct control of the Nazis and they had renamed the city Litzmannstadt

Glass made by Joe, age 14

after the German Army General, Karl Litzmann, who had captured the city during World War One. The Nazi authorities had created the Litzmannstadt ghetto in the city, a detention camp that was used to detain Polish Jews. There was no threat to the family from the Nazi occupiers of the city as Franz Terme was a German citizen and all his children spoke fluent German. There was, however, a price that the family had to pay for that freedom. Germanic populations from Eastern Europe were conscripted into the German armed forces and Aurelian, Octavian and Iosif were ordered to travel to the city of Erfurt in Germany, where they were assigned to divisions of the German army.

Iosif was assigned to Unit 2, Grenadier Company Batallion 163, with Identification Tag Number, 351. He was told that he was setting out on an adventure that would last no more than six months. Aurelian was also deployed to the Wehrmacht division and Octavian was deployed to the Waffen-SS.

Iosif was granted German citizenship because his father was a Sudeten German and his conscription into the German army expedited the naturalisation process. He was officially registered as a German citizen on 18 September 1941.

German Empire
Certificate of Citizenship

Mr Josef Cretzan

In Erfurt, born on 14ᵗʰ April 1924 in Putna Monastery, Romania, has been granted German Citizenship through naturalisation, (Citizenship of the German Empire) from the time of the issue of this document. Naturalisation does not apply to family members.

Erfurt, 18ᵗʰ September 1941

Imperial Minister of the Interior Special Officer

(signed on his behalf)

Fee: not applicable Ref. nr. 392229/IX

In the *Certificate of Citizenship* the name that was recorded was Josef Cretzan, not Iosif Crețan. Josef Cretzan was the German phonetic spelling of both his Christian and surname, and this spelling of his name would remain with him for the rest of his life.

Franz Terme remained in Lodz for several months with his remaining children Christine and Mirtscha. For Christine, the inhumanity and cruelty that she witnessed in Lodz was a burden that she carried with her for the rest of her life, and she never spoke to anybody including her own children about the atrocities she had witnessed in the city. In 1942, the family moved to the city of Erfurt where they stayed at Barfusser Strasse before finally moving to the nearby city of Ilmenau in 1944, where they lived at Schlachthof Strasse 18.

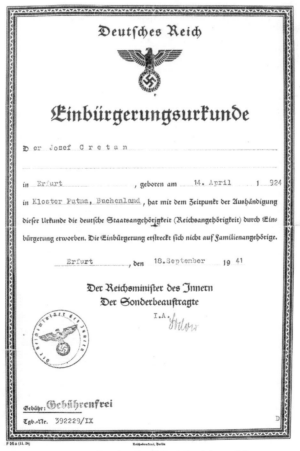

Photo of Joe's Third Reich citizenship

Although Christine and Mirtscha were still only children the military machine that was the Third Reich created a youth movement for the Nazi Party for boys and girls of their age, which both Christine and Mirtscha had to join. The Hitler Youth movement was for boys between fourteen and eighteen years old, and the Deutsche Mädels (League of German Girls) was for girls aged from ten to eighteen.

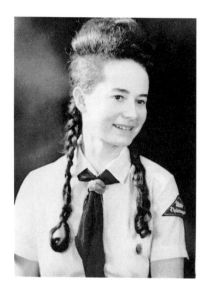 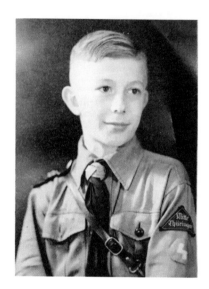

Christina, League of German Girls and Mirtscha, Hitler Youth

Chapter 3

The Iron Curtain

Throughout the war years Josef was involved in front-line duty on the Eastern Front in Russia, Libya in North Africa and Monte Cassino in Italy. He made close friendships with many of the soldiers in his battalion, however none of those young men survived the war. The German campaign on the Russian front was the most difficult period of combat due to the harshness of the Russian winter and the intensity of the front-line fighting. On three occasions Josef was injured with gunshot and shrapnel wounds. In 1944, his military service to the German Empire was recognised and he was awarded three medals, the Iron Cross (Second Class) for distinguished service; Wound Badge in recognition of injuries sustained during combat; and the Infantry Assault Badge in recognition of front-line infantry assaults.

Following Germany's surrender in May 1945, Josef travelled to Ilmenau where he was reunited with his father and younger siblings. After spending some time with his family, he went to the Town Hall where he registered as a resident of the town. The Office of Military Government issued him with a Military Government of Germany registration card registering him as a resident of the town. Within days he was detained by the American authorities who had taken control of the region and sent to Camp Wagram in France, where he was detained officially as a prisoner-of-war for six months. He was released from Camp Wagram on 13 November 1945.

Joe's Military Government of Germany identity card

Following his release, he returned to Ilmenau where he reunited with his family. His brother Aurelian had survived the war and had also returned to Ilmenau, but Octavian never returned. He had been a member of the third division of the Waffen SS, under the command of Brigadier Leader Hellmuth Becker. The unit was recognised as the elite force of the German army and took part in almost all the major battles during the war, including Operation Barbarossa, the German invasion of the Soviet Union, where the unit suffered catastrophic losses. With the assistance of the German High Command and the Red Cross, a search was completed to establish if Octavian had been killed, injured or imprisoned during the war. However, no information was available about him. The family was told to presume that Octavian had been killed in front-line combat, most likely in the Soviet Union. He was classified as one of the two million German soldiers who had been killed during the war, or more specifically as one of the 314,000 Waffen SS soldiers who died during the conflict.

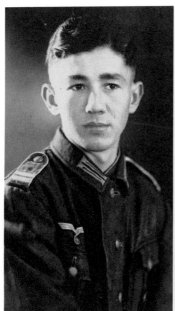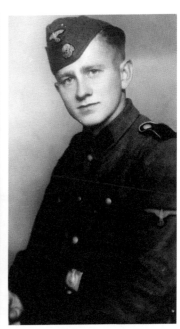

(l-r) Joe's first day in uniform, Aurelian in German army, Octavian in Waffen SS uniform

Following the immediate aftermath of the war, Josef remained in Ilmenau with his father. Ilmenau was a centre of glass and porcelain production and there were opportunities for skilled workers in many of the local glass factories, including the town's largest employer, the renowned ceramic factory, Graf von Henneberg, which had been manufacturing porcelain in the city since 1777. Franz Terme's skills as a glass painter were in demand in both the glass and ceramic factories following the war, as many of the skilled workers had been killed resulting in a shortage of craftsmen.

The division of Germany by the Allies into four zones following the Potsdam Conference in 1945 meant that Ilmenau was in the Russian zone and there was no freedom of movement to allow workers to move to the British, French or American zones. Josef had secured German citizenship so had the option to leave Ilmenau legally, but his younger siblings, Mirtscha and Christine, were stateless and therefore trapped in the Russian-controlled zone of Germany that was later to be renamed Deutsche Democratic Republic, better known as East Germany. Their father, who held a German passport, had no

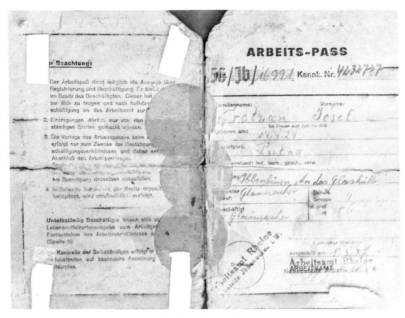

Joe's Arbeits-Pass

option but to stay with his children in East Germany; nonetheless, the family planned to move to the west as soon as the opportunity arose.

On his father's insistence Josef made the decision to leave Ilmenau and travel to the American-controlled zone in Germany. As Josef prepared to leave his family he promised his father that he would stay in contact by letter and that he would return to Ilmenau as soon as the Russian forces had left the city.

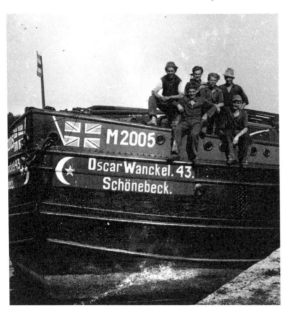

Joe, standing on far left, on the Saerbeck Harbour barge

When he left Ilmenau Josef travelled to the region of North Rhine-Westphalia in northwest Germany where he registered, as required, with

the municipal employment office, who issued him with an *Arbeits-Pass* (Work Pass) booklet. The entries listed in the *Arbeits-Pass* document recorded the details of Josef's employment from May 1947 to February 1949. From 9 May to 25 June 1947 he worked as a glass blower at Kösters Glashüttenwerke (Kösters Glass works) in the town Ibbenbüren. In July 1941, he moved to the nearby town of Saerbeck where he worked as a harbour worker on the River Ems for Speditiongesellschaft Saerbeck-Hafen (Shipping Company Saerbech Harbour) until 19 August 1948. In August 1948, he moved to

Joe and Aurelian in Limburg an der Lahn, 1949

the city of Düren where he returned to glass blowing at the Peill & Putzler, Glashütte Düren (Düren Glass works).

The glass works at Düren employed 1,500 workers and produced stemware and lighting-ware from the five furnaces at the factory. It was at the Düren factory that Josef established his reputation in Germany as a glass blower of exceptional skill. He remained at Düren until 30 January 1949, and then moved to the city of Hattersheim, where he worked for two months at the Taunus Glashütte (Taunus Glass works). From 25 April 1949 until 17 April 1951, he worked at the Glashüttenwerke Limburg where his brother, Aurelian, was also working as a glass blower. He left the factory in Limburg on 17 April 1951, having received an offer from the Taunus Glashütte to return to their factory in Hattersheim where he remained until 8 of June 1951, before he returned to live in Limburg an der Lahn. The opportunities that his father had told him would exist for him as a glass blower had become

a reality, and he had substantial earnings which ensured he had an excellent standard of living that allowed him to move freely from one factory to another throughout Germany.

Despite his relative affluence, Josef never forgot the plight of his father and younger siblings whom he had promised to support in every way he could. His wish was for his family to be reunited again, but not in Ilmenau; his plan was for them to join him in the American zone in Germany. It was not possible to have any form of direct contact with his father, but they stayed in regular contact by letter over the following months and years. Josef kept, and guarded closely, all the letters that he received from his father. The content of those letters give an insight into the challenges, both economic and personal, that Franz Terme endured while living in Ilmenau. The letters also give an insight into the character and personality of Franz Terme and indicate that he was a well-educated man, who had high standards and expectations, both morally and socially, for himself and his children. In the letters, Josef's father refers to him as Seppel, the German diminutive for Josef, and he refers to his daughter Christine as Dita. The letters have been translated from German and in some cases the context of the letters can be lost through the translation. The letters date from June 1948:

Ilmenau / Th *26.6.1948*

Dear Seppel,

Greetings from both of us. I received your last letter yesterday. We are also healthy. In the meantime, you will probably have also received my letter. It cannot be helped that Mircea did not arrive home quite well; but it has now got even more difficult and so we will have to do things differently so that we don't fall into complete poverty and perish. Send 1 or 2 parcels each week if possible. Mircea sent a parcel of empty sacks. Parcels will certainly arrive. You wouldn't believe what great hardship we suffer.

Mirtscha is still working as blower of ½ litre vinegar bottles. He doesn't help much in the house. We often have poor glass, quite brown. Some people have already stayed at home because they

have nothing to eat. If Mirtscha hadn't brought maize flour, it would have looked very bad for us. Today we are having Mamaliga[1] for the last time. Mirtscha is growing. I don't get anything from Aurelian. We will have to wait for different times when you can come, and you will certainly come. Be patient. We have to be too. Dita was sick. Pneumonia. Erwin also. We also exchanged money. 70 DM. (Deutsch Mark) per person and the rest for 1000 DM. We should also get something from the old savings books, but later.

Regards, Your father. Write again.

Ilmenau / Th.

29.6.1948

Dear Seppel!

I have to write to you again today because we cannot work. It doesn't work at all, such miserable, poor glass, because the old craftsmen who understood something have been dismissed. I am expecting the factory to come to a complete standstill. It was good that you stayed. We are very worried about what will happen to us this month. Mirtscha would like to travel to you, but what would I do without him. But he has no money for the British Zone, so he asks you to enclose some in the maize flour when you send a parcel. Parcels arrive from other zones when they are registered. I'm sure you will help us again as you have done so far. We do not expect anything from Aurelian and Dita. Dita did not return the shirt and we got nothing for it.

Will we ever see you again? It has never been so bad for us before. It is just good that you took my advice and stayed. Stay respectable and good. Perhaps everything will turn out as we would like it.

Until then, warmest regards from Mirtscha and Your Father.

Mirtscha is a good boy and he is just washing the shirts and hand-towels, and he is always very clean. Do not forget us.

1 Mămăligă is a traditional Romanian porridge made out of yellow maize flour.

Ilmenau / Th.

12.7.48

Dear Seppel!

I've been waiting a long time for your letter. Best greetings from us. By now you will have received my letter and the parcels with the little bags. There is not much news here. The factory is still going but it looks as if it might come to a standstill soon. Only 5-6 machines are running, more often less. Preserving jars are produced as well. We didn't get any yet as the company is delivering to such customers that deliver food to us. We have also received some vegetables, vinegar etc. as otherwise the workers would run away. I received a long letter from Aurelian this week. He is requesting a lot again. But I wrote him a letter today which he will not stick behind his mirror (will not put it in his pipe and smoke it). He thinks I have fallen on my face. Always wishes and requests and he never shows any gratitude with a small thing. He is well. He has time for Mr Klinger but not for us. So someone else can do his bidding. He wants papers, a letter written to Havelsberg and taking people for fools. I don't go along with that. He also complains about you. He thinks you have too much air in your head. I replied to this that you may be a fool but you have a good heart. You do not forget to support your old father while I do not get the slightest kindness from him. The fact that Helene has found a good place is only due to Dita and us, as Dita made a useful person out of her so that she can mix with better people. That has cost me money and Dita enough trouble and work. You seem to have forgotten everything. I have done my duty as a human and Christian. He shouldn't think that Mirtscha is going to him. Then I wrote to him that you will find your way even without Düren. If not, you can come home, the door is always open for you, as you showed an open heart for me. He will certainly know now what he owes me. Dita visits often. She gets injections. She doesn't look well. Myself, and Mirtscha are very worried about food problems. He cannot get to you right now. Is there a possibility that you could come home soon? Kauber came to see me this week, he wanted preservation jars. We would be delighted if we could get something

from you. But no delicacies. Greetings from your Father and Mirtscha

With the money that Joe had sent to his father, Mirtscha did obtain an inter-zone pass and crossed the border into the U.S. zone. He then travelled to Limburg an der Lahn where Josef provided him with accommodation and organaised a job for him at the glass factory.

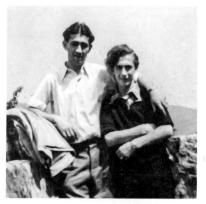

Joe and Mirtscha

--

Ilmenau / Th.

8.11.48

Dear Seppel!

Firstly I have to thank you for the parcels you sent me. They arrived undamaged, 4 on the 5th and one on the 6th. And they contained exactly what we love most. Corn flower. It was a small feast day for us both. Mirtscha was very happy too. Greetings from both of us. So far we are healthy which is what we wish for you too. Our factory is still running but if we're not getting coal soon we will have to stop again. The weather here is rough and bad. There are about 80 people employed here and they will get a small company kitchen soon. It'll be a help for both of us. It is a little better now but there is still a lot missing. Every now and then we receive additional potatoes from the company. We also got a special coupon for clothes. Mirtscha spent 30 Marks on cloth for a suit and lining and I gave him my coupon too. A pullover and socks is what he got. There is a big storm on the co-op (store). Dita came to see me again and brought 5 pounds of onions. She told me she will get married soon. She'll be 22 years of age on the 10th of this month. Mirtscha is growing fast and he will be as tall as you. But he needs more to eat. Have you no prospect of setting up your own house-hold? Helene has not been to see me for a while. Stussig is now chairperson of the works council.

I also need to tell you that Frau Belsa from Gehren came to see me this week. She wanted 50 Marks which you owe her sister-in-law from Bad Berka. But I didn't pay her anything. She then wanted your address which I gave her. But you cannot send money. I told her it's not possible. It is impossible at the moment to send Helene, I am well informed. And Helene herself said she didn't want to leave Ilmenau as she is doing fine. She owes this to Dita._Mirtscha is working as a blower of 1 litre urinary jars but he hasn't got the right perseverance. Soft hands.

Your Father

--

Ilmenau / Th.

18.5.49

Dear Seppel!

Why did you let us wait so long for a letter from you? First of all, many greetings from myself and Mirtscha. We are also well and wish to remain so for a long time. I knew you wouldn't stay with Aurelian for long, but you don't listen to me. You could have saved yourself the trouble. Everything is still the same here. We are working, myself and Mirtscha, but who knows for how long? We don't like it at all here in Ilmenau but what can we do? I am too old and Mircea too young to change our circumstances. I earn good money, had nearly 50 marks but worked over 70 hours in the week. There is a lot of tax to pay though. Mirtscha doesn't like to work regularly, so we argue a lot. But he will try to improve himself, he started this week. He liked Hattersheim and he brought back loads of things so that we still have enough. We do not suffer hardship anymore, and it has changed for the better. I bought a hundred-weight of flour and potatoes from Dita so that we are not hungry anymore. Mirtscha and I also get coupons. I don't have many clothes. Mirtscha has bought 2 new suits and a rubber (rain)coat. He has to see Karin this week and when you first meet you will get the shirt and swimming trunks back. Dita comes visiting often and she will marry soon. She has bought a wedding dress. You should get married soon too. It's about time so that you could get some

rest and find a new home. May God protect you wherever you are. The zone borders will soon be gone and we shall see each other. I will close with lots of greetings and hope to hear from you soon.

Your Father

I received the letter with the photos and I am happy about them.

Ilmenau / Th

27.8.49

Dear Seppel!

Best regards. I hope my letter finds you in the best of health. I have not much to write today but, because I am quite alone and my thoughts are always with you and Mirtscha, I have to write to you again.

I don't yet know where Mirtscha is, but I think he will come to you. You won't believe how sad my old days are when I'm all alone. Dita was with me the whole day today and has cleaned the rooms and cleared the beds of bugs. I have not yet been able to work. But we cannot go on, the boxes are small so there are piles of glass everywhere. The furnace is working well. We also have enough coal but there is not much in the way of food. As there are no potatoes at all and it's hard to fetch vegetables when I have to work. I advertised the rabbits in the newspaper, but nobody has money anymore. If you have anything in the way of shirts or working clothes, which you don't want to wear, do not throw them away, but send them to me, I can use them. I would be grateful. As for your wish to go to Sweden, I would advise you strongly against it. Stay in Germany. You would not have it better in Sweden but would be more exploited than here and then you would get a kick up the arse. We are not respected any more, just exploited. And when you come home, there would be great joy, but I understand that it is difficult for you, I advise you not to stay here, many people are forced to go to Austria. It is supposed to be good there. They come? Big and fat on holiday. Leave the women. Do the same as me, don't look at them. Dita has grown very strong. If the little one comes to you, write and

don't forget your father, who is with you in his thoughts every day.

Your Father

--

Limburg.

24.10.49

Dear Father,

I got your letter and your card and I was happy that you wrote. I got the papers from the factory.

How are you otherwise?

Dear Father, Frau Frenzel sends greetings, and you do not need to worry about the flat. You will get your room for yourself, and it is nice too. I too have a room to myself and I have all I need, even a book case with books.

Dear Father, get ready, I am sending you the papers that you need for here, first the residence permit, I am sending you that first, when you get that you need to go to the mayor to get the Interzonepass (permit for travelling between zones) and if you don't get it we will cross the border illegally. Don't be afraid I will make sure you get through. And when you are there the journey goes on to Sweden. We got mail from there. You can go there as glass maker, I as gatherer and Seppel as master craftsman. Aurelian is not coming. We have a flat there.

Dear Father, I am leaving here on November 14th and will come and get you. We thought it all through first, and it is possible, I am looking forward to seeing you again. I have been dying to see you. Who is Dita marrying? Wait with the packing till I come, I will do that when I get there. Just keep everything in good order. We don't even have to pay the fare to Sweden, the company will do that.

I am healthy and I hope you are too. I will bring enough food for the two of us for the journey and for home as well. Are you not looking forward to it? I am, it is much better here than in your place. What

is Dita up to? Is she still well or does she quarrel with Edwin sometimes? So, do get ready, you know everything else. Want to end now, cordial greetings from your sons Mirtscha and Seppel

Greetings from Frau Frenzel and to Dita too. Please reply.
Waiting for mail from you to see what your answer to this is.

Dear father, please be so good to send a telegram immediately when you get this letter saying that you are very ill, I will then get a pass for you and me, send immediately.

Limburg.

10.12.49

Dear Father

I got your letter and I was delighted. The parcel with the socks arrived in good condition. How are you?

Dear Father, you asked what to do with my points. Spend them all on socks, 3 pairs of tights for women size 8. Let Dita buy them when she comes, and the rest on socks for men. You can take 2 pairs for yourself from those. I am enclosing West money, which you can change and use for the purchases. Do it as fast as possible, dear Father.

When the other parcel arrives, I will write to you that you can send the other things. How are you otherwise? I am still working with Seppel and also in a shop as a saddle maker. I earn quite good money. Sepp always gets 90 to 100 Deutsch Mark a week. You can live the life of God with that, and you can buy things as well. I got 70 Deutsch Mark this week and so far I was able to buy 1 coat, 1 pair of suede shoes, 1 pair of leather shoes, 1 pair of trousers. You will also get something from me, Sepp and Frau Frenzel for Christmas. Keep it all for yourself, we might send something for Dita too. We are all healthy. What is Stasny up to? I am getting as tall as Sepp, just a bit more to go. That's from the eating and sleeping. You will be astonished when we both get to you. Be so good to do everything as I wrote. I will finish now. Best regards from all of us.

Please reply

Limburg.

18.12.49

Dear Father

I received the letter and the parcel and was delighted. Sepp sent you 2 parcels last week. Write when you get them, I am still healthy and hope the same of you. What is it like in Ilmenau? All is nice and good here, 1 year is coming to an end and we are sad that you are not with us, but this year should be the last one, you may be assured. It won't be long now and then we will all be together, forever. Do not be sad that we are not coming, this will be the last Christmas that we are not together. Dear Father, please be so good and send me my other shirts and jumpers together and then the other stuff, the trousers and the light training suit. You write that Dita wants to get married and I wish her lots of luck. Sepp will soon get married too. One other thing, you say that people are asking about me down in the factory. I am learning more here than I would there at the machine, and better.

When you send the parcels please include a Karl May[2] book in each of them, slowly but surely I will turn into a cowboy. What is Siegfried up to? Please give him my regards and he should write to me. I am keeping well. You can buy anything here - guns and pistols, and everything you want. What is Herr Stasny up to? Give him regards from Sepp and myself.

Dear Father, I will be 17 years old in 4 days and I am so sad. How are the rabbits, do you still have the radio? I listen to music and I write along to it. We always work dayshifts.

Dear Father, something else, send me the ring too, it is in the top middle of the kitchen cupboard, and my dagger and my wristwatch. It's in my bedside cupboard.

For Christmas, I got 1 shirt, 1 pair of white socks, chocolate, 1 pair of boots, 1 navy jacket, 1 coat, shoes and other things. We will send you things too.

2 Karl May was a German writer who wrote adventure novels for young adults, most famous were his novels about the Red Indian named Winnetou.

How did you fare over Christmas? Did you at least have cake? I always thought of you, did you get the parcels? Please write, Sepp and I will come and get you in February, we will have annual leave then. We have an Interzone pass. I will finish now. Best regards from me, Sepp and Frau Frenzel.

I also wish you a Happy New Year. Please reply

--

Limburg.

4.1.1950.

Dear Father,

Have received the letter and the parcel and we were delighted, did you get both parcels? How are you, are you still healthy? We will send another 2 parcels, we are still well. Did you get into the new year all right? What are you up to? Did Frau Frenzel write to you about Sepp? Everything is alright again, they are getting along again, you can rest assured. What is Herr Stasny up to? Is everything still the same with you? I listen to music and write along. I work in the factory and in the shop, work in the factory from 6-2.30 and then from 3 - 7 in the shop. I earn good money and can buy things and save. What is Siegfried up to? Give him my regards and he should write to me. It is nice here, and with you? Dear father, please be so good and send me the rest of my things, send me my penholders and mechanical pencils, they are in the bedside cupboard with my penholders. What is Dita up to? I will write to her too. We got into the new year alright and are hoping that it will also be good in future. I will finish now as I want to go to sleep now. Best regards, from me Sepp and Frau Frenzel

Greetings to Stasny Please reply

--

Ilmenau/ Th.

9.1.50

Dear Mirtscha!

Dear Seppel!

Greetings to you and to Mrs Freuzel.

Now it is over. The special day of your sister. The wedding was on Saturday the 7th and lasted into Sunday night. She was a gorgeous bride. I drove there on Saturday morning with others from Ilmenau, Langewiesen und Gehren. We were 40 persons at the wedding feast. They went to the registry office at 10am and the wedding in the protestant church was at 2 pm in the afternoon. Dita converted to the protestant faith. Many spectators in the church and on the streets. The deeply moving words of the vicar during the ceremony will always stay in my memory and I would have regretted it for the rest of my life if I had not been present. Duty is the most important thing to me, and I want to convince both of you of this too. The vicar used the words of the Saint Ruth in his sermon. 'May your way be my way, may your wish be my wish, where you go, I will also go.'

I saw that many people were moved by this sermon, as I was. May they both now move along the same path, united and true in the same faith, as it should be in life. It's a new chapter in life. May God grant that it be a happy one.

The blessing of the parents builds houses for children. Remember that.

The wedding table was covered with plenty of whatever food and drink you could imagine. Of course, I indulged myself far too much with food, but not with drink, and therefore I could enjoy the fun.

Music: lute and accordion songs and speeches by funny girls. There were some very good looking ones among them. Seppl! you would have fallen in love at least 4 times. Isn't it a pity? At five on Sunday morning I had to rest a bit but I was up again at 8. There were mountains of cake that had to be eaten and wines and liqueurs had to be drunk, and we had to rush to get the train in the evening. And I was given cake to take away in memory. The bride and

groom got over 70 greeting cards and 4 telegrams. A long table full of presents: smoking table, crockery, clothes, even a nickel bottle and baby's hat were there. Even more presents arrived on Sunday.

The vicar was funny at the table and made a good contribution with funny stories and a very nice speech. I know that there are always wishes that are not fulfilled. In our case it was that you two were noticeable by your absence. Especially you, Seppel, you could have represented our beloved, old homeland in the far east, where you were born, with your slightly dark skin colour. I forgive this to a certain extent as it is no stone's throw from Limburg to Möhrenbach. But you are sure to make up for what you missed, as is correct, and respectability and duty demand.

And now for something else:

Dear Mirtscha, on Friday I received a letter to which I replied with a card, and I just received a letter dated 5.1., saying I should send some of your things again. I am glad to do this but until I am certain that you have received 4 shirts and 3 pullovers, I would not like to risk your things going missing. I will pack them. 1 sleeveless pullover 1 suit and the requested, except for D. You must not think me so stupid, that would not be pleasant for you and me. Find another sport. It is my duty to make you aware. It is not written anywhere that a servant should always remain a servant. Strive to be a little gentleman rather than a big servant. I am not sending regards to Siegfried. This friendship could be an unpleasant nuisance for you. There is already very bad talk about the whole family. A brother imprisoned and a sister with a sexually transmitted disease. I don't know if it is true. Look for better friends, you must always write and tell me that you have received what I send. What has happened to Mrs Freuzel Has he behaved badly again, does he need dressing down? He's still a big boy. I'm glad that you are in a business. Stay honest. It can only be useful to you later. Take an example from Dita. She will be a respected woman.

Today we are back at work again for the first day and are on nightshift.

Your father.

Limburg

16.1.50

Dear Father.

First, I have to tell you that we received your letter with great joy. I have to tell you that Mirtscha went into hospital yesterday. He will be operated on the appendix at 9 o'clock today. I will go to see him in the afternoon. I too have been off sick for the last 14 days. I have the illness which I caught abroad. Malaria. Dear Father don't worry about it. Mirtscha will be well again and so will I. I am going back to work on Thursday and then all will be well again. Dear Father, Mirtscha and I are pleased that Dita had a nice wedding and I wish her a lot of luck in her new life, Mirtscha too. It would have been nicer if Mirtscha and I could have been there too, but we hope that we will get an Interzone pass to go home. You know how difficult it is to get over otherwise I would have been over already. And now my dear Father, from the bottom of our hearts, Mirtscha and I wish you good luck and all the best. The birthday parcel will be on its way soon. Dear Father, I'm just back from the hospital, all went well, and he is asleep. Don't worry, Mirtscha will be well again soon.

Now, Dear Father, I will finish, cordial greetings,

Your Seppel

Many greetings from Frau Freuzel too.

Greetings to Dita from Mirtscha and me and she should write to us sometime.

--

Ilmenau/ Th.

10.1.50

Dear children,

You wrote and told me that you have an Interzone pass and want to come here soon to fetch me. Have you considered this properly and thought it through? I would like to get away from here, not that I am doing badly, I am not in need. But I can't stand life alone. The time will soon come when I am no longer able to work at all and then I will have to go away, and then I will have to leave the factory. Hope to get permission to join you so that I can also get an Interzone pass and exit visa, as I cannot and will not leave by illegal means. Next week I will be 68 and I don't want to be a burden on anyone. I have not yet applied for old age pension, as I don't want to be a burden on the state either. I can still work, but that could be finished soon, in 2-3 years. Discuss this and write to me objectively and fully. I realise that I can't turn to the Schulz family. Write and tell me what sort of work you do in the business and how you achieved this. It is better than chasing girls. It seems like quiet work in the factory as Pfeffer has moved into the Westzone. The family is still here.

Herr Stussig also wants to move away as there is no great chance that the factory will last much longer. Do write to me soon and in detail about things that interest me.

I'll finish off now and wait for the postman who is supposed to bring me 2 parcels. I am looking forward to your coming even if it is only for a visit as you wouldn't want to stay here, that I know; we will all three drive to the young Mrs Schulz. Again, greetings to you and Mrs Freuzel.

With always present love

Your Father

Did you really send me money. There was nothing in it. I have paid 6 months rent in advance and I also gave Dita a decent wedding present so that she had pure joy on her wedding day. The postman brought nothing today.

Limburg

16.1.50

Dear Father.

First, I have to tell you that we received your letter with great joy. I have to tell you that Mirtscha went into hospital yesterday. He will be operated on his appendix at 9 o'clock today. I will go to see him in the afternoon. I too have been off sick for the last 14 days. I have the illness which I caught abroad. Malaria. Dear Father don't worry about it. Mirtscha will be well again and so will I. I am going back to work on Thursday and then all will be well again. Dear Father, Mirtscha and I are pleased that Dita had a nice wedding and I wish her a lot of luck in her new life, Edwin too. It would have been nicer if Mirtscha and I could have been there too, but we hope that we will get an Interzone pass to go home. You know how difficult it is to get over otherwise I would have been over already. And now my dear Father, from the bottom of our hearts, Mirtscha and I wish you good luck and all the best. The birthday parcel will be on its way soon. Dear Father, I'm just back from the hospital, all went well, and he is asleep. Don't worry, Mirtscha will be well again soon.

Now, Dear Father, I will finish, cordial greetings,

<div align="center">

Your Seppel

</div>

Many greetings from Frau Frenzel too

Greetings to Dita from Mirtscha and me and she should write to us sometime.

<div align="center">

</div>

Limburg.

31.1.1950

Dear Father

Have received your letter and was delighted. I am well again and hope the same for you. I was in hospital for a week with appendicitis, was operated on and all is well again. How are you? I received a big and a small parcel, please send the other one as well.

Dear Father, do not be angry that I couldn't write earlier, did you get the letter from Sepp? Why are you not writing, what is Dita up to, is she well, is everything the same with you, is the factory still going? It is nice here but cold. What is Herr Stasny up to? I have been home for the last week, will soon back to work in the shop. We want to go away from here in spring, there are plenty of possibilities to get out of Germany, to Argentina or anywhere you want to go. I have one more favour to ask. Please send me the things. I got the other ones, both parcels. Sepp is having trouble again, he wants to go to Hattersheim again to see Ria. First, she exploited him and now he wants to go back to her, he had everything here that he wanted and now he is a burden. If it goes on like this it won't be long and I will be in Argentina. You needn't worry, before I go I will come home one more time. Write again soon.

Best regards from all of us.

<div style="text-align:center">

Mirtscha

Please reply.

</div>

--

Limburg.

21.2.1950

Dear Father,

I received your letter with great joy and I was delighted. How are you? Are you well? Sepp and I are still well. I received the parcel and everything was in good condition. Can you send the

other one too? The jumper, the brown shirts, the green scarf and some other small things from my bedside cupboard. Dear Father, Sepp and Frau Frenzel are planning to get you here before Easter. Everything has been prepared here. I will send you a certificate that I have been operated on and that it was unsuccessful, and I would like to see you one more time. You should go to the mayor's office with that and request an Interzone pass for yourself. Frau Frenzel and I will come and collect you. We cannot get the Interzone pass for you here. I will get the certificate from the doctor. I will send the certificate with the next letter, you can be sure that it will work this time. Prepare everything so that all is ready when we come. One more thing, you asked if I don't work in the factory. I work from 6.30 to 2.30 in the factory and from 3 to 7 in the evening in the leather-goods shop, where I learn new things. Everything is still the same, we are still very well. Did you receive the 2 parcels? The big one with flour and then another one? We will send a big parcel this week. Don't be angry that I couldn't write earlier. Will finish now. Kind regards from me, Sepp and Frau Frenzel.

<div align="center">Please reply.</div>

Today, the 24th, we will send a parcel for your birthday.

<div align="right">A present</div>

Limburg.

<div align="right">*6.3.50*</div>

Dear Father,

Today, 6th March I received your letter and I was happy that you wrote. You wrote that Stasny is coming to visit me here. Dear Father, we are asking you to come along with Stasny when he comes over. Leave everything there for Dita, she should stay for 1-2 weeks in Ilmenau and get everything ready in the flat. We have everything organized for you here, believe me. Tell Herr Stasny that we will be very thankful if he gets you over safely. He would not be doing it for nothing. Leave everything there, just take the money you need and change it at the border. You are not working, and it will work now. You do not need to work here, myself and Sepp will

see to that. Do not always write that you will be a burden to us, that is not true. On the contrary, we would love to have you here. Do not ever write that again. And one more thing, when you travel with Herr Stasny it would be best just to take a small suitcase, so it won't be too heavy for you. Dita can send all the rest, so leave her money so she can send it. Do you understand? No more contradictions, that is all.

Will finish now. Kind regards from all of us.

Greetings to Herr Stasny too.

Please reply

Send your things so that you don't have to carry anything heavy, books as well

All my things have arrived here alright. Do send the other things, be so good. Do everything as I wrote to you . Okay

Limburg,

7.3.50

Dear Herr Terme,

Sepp and Mirtscha and Frau Frenzel send you best wishes from Limburg. Many thanks for your kind greetings that you have sent me so far.

Dear Father, I have been trying for weeks and months to get you to us either illegally or with a pass, but unfortunately it was not possible for me to get to you. But dear Father only one thing is possible, someone has come here from Ilmenau. His son is still in Ilmenau. He will come illegally to Limburg in the next few weeks. I have talked about this with his father that you should come with him. He is well known at the borders. If you cannot decide, there is

one more possibility. As you wrote to us, Staßnieck wants to visit us. Mirtscha and I can only organize work for Staßnieck if he will take you with him. To show gratitude for that, he could stay with me for a long time, if he gets you here well. Dear Father do not let this opportunity slip, who knows what will happen by Whitsun. The room has been ready for the past half year. We also have plenty to eat. Do not bring anything else except your clothes. Give every-thing else to Dita. But do not hand in notice for your flat until you are here. Give Dita the key and we will send her a telegram from here. Just in case you have to return from the border, you will still have your flat. Dita can then sort everything. Mirtscha and I are very worried about you. Only you and I know the strain we went through in Putna. You should have it better here with us to make up that in your old age. We have set down roots here and have found a home here in Limburg. Frau Frenzel is also inviting you cordially. And is expecting your arrival soon. Her two boys are very sad that you are not here with us yet, especially Sepp. Good luck that you will be getting here safely.

Best regards from Frau Frenzel, Sepp and Mirtscha.

Ilmenau / Th

19.4.50

Best wishes on your birthday.
The factory is still here.
Big news here.
Schorte, Mannebach and Ilmenau mines are being put back into operation by our occupying power.
Many people will be needed.
Letter to follow soon. Greetings to Mirtscha and Mrs. Frenzel.
Write again soon. Your Father

The letter that was to follow soon never arrived. Eight days after writ-ing the birthday card to Josef, Franz Terme died. He had taken the

short train journey from Ilmenau to Mohrenbach on Sunday, 23 April 1950, to visit Christine and her family, including her newly born baby daughter, Renate. Having spent the day with the family he returned to the train station in Mohrenbach for the return journey to Ilmenau. While standing on the station platform waiting for his train, he collapsed and died. Josef received a telegram from Christine later that evening with the message:

Come immediately Father is dead – Christine Schulz

To travel across the border into East Germany to attend the funeral, an entry permit was issued on a humanitarian basis by the regional council, following representations made by Christine to allow her siblings to attend their father's funeral. The entry permit granted permission for Josef and Mirtscha to travel to Mohrenbach for the funeral, which was to be held on 27 April 1950.

Der Kreisrat des Landkreises
Arnstadt

Arnstadt, den 26.4.1950

Einreisegenehmigung

Gegen die vorübergehende Einreise des/der

Herrn Frau/Frl. Josef Cretzan geb. am 28.4.24 in Putna
Mirdscha Cretzan 21.12.32 Putna

wohnhaft in Limburg/Lahn vom 26.4.50 bis 26.5.50 nach Möhrenbach

bestehen unsererseits keine Bedenken.

Reisegrund: Beerdigung des Vaters am 27.4.50.

Die Einreisegenehmigung gilt für die Dauer des Interzonenpasses.

1810 Nr. 6 V & B

1.stellvertr.Landrat

Entry permit to enter Russian zone

43

The official death certificate was issued on 28 of April 1950:

Death Certificate Franz Terme

Glass-painter Franz Terme

Resident in Ilmenau, Schlachthof Street 18

Died on April 23rd 1950 at 4.10 pm at the train station in Mohrenbach

The deceased was born on January 17th 1882 in Parchen-Schelten, Tetschen District, CSR

Father: Guertler Terme, whose last residence and place of death was Steinschonau, Tetschen District

Mother: Anna Terme, nee Glaesner, whose last residence and place of death was Steinschonau, Tetschen District

The deceased man was married to Maria Terme, who lived in Bad Schandau near Dresden

Written record of statement by commercial clerk, Edwin Otto Emil Schulz, resident in Mohrenbach

The informant is known to the clerk of the registry office.

He stated that he had known of this death by his own knowledge.

Stated, approved, and signed by Edwin Emil Otto Schulz

Signed by the clerk of the registry office

Cause of death: old age, no particular illness, only general effects of ageing (degenerative)

Christine and Joe at their father's grave

The funeral mass of Franz Terme was held at the Catholic Church in Ilmenau and he was buried in the graveyard in Mohrenbach. The official church records differed from the records at the Municipal Office in that they recorded his cause of death as 'stroke'. Following the burial, Josef spent several days with Christine and her family at their home in Mohrenbach. When he left for the return journey across the border into West Germany, he had no way of knowing that it was to be the last time he would ever talk to, or be in the company of, his sister.

Grave of Franz Terme at Mohrenbach Graveyard

Chapter 4

Greener Pastures

Although he had received offers to work in the glass industry in Sweden, Josef refused to leave Germany because he was committed to supporting his father in every way that he could as long as he was alive. With the death of his father that commitment no longer existed. At twenty-six years of age, he had the opportunity to travel to any part of the world. Although his earnings as a glass blower in West Germany ensured that he was able to live a comfortable lifestyle, earning up to 100 Deutsche marks per week, he was not content with his life there; he wanted new experiences and to travel to other countries.

Within weeks of his father's death he saw an advertisement in the local newspaper for experienced glass blowers for a factory in Ireland called Waterford Glass. He took the advertisement, folded it neatly and placed it in his pocket. A week later his landlady, Frau Frenzel, found the folded piece of newspaper in his pocket while washing his laundry and asked him if he wanted it. He had forgotten all about it, and as he took it from her he reread it. The factory was located in a country called Ireland, a country he had never heard of. Frau Frenzel said she believed that Ireland was in the middle of the Atlantic Ocean and was very cold with mountains, glaciers and volcanos.

Josef wrote a short letter expressing an interest in travelling to Ireland to work for Waterford Glass. He also stated that his brother Mirstcha and his friend Josef Landgraff would also be interested in travelling with him to work at the factory. A series of letters were exchanged from August 1950 to September 1951, and their content

detail Waterford Glass's plans for glass production in the factory, and in particular their wish to produce lead crystal there.

During the early summer of 1951, Charles Bačik and Franz Winkelman travelled to West Germany to meet Josef and watch him at work at the glass factory in Limburg an der Lahn. They watched in delight as Josef demonstrated his glass making skills, producing a selection of pieces for them. Winkelmann, who had years of experience in the glass industry across Europe, recognised Josef's talent

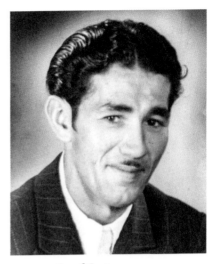

Josef Cretzan, 1950

immediately. As he watched him at work, he asked the other glass workers why they referred to Josef as *der schwarzes zigeuner* (the black gypsy). The workers had given him that nickname because of his sallow skin and jet-black hair, a feature common amongst Romanians. As the two visitors left that afternoon, Winkelmann shook Josef's hand tightly and said, 'if there is one glass maker we want at our factory in Waterford it is you, *der schwarzes zigeuner.*'

When Bačik and Winkelmann returned to Waterford they told the company secretary Noel Griffin to write to Josef Cretzan immediately making official contact with him. A series of letters were exchanged establishing his experience and background in glass blowing. After several weeks, a letter describing the terms and conditions of employment for Josef was sent to him in an attempt to entice him to travel to Waterford as soon as possible. A guaranteed minimum wage of £8.00 per week was offered. In anticipation that he would accept the offer, Noel Griffin contacted the Department of Justice in Dublin to commence the process of having a work permit issued for him. On 21 June 1951, Noel received a letter from Josef confirming that he would accept the offer of employment from Waterford Glass and final arrangements were made for his work permit to be issued.

Waterford Glass Limited

Our Ref FE/FM.

<div align="right">

16.8.1950

</div>

Herrn Josef Cretzan,
Fischmarkt 20,
Limburg / Lahn,
U.S. Zone,
Germany.

Dear Mr. Cretzan,

Thank you for your letter of the 8th, your application regarding our ad in the latest edition of the 'Sprechsaal'.

As we can gather from your description, we could staff a complete working place with you, Mr. Josef Landgraf and Mr. Mirtscha Cretzan. We are not adverse to employing you, but we would like to know the following information:

What's your method of making goblet glasses (Rhinish or the stem turned over by an assistant)?

Can you produce all sizes of wine glasses and how many of each type in an 8 hour shift?

Have you worked with lead crystal?

Can you blow goblets, vases, salad bowls with the crew?

In which glass works have you worked so far?

Which nationality have you, Mr. Landgraf and Mr. Cretzan? Have you got valid passports?

Please send us your detailed answer as soon as possible, so that we can get a better picture about your abilities. We will then let you know as soon as possible our employment conditions and details about wages etc.

In the meantime, we greet you

Regards

Waterford Glass Ltd.

ALL COMMUNICATIONS TO BE ADDRESSED TO THE COMPANY.

TELEPHONE:
WATERFORD

TELEGRAMS:
"GLASSFACTORY," WATERFORD

Waterford Glass Limited

DIRECTORS:
JOSEPH McGRATH, (CHAIRMAN)
JOSEPH GRIFFIN.
FRANZ WINKELMAN (FORMERLY GERMAN)
B. J. FITZPATRICK.

JOHNSTOWN,
WATERFORD, IRELAND

YOUR REF
OUR REF FE/FM.

den 16.8.1950

Herrn Josef Cretzan,
Fischmarkt 20,
Limburg / Lahn,
U.S.Zone,
Germany.

Geehrter Herr Cretzan,

Wir danken Ihnen fuer Ihr Schreiben vom 8.ds.Mts., mit dem Sie
sich auf unser Inserat in der letzten Nummer des Sprechsaal be-
werben.
Wie wir aus Ihren Ausfuehrungen ersehen koennen, koennten wir
mit Ihnen und Herrn Josef Landgraf sowie Herrn Mirca Cretzan eine
komplette Werkstelle besetzen. Wir waeren nicht abgeneigt Sie
bei uns einzustellen, moechten aber zunaechst folgende Auskunft
von Ihnen haben.
1.) Auf welche Art machen Sie Kelchglaeser (rheinisch oder den
 Stiel umgelegt beim Gehilfen)?
2.) Koennen Sie alle Groessen von Weinglaesern erzeugen und wieviel
 von jeder Sorte per 8 Stunden Schicht?
3.) Haben Sie schon Bleikristall gearbeitet?
4.) Koennen Sie mit der Werkstatt Becher, Vasen, Salatschuesseln
 eibblasen?
5.) In welchen Glashuetten haben Sie bisher gearbeitet?
6.) Welche Staatsangehoerigkeit besitzen Sie, Herr Landgraf und
 Herr Cretzan? Haben Sie gueltige Paesse?

Lassen Sie uns Ihre ausfuehrliche Antwort baldmoeglichst zukommen,
sodass wir uns ein besseres Bild ueber Ihre Faehigkeiten machen
koennen. Wir werden Ihnen dann sobald als moeglich unsere Anstellungsmen
bedingungen und Einzelheiten ueber Loehne etc. mitteilen.
Inzwischen begruessen wir Sie

hochachtungsvoll
Waterford Glass Ltd.

Letter from Waterford Glass, 16 August 1950

Waterford Glass Limited

2.9.1950

Herrn Josef Cretzan,
Fischmarkt 20,
Limburg / Lahn,
U.S. Zone, Germany.

We are referring today to your letter dated 21st of last month and we acknowledge its content.

We gather from that that you know about goblet making and also that you understand how to do lead crystal pieces. We would be interested in the Bavarian method with 4 men (1 stem maker, 1 base maker and 2 assistants). We assume that the goblets are blown over the hub, not over the parison (?), so that there would be 5 people including the carrier in working in the workplace. Did we understand that correctly?

Other articles such as salad bowls, vases, bowls, cream jugs will be worked over the parison (1 glass maker, 1 assistant, 1 parison maker, 1 carrier in).

We would also like to know if you produce 1-2 litre jugs. If so, do you also work with 1 craftsman, 1 assistant, 1 parison maker and 1 carrier in per workplace?

We need a well-trained crew for goblets and handle items.

Our glass makers work solely on piece work, but we would guarantee a minimum wage of £ 8.00 (eight English pounds) per week. With good production and good work you could earn much higher wages. We work 45 hours per week in daily shifts. Monday to Friday 8 hours and Saturdays 5 hours.

You would also be interested in hearing that life in Ireland is relaxed, there is no more rationing, and one can buy everything without difficulties. The standard of living for glass makers in Ireland is very good.

Looking forward to hearing from you soon.

Regards, Waterford Glass Ltd

ALL COMMUNICATIONS TO BE ADDRESSED TO THE COMPANY

TELEPHONE:
WATERFORD 715

TELEGRAMS:
"GLASSFACTORY," WATERFORD

Waterford Glass Limited

DIRECTORS:
JOSEPH McGRATH, (CHAIRMAN)
JOSEPH GRIFFIN
FRANZ WINKELMAN (GERMAN)
M. J. FITZPATRICK

JOHNSTOWN,
WATERFORD, IRELAND

YOUR REF

OUR REF FE/PM.

den 2.9.1950

Herrn Josef Cretzan,
Fischmarkt 20,
Limburg / Lahn,
U.S.Zone,
Germany.

Wir beziehen uns heute auf Ihr Schreiben vom 21.v.Mts, dessen Inhalt
wir zur Kenntnis genommen haben. Wir können daraus ersehen, dass Sie
gut als Kelchmacher eingerichtet sind und auch die Bleikristall Ar-
tikel verstehen. Interessieren würde uns die bayrische Art mit 4 Mann
(1 Stielmacher, 1 Bodenmacher und 2 Gehilfen). Wir nehmen an, dass
die Kelche über den Nabel geblasen werden, nicht über das Külbel,
sodass mit dem Einträger 5 Leute in der Werkstelle arbeiten. Haben
wir das richtig verstanden?
Andere Artikel wie Salatschalen, Vasen, Bowlen, Sahnekännchen werden
über das Külbel gearbeitet (1 Glasmacher, 1 Gehilfe, 1 Külbelmacher,
1 Einträger).
Wir möchten ausserdem auch noch gern wissen, ob Sie 1 - 2 Liter Krüge
(ausgeschnittene sowie aufgetriebene) verfertigen? Wenn ja arbeiten
Sie dann auch mit 1 Meister, 1 Gehilfe, 1 Külbelmacher und ein Ein-
träger pro Werkstelle?
Wir brauchen eine gut eingearbeitete Werkstelle für Kelche, sowie
auch für Henkelsachen.
Unsere Glasmacher arbeiten ausschliesslich im Akkord, jedoch würden
wir Ihnen einen Wochenmindestlohn von L 8-0-0 (acht englische Pfunde)
garantieren. Bei guter Produktion und guter Arbeit würden Sie jedoch
wesentlich höhere Löhne erzielen können. Wir arbeiten hier 45 Stunden
die Woche in Tagesschichten. Montag bis Freitag 8 Stunden, Samstag
5 Stunden.
Es wird Sie ausserdem interessieren zu erfahren, dass das Leben in
Irland sehr frei ist, es gibt keinerlei Rationierung mehr, und man
kann alles ohne Schwierigkeiten kaufen. Der Lebensstandard für Glas-
macher hier in Irland ist sehr gut.
Wir sehen Ihrer baldigen Rückantwort mit Interesse entgegen.

Hochachtungsvoll
Waterford Glass Ltd.

J.H.: 11.74

Letter from Waterford Glass, 2 September 1950

Waterford Glass Limited

Our Ref FE/FM.

<div align="right">

27.9.1950

</div>

Herrn Josef Cretzan,
Fischmarkt 20,
Limburg / Lahn,
U.S. Zone,
Germany.

Dear Mr. Cretzan,

We are in possession of your letter dated 11th of this month, in which you inform us that you are able to do goblet items and Mr. Landgraf can do items with handles, such as cut out jugs, reamed cream jugs and similar things.

We gather that in this case there could be 2 workplaces.

It could also happen that, for example, you and Mr. Landgraf would do half shifts on blown articles, such as vases, salad bowls, cake plates etc. We assume that this would not cause any difficulties in production and would be grateful if you could confirm this.

As soon as we receive your reply we will write to you a definite letter.

Regards

Waterford Glass Limited

ALL COMMUNICATIONS TO BE ADDRESSED TO THE COMPANY

TELEPHONE:
WATERFORD 715

TELEGRAMS:
"GLASSFACTORY," WATERFORD

𝔚𝔞𝔱𝔢𝔯𝔣𝔬𝔯𝔡 𝔊𝔩𝔞𝔰𝔰 𝔏𝔦𝔪𝔦𝔱𝔢𝔡

DIRECTORS:
JOSEPH McGRATH, (CHAIRMAN)
JOSEPH GRIFFIN.
FRANZ WINKELMAN (FORMERLY GERMAN)
B. J. FITZPATRICK.

JOHNSTOWN,
WATERFORD, IRELAND

YOUR REF

OUR REF FE/FM.

den 27.9.1950

Herrn Josef Cretzan,
Fischmarkt 20,
Limburg-Lahn,
U.S.Zone,
Germany.

Geehrter Herr Cretzan!

Wir sind im Besitz Ihres Schreibens vom 11.ds.Mts., in dem Sie
uns mitteilen, dass Sie auf Kelcharbeit eingerichtet sind, und
Herr Landgraf auf Henkelsachen wie ausgeschnittene Krüge, auf-
getriebene Sahnekännchen u.dgl.
Wir entnehmen daraus, dass in diesem Falle zwei Werkstellen
in Frage kommen würden.
Es würde auch der Fall eintreten, dass z.B. Sie und auch der Herr
Landgraf halbe Schichten eingeblasene Artikel wie Vasen, Salat-
schüsseln, Kuchenteller u.dgl. arbeiten würden. Wir nehmen an,
dass dies keine Schwierigkeiten in der Produktion bereiten würde,
und wären Ihnen dankbar, wenn Sie uns das noch bestätigen möchten.
Sobald wir Ihre Antwort haben, werden wir Ihnen endgültig schreiben.

Hochachtungsvoll
Waterford Glass Limited.

Letter from Waterford Glass, 27 September 1950

53

Waterford Glass Limited

Our Ref FE/FM.

<div align="right">

16.10.1950
</div>

Herrn Josef Cretzan,
Fischmarkt 20,
Limburg / Lahn,
U.S. Zone,
Germany.

Dear Mr. Cretzan,

We are referring to the exchange of letters regarding your and your friends' application as glass makers.

We ask you to be a patient for a while, as we are building a new furnace at the moment. When this is finished we will contact you again.

In the meantime we would like to thank you for your offer.

Regards

Waterford Glass Limited

ALL COMMUNICATIONS TO BE ADDRESSED TO THE COMPANY

TELEPHONE:
WATERFORD 715

TELEGRAMS:
"GLASSFACTORY." WATERFORD

Waterford Glass Limited

DIRECTORS:
JOSEPH McGRATH, (CHAIRMAN)
JOSEPH GRIFFIN.
FRANZ WINKELMAN (FORMERLY GERMAN)
B. J. FITZPATRICK.

JOHNSTOWN,
WATERFORD, IRELAND

YOUR REF

OUR REF FE/FM.

den 16.10.1950

Herrn Josef Cretzan,
Fischmarkt 20,
Limburg / Lahn,
U.S.Zone,
Germany.

Geehrter Herr Cretzan,

Wir beziehen uns auf den Briefwechsel bezüglich Ihrer und Ihrer
Freunde Bewerbung als Glasmacher.
Wir möchten Sie bitten, sich noch eine Zeit zu gedulden, da wir
gerade einen neuen Ofen bauen. Nach Fertigstellung desselben
werden wir uns wieder an Sie wenden.
Inzwischen danken wir Ihnen für Ihr Angebot.

Hochachtungsvoll

Waterford Glass Ltd.

Letter from Waterford Glass, 16 October 1950

Waterford Glass Limited

Our Ref FM.

13.6.1951

Herrn Josef Cretzan,
Fischmarkt 20,
Limburg / Lahn,
U.S. Zone,
Germany.

Dear Mr. Cretzan,

We have not received a reply to our letter dated 8th of last month, in which we informed you about the difficulties concerning your brother's work permit.

As we would like to know your opinion about our explanations and what the situation is, we would like to hear from you as soon as possible.

Regards

 Waterford Glass Limited

ALL COMMUNICATIONS TO BE ADDRESSED TO THE COMPANY

TELEPHONE:
WATERFORD 715

TELEGRAMS:
"GLASSFACTORY," WATERFORD

Waterford Glass Limited

DIRECTORS:
JOSEPH McGRATH, (CHAIRMAN)
JOSEPH GRIFFIN
FRANZ WINKELMANN (FORMERLY GERMAN)
B. J. FITZPATRICK

WATERFORD, IRELAND

SECRETARY:
NOEL M. GRIFFIN A.C.A

YOUR REF.

OUR REF. FM.

den 13.6.1951

Herrn Josef Cretzan,
Fischmarkt 20,
Limburg/Lahn,
Germany.

Geehrter Herr Cretzan,

Wir haben noch keine Antwort von Ihnen auf unser Schreiben vom
8.v.Mts. erhalten, in dem wir Ihnen ueber die Schwierigkeiten
bezueglich der Arbeitsgenehmigung fuer Ihren Bruder schrieben.
Da wir wissen moechten, was Sie zu unseren Ausfuehrungen zu sagen
haben und woran wir sind, waeren wir Ihnen fuer Ihren umgehenden
Bescheid dankbar.

Hochachtungsvoll
Waterford Glass Limited

Secretary.

Letter from Waterford Glass, 13 June 1951

Waterford Glass Limited

Our Ref FM.

29.6.1951

Herrn Josef Cretzan,
Fischmarkt 20,
Limburg / Lahn,
U.S. Zone,
Germany.

Dear Mr. Cretzan,

We confirm the receipt of your letter dated 21st of this month with thanks and are delighted to see that you have finally decided to come to us, and we have also noted that your brother will stay in Limburg for the moment.

We expect you in September, and as you already have your passport you do not need to do anything else at the moment.

We will send you your work permit within the next weeks and will write to you what you need to do to get the necessary visas. We will initiate the necessary steps from this end so that you will have no difficulties.

Regards

Waterford Glass Limited

Secretary

ALL COMMUNICATIONS TO BE ADDRESSED TO THE COMPANY

TELEPHONE:
WATERFORD 715

TELEGRAMS:
"GLASSFACTORY," WATERFORD

TRADE MARK

Waterford Glass Limited

WATERFORD, IRELAND

DIRECTORS:
JOSEPH McGRATH, (CHAIRMAN)
JOSEPH GRIFFIN
FRANZ WINKELMANN (FORMERLY GERMAN)
B. J. FITZPATRICK

SECRETARY:
NOEL M. GRIFFIN A.C.A

YOUR REF.

OUR REF. **FM.**

den 29.6.1951

Herrn Josef Cretzan,
Fischmarkt 20,
Limburg/Lahn,
Germany.

Geehrter Herr Cretzan,

Wir bestaetigen dankend den Erhalt Ihres Schreibens vom 21.ds.Mts.,
und freuen uns daraus zu ersehen, dass Sie sich endgueltig entschlossen
haben, zu kommen, und wir haben uns ausserdem vorgemerkt, dass
Ihr Bruder in Limburg bleiben wird.
Wir erwarten Sie im September, und da Sie Ihren Pass schon haben,
brauchen Sie im Augenblick nichts weiter zu unternehmen.
Wir werden Ihnen Ihre Arbeitsgenehmigung innerhalb der naechsten
Wochen uebersenden, und werden Ihnen dann noch schreiben, was Sie
zu tun haben, um die notwendigen Visas zu erhalten. Die notwendigen
Schritte leiten wir von hier aus ein, sodass Sie keinerlei Schwie-
rigkeiten haben werden.

Hochachtungsvoll
Waterford Glass Limited

Secretary.

Letter from Waterford Glass, 29 June 1951

Waterford Glass Limited

Our Ref NG/BM.

10.9.1951

Herrn Josef Cretzan,
Fischmarkt 20,
Limburg / Lahn,
U.S. Zone,
Germany.

Dear Mr. Cretzan,

We have received your letter dated 22nd August and would like to tell you that your employment here is completely secured, however there is a delay in getting your work permit.

As soon as we get it we will send it to you together with a detailed letter. We are expecting the permit any day and you can hand in your notice as soon as you get it from us. However, we doubt that you will be able to arrive here within a fortnight as you will have to get your passport and other things organized.

With cordial greetings

Waterford Glass Ltd.

Secretary

ALL COMMUNICATIONS TO BE ADDRESSED TO THE COMPANY

TELEPHONE:
WATERFORD 715

TELEGRAMS:
"GLASSFACTORY," WATERFORD

Waterford Glass Limited

WATERFORD, IRELAND

DIRECTORS:
JOSEPH McGRATH, (CHAIRMAN)
JOSEPH GRIFFIN
FRANZ WINKELMANN (FORMERLY GERMAN)
B. J. FITZPATRICK

SECRETARY:
NOEL M. GRIFFIN A C A

YOUR REF.

OUR REF. **NG/BM.**

den 10. 9.1951.

Herrn Josef Cretzan,
Fischmarkt 20,
Limburg/Lahn,
GERMANY.

Geehrter Herr Cretzan,

Wir haben Ihren Brief vom 22 August bekommen und moechten Ihnen sagen
dass Ihre Beschaeftigung hier ganz sicher ist, jedoch es ist eine
Verzoegerung entstanden mit Beschaffung Ihrer Arbeitsge nehmigung.
In dem moment wo wir dieselbe bekommen schicken wir sie Ihnen mit einem
detailierten Brief. Wir erwarten die Genehmigung jeden Tag und Sie
koennen ihre Kuendigung einreichen sobald Sie sie von uns bekommen,
obwohl wir zweifeln dass Sie hier dann binnen 14 Tagen eintreffen
koenten, da Sie noch Ihren Reisepass und Anderes in Ordnung bringen
muessen.

Mit herzlichen gruessen,

 Hochachtungsvoll,
 WATERFORD GLASS LIMITED,

 Secretary.

Letter from Waterford Glass, 10 September 1951

Chapter 5

Alien in the City

Within weeks all the necessary arrangements had been made and the travel documents and tickets were delivered to Josef to allow him to undertake the three-day journey to Waterford. The trip brought him across Europe by train to the Hook of Holland from where he took the ferry to Dover. From Dover he took the train to London and onward to Fishguard where he boarded the *Great Western* steamship for the final leg to Waterford.

As the *Great Western* steamed out of the harbour at Fishguard and the darkness of a winter night set in, Josef knew he was on the final leg of the journey to Ireland. Waterford Glass had prepared all his travel documentation for him and the ticket he produced at the terminal in Fishguard was the final remaining one. On the last leg of the journey across the Irish Sea he had many hours to think about what he was leaving behind in West Germany: his work, of course, but also his brothers, his sister and his niece Renate and his nephew Peter. His father had always advised him to stay in Germany and not to leave for another country as he believed that Germany offered the best employment opportunities for him. He thought about his mother and wondered if he would ever return to Putna to visit her grave. Standing out on the deck he smoked his cigarettes throughout the night sailing as he waited to see landfall.

Shortly after daybreak a large black and white lighthouse came into sight. Many of the passengers were excited at the sight of the lighthouse but Josef had no idea what all the excitement was about.

Because he had no English he couldn't talk to anyone during the sailing, so he sat out on deck with his suitcase beside him, not sure what the next chapter in his life would bring. He had no idea of what to expect in Waterford – its people, the language, the food or the culture – and of course he had no friends or family there. However, there was something missing in his life in Germany, and it wasn't the rationing of food or restrictions on movements that made him decide to leave; he was looking for a new life and a new beginning.

As the *Great Western* made its way into the Waterford estuary he saw for the first time the small fishing villages of Dunmore East, Passage East and Cheekpoint, villages in which he would socialise in the years to come. The *Great Western* continued its passage up the River Suir until it came to Waterford city to take its berth at the Adelphi Quay. Unsure if he was in Waterford or not, Josef held on to his suitcase which contained all his personal belongings – his clothes, family photographs, letters and documents, and all his savings which amounted to two hundred pounds. Everything he possessed was packed into that single suitcase. As he looked out onto the quayside, he recognised Charles Bačik and Franz Winkelmann waving frantically at him, signalling for him to come off the ship. As he walked up the gangway, he looked at his watch. It was exactly 11.00 a.m. on Thursday, 1 November 1951.

Adelphi Quay that morning was packed with people greeting the passengers coming off the ship from Fishguard. These were predominantly men returning home from the many cities in the United Kingdom where they had found work so that they could support their families back in Waterford. There were few employment opportunities for young men in Ireland in the early 1950s and the *Great Western* brought tens of thousands of Irish workers from Waterford to Fishguard where they dispersed to the various cities in the United Kingdom.

As Josef made his way through the clambering crowd, Bačik walked towards him, smiling with his arms opened wide to embrace

him and welcome him to Waterford. Both Bačik and Winkelmann were relieved that he had completed the journey successfully, as there was still negative sentiment towards Germany and its citizens in the aftermath of the war. Winkelmann took his suitcase and Bačik led him through the crowds of people towards the Adelphi Hotel where they went for a meal to discuss the arrangements that had been put in place for Josef. Because Winkelmann spoke German fluently, he could explain what plans they had made for Josef over the next few days to allow him time to rest sufficiently before completing the required legal documentation at the local Garda station in Ballybricken. As they finished their meeting, Winkelmann asked Josef if he had any questions before they brought him to the accommodation they had arranged for him. Josef did have one question for him:

'Where was all the snow and ice and glaciers that Ireland was famous for?' he asked.

Surprised by his question, Winkelmann told him that there was rarely ice or snow in Ireland, and that there were certainly no glaciers there. As they spoke Josef's misunderstanding became obvious: he thought he was travelling to Iceland.

As part of the offer to come to Ireland to work at the factory, Waterford Glass provided accommodation for Josef for a number of months, a first floor flat at 110 The Quay, between Keizer Street and Henrietta Street. The flat was only a short walking distance from Adelphi Quay and close to the city centre. As Bačik and Winkelmann walked him to his flat, they explained their plans for him over the next few days, including a visit to the factory in Ballytruckle to see the glass blowing department and to meet with the other German glass workers who had arrived in Waterford during the summer of 1951.

Bačik and Winkelmann brought Josef up to his room to show him the layout of the flat which included a small living room and kitchen area which overlooked the river and a separate bedroom and toilet. Having agreed the time to meet the next day, Bačik and Winkelmann left the flat to give Josef time to sleep and recover after his journey.

Because of the excitement and restlessness of having just arrived in a foreign country, Josef decided to go for a walk around the area to see what Waterford was like. As he left his flat he walked along the Quay and turned up Barronstrand Street where many of the local shops and traders operated. As he walked along the streets he was shocked by the level of poverty that he saw, particularly the children walking around the city centre in small groups, many in their bare feet and wearing old, ragged and dirty clothes. Old ladies wearing shawls and smoking clay pipes seemed to be everywhere, and packs of dogs chased cats up and down the streets. When he walked into a local butcher shop he was surprised to see that there was no refrigeration for the meat. A dog walked into the butcher shop, lifted its leg and urinated before walking straight back out. He had never seen such poor levels of hygiene anywhere before.

Josef's dark hair and sallow skin ensured that he stood out from the crowds of people on the street, as did the suit he was wearing. Although he had grown up in a small rural village in Romania and had travelled throughout Europe during the war years, none of those experiences had prepared him for the poverty he saw in Waterford. The lack of basic standards in sanitation, and the children walking the streets looking desolate, cold and hungry, led him to reconsider his decision to come to Ireland. Although he was only in the city for a few hours and had not yet visited the factory, he decided that he would make arrangements as soon as possible to return to Germany. When he got back to his flat he sat down for a cigarette and a cup of coffee.

As he smoked his cigarette he realised that he was totally alone, with no friends or family, in a country where he could not speak the language. The prospect of having to learn and speak a third language was overwhelming for him. Throughout his years in the army he had never felt as isolated or unsure as he did now. As he lay on his bed that evening he remembered the advice his father had always given him, which was to stay in Germany and not to go to any other country as he would be exploited for his skills. He felt for the very first time

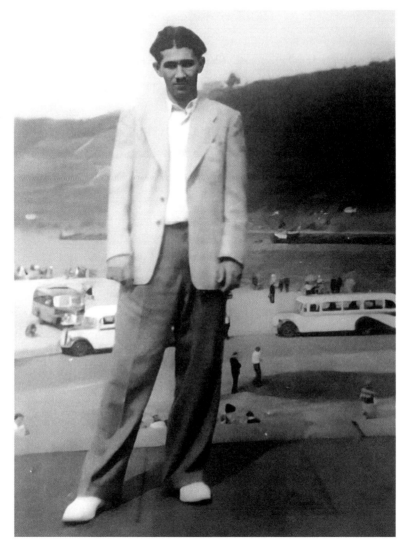

Joe two weeks after he'd arrived in Ireland.

that he had made a huge mistake in leaving Germany, although he knew it was one he could rectify. He had originally planned to stay in Waterford for at least six months, but now his plan had changed and he wanted to return to Germany as soon as possible.

The following morning, Friday, 2 November, Bačik and Winkelmann collected Josef at his flat and brought him to report to the Garda station in Ballybricken. This was a requirement in accordance with the work permit that the factory had received for Josef.

In addition to the work permit application the factory had to apply to the Department of Justice for a Certificate of Registration under the Aliens Order Act, 1946. The Aliens Order Act required any alien coming from outside the State, other than Great Britain or Northern Ireland, to report to a Garda station within twenty-four hours of arrival to produce a valid passport to establish their nationality.

When they arrived at the Garda station they met with Superintendent Michael Walsh, who was familiar with the registration procedure for the foreign glass workers as several others had arrived during the summer of 1951. After producing his passport, Josef had his photograph taken which along with his passport details were sent to the Department of Justice in Dublin to allow for a Certificate of Registration booklet and registration number to be issued.

Having completed the required registration requirements, a visit to the factory was the next thing to be undertaken. The glass factory was located in Ballytruckle on the outskirts of the city. The journey from the Garda station to the factory lasted only five minutes as there were very few cars using the roads. As they came to Ballytruckle they passed the Ursuline Convent before turning left through a small set of gates leading into the factory entrance. In comparison to the glass factory in Putna where he had started his glass making career, the Ballytruckle factory was small, but in comparison to any of the glass factories in Germany where he had worked, it was tiny. As they stepped out of the car Bačik brought Josef into the small office area and then out onto the factory floor. Bačik wanted to show him the design department and the cutting and blowing rooms that were already in place in the factory. Also, there were the other workers to meet, some of whom were German and had arrived a few months earlier.

As he was brought around the factory it became apparent that it was nothing like Josef had seen before. It seemed to be disorganised and there was only a handful of craft workers in the cutting and blowing rooms. The furnace in the blowing room was small and noisy. The tools used by the glass blowers, including the blowing irons and moulds, all

looked primitive compared to what Josef had used as a boy in Putna. The factory wasn't anything like what Bačik and Winkelmann had described to him when they enticed him to leave Germany. The whole situation in Waterford, including what he had seen at the factory, left him feeling disillusioned and he was disappointed at his decision to come to Waterford. He felt that the offers to work in the glass industry in Sweden would have been a better option to take.

As he walked around the platform and the furnace he was introduced to a German glass blower named Max Göstl. As they spoke it became clear that they shared much in common. Both were German citizens, both had been soldiers in the German army during the Second World War and both were skilled glass makers who had left Germany in pursuit of a new life in a country they knew nothing about. Max Göstl had arrived from Düren in Germany in the summer of 1951 with his wife and their four children. From that moment there was an immediate sense of relief for Josef; he felt he was not

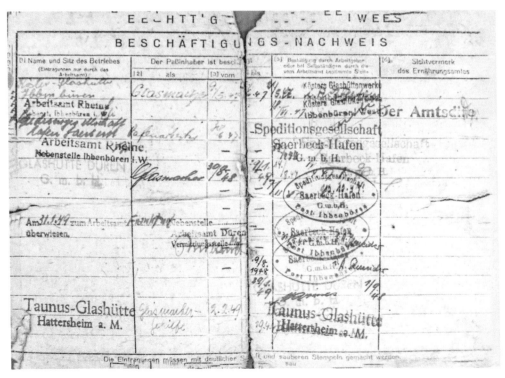

Inside of Joe's Arbeits-Pass, official German work pass registration book

alone anymore. But more importantly, it was the beginning of a friendship between two men that would last for over thirty years.

Josef and Max had both worked as glass blowers at the Glashütte Düren (Düren glass house) near Cologne in Germany, where there were over 1,500 workers producing handmade glass. It was a major centre for glass production in Germany immediately after the war. Josef's *Arbeits-Pass*, his official German work pass registration book, shows that he worked at the Düren factory from 30 August 1948 until 29 January 1949. Kurt Berger, the wooden mould-maker who came to work at Waterford in 1951, also worked at the glass factory in Düren. Although Josef, Max and Kurt all worked there at the same time, they never knew each other personally while working there.

Göstl Family

Max Göstl was born on 31 January 1910 in Zweisel, a small town located in the lower Bavarian region of southern Germany. The region has a centuries-old tradition for glass manufacturing and Max joined the glass factory in Zweisel, specialising in stemware production. Taught by the local glass blowers he developed his skill and understanding of all the elements of glass making. In Zweisel he met and married Friede Smielhavy and the couple lived comfortably in the lower Bavaria region. The couple had their first child, Liane, in 1937 and two years later a second daughter, Elfride, was born. With the outbreak of the Second World War, Max was conscripted into the German army and served with a specialised division, the Gebirgsjäger (mountain infantry). The division was made up almost entirely of young men from the Bavaria region, men accustomed to mountain terrain and extremely cold weather and therefore ideal candidates for a division specialising in mountain combat. Max served in the Gebirgsjäger for the entire duration of the war and fought throughout Europe. He was captured in Italy and held as a prisoner-of-war until he was released following the end of the war in 1945.

For his wife Friede, it was a particularly difficult challenge raising two young daughters in war-torn Germany during this time, where there was food rationing, continuous warfare, plus the added anxiety of not knowing if her husband was dead or alive. When Max returned to Zwiesel after the war he settled back to normal family life. However, the glass industry had been decimated and there was no immediate prospect of employment for him in Zweisel. Max and Friede had two more children, Ursula and Max, born in 1947 and 1949 respectively. The small-scale glass factories that operated in the Bavaria region could not provide stable employment for Max so he decided that the family would have to leave in search of more secure work.

At this time one of the largest glass factories in operation in Germany was the Peil & Putzler, Düren Glashütte, located near the city of Cologne, almost 400 miles northwest of Zwiesel. The factory had recommenced production following the end of the war and there was an acute shortage of experienced glass workers available. For Max, who was now almost forty years old, this was an opportunity to join a major glass manufacturer that would provide guaranteed employment and a good standard of living for his family. Although he and Friede wanted to raise their children in the Bavaria region, they decided to move to Düren. However, the family was not destined to remain there for very long. When Bačik travelled to Germany in 1950 to recruit experienced glass blowers, he went to the factory at Düren knowing he would find some who might be persuaded to come to the factory in Waterford. The offer to move to Ireland was discussed between Max and Friede. There was a lot for the family to consider, including moving to a country that they knew nothing about, learning a new language and the effects the move might have on their children. Having studied the offer made to them, which included the promise of housing and free medical and dental care for the family, they decided to accept and move to Ireland.

Max, Friede and their four children arrived in Waterford during the summer of 1951. Their second son Manfred was born in Waterford a few weeks after their arrival. The family was provided with accommodation at the Adelphi Hotel for a period of almost two years until Waterford Glass provided them, like many of the other migrant glass workers, with a house on the German Road in the Saint John's Park area of the city.

The *Certificate of Registration* booklet for Josef was issued to him at Waterford Garda station just two weeks after his arrival in Waterford, on 14 November 1951. Page one of the booklet listed his personal information including nationality, place of birth, profession, address of residence, date of arrival in Eire, address of last residence outside Eire, Government Service, passport or other papers as to nationality and identity. There was a notice to the holder on the back page of the booklet relating to the strict conditions placed upon them as aliens residing in Ireland. The conditions listed were:

1. *Before you change your residence (i.e., the address shown in this certificate) you must give the Police of the district in which you reside your new address and the date on which you intend to move.*

2. *If your new address is in another Police district you must within 48 hours of your arrival there, report to the Police of the new district.*

3. *If you are absent for more than one month from your residence you must report your temporary address and all subsequent changes of address (including your return home) to the Police of the district where you are registered. This may be done by letter.*

4. *If you stay at an hotel, lodging house, boarding-house or other place where lodging is provided for payment, you must on arrival, write your name, nationality and the address from which you have come, and, before leaving, must write the address to which you intend to go in the register provided for the purpose.*

NOTICE TO THE HOLDER OF THIS CERTIFICATE.

1. Before you change your residence (i.e., the address shown in this Certificate) you must give the Police of the district in which you reside your new address and the date on which you intend to move.

2. If your new address is in another Police district you must, within 48 hours of your arrival there, report to the Police of the new district.

3. If you are absent for more than one month from your residence you must report your temporary address and all subsequent changes of address (including your return home) to the Police of the district where you are registered. *This may be done by letter.*

4. If you stay at an hotel, lodging-house, boarding-house or other place where lodging is provided for payment, you must on arrival, write your name, nationality and the address from which you have come, and, *before leaving*, must write the address to which you intend to go in the register provided for the purpose.

5. You must report to the Police of the district where you are registered any change in any of the personal particulars given within.

Failure to comply with any of the above requirements—
Refusing to answer any questions by a registration or immigration officer or other person lawfully acting in the execution of the Aliens Order with regard to registration or with regard to this certificate—
Making any false statement with regard to registration or with regard to this certificate—
Altering this certificate or any entry upon it—
Refusing to produce this certificate as directed upon the front page—
Having in possession or using without lawful authority any forged, altered, or irregular certificate, passport, or other document connected with registration :—
Will render the offender liable to be detained in custody and to a fine of £100 or six months' imprisonment.

No. G.S. 16356A

Aliens Order, 1946.

CERTIFICATE OF REGISTRATION

To be produced by the holder when—

(a) he reports to the Police that he is about to change his residence ;

(b) he reports to the Police on his arrival in a new district that he has changed his residence ;

(c) he presents himself at a Police Station for any purpose connected with his registration, or

(d) the Police or an Immigration Officer demand its production.

REGISTRATION CERTIFICATE No. GS 16356 A

ISSUED AT WATERFORD

on 14 NOVEMBER 1951

NAME (Surname first in Roman Capitals) CRETAN Josef

ALIAS.

Left Thumb Print (if unable to sign name in Irish or English Characters).

PHOTOGRAPH.

GARDA SIOCHANA WATERFORD

Signature of Holder } Joseph Cretan

1

Nationality GERMAN

Born on 14.4.1924 in PRINA, KREIS RADAUTZ, RUMANIA.

Previous Nationality (if any)

Profession or Occupation } GLASS BLOWER

Address of Residence 110, THE QUAY, WATERFORD

Arrived in Eire 1ST NOVEMBER, 1951.

Address of last Residence outside Eire } FISCMARKT, 20, LIMBURG/LAHN GERMANY.

Government Service Plain Infantry Corps of German Army from 2.4.42 to 13.11.45. Prisoner of War in France from 15.6.45 to 13.11.45

Passport or other papers as to Nationality and Identity. GERMAN PASSPORT No. 250/51 ISSUED AT LIMBURG/LAHN, GERMANY, ON 11/6/1951 & VALID to 10/6/1953.

Joe's Certificate of Registration booklet

5. *You must report to the Police of the district where you are registered any change in any of the personal particulars given within.*

Failure to comply with any of the above requirements:

Refusing to answer any questions by a registration or immigration officer or other person lawfully in the execution of the Aliens Order with regard to registration or regard to this certificate-

Making any false statement with regard to registration or with regard to this certificate-

Altering this certificate or any entry upon it-

Refusing to produce this certificate as directed upon the front page-

Having in possession or using without lawful authority any forged, altered or irregular certificate, passport, or other document concerned with registration-

Will render the offender liable to be detained in custody and to a fine of £100 or six months imprisonment.

Chapter 6

Settling In

There was no lead glass produced at the factory in early 1951 as the raw materials and proper furnaces were not in place. It was, however, the intention of management to produce lead glass as soon as the resources and expertise were available, and the correspondence with Josef in 1950 explicitly asked about his experience in this area. Sam Jacob was one of the first Irish workers to work in the blowing room when he entered the factory in 1950 at fifteen years of age. Below Sam reminisces about the blowing room and those who worked there in the early 1950s.

> *The factory was very small in size with forty to fifty workers working there in 1951. Bačik was the manager and he was always around the factory floor. He had a rough voice, but he was a good man who kept everybody in line. I started working in the blowing room holding the mould for the blowers. There were a few Irish blowers there at that time, Donald Cahill, Bomber Flavin and Eddie Elliott. My first job was holding the mould for Donald Cahill. The conditions were tough for everyone working there. After a few months I started to blow balls and bit gathers on the platform. Bačik gave me that chance. The foreign blowers arrived then, Max Göstl and Joe Cretzan, they brought the experience and skills with them to the factory. I remember them well.*

Josef began blowing soda glass at the factory. The quality of the glass, the wooden hand tools and the general equipment in the blowing room were the worst he had ever seen. The Irish workers who were

blowing glass had no technical knowledge or expertise. The drinking glasses that they were making were too thick on the rims because they did not know how to divide the thickness in the walls of the glass. Bačik wanted Josef and Max to teach the young Irish apprentices the techniques for gathering glass, shaping the molten glass and achieving the required thickness in the walls and the rims of the drinking glasses. These were the most basic principles of glass making that had to be passed on to the Irish apprentices.

Although Josef was an experienced and exceptional wine glass and tumbler maker, it was not the type of glass making he wanted to do. His preference was to make more complicated and challenging items of glassware including the use of coloured glass. There was also a language issue for the foreign craftsmen to overcome when teaching the Irish apprentices because none of them could speak English. In 1953, the City of Waterford Vocational Education Committee was approached by the Secretary of the German Legation in Ireland with a proposal to organise English classes for the German families who were working at Waterford Glass. Shortly afterwards English classes were provided at the Central Technical Institute in the city. Josef never attended the classes as he had befriended a young Christian Brother, Brother Kelly from Mount Sion school, who offered to give him English lessons on an individual basis every week.

For Josef, when work finished in the afternoon, he often stayed back to teach some of the workers on the floor of the blowing room how to blow balls and bit gather. It was a way for him to improve his English in a more relaxed atmosphere while killing time in the afternoon. Often after work he would

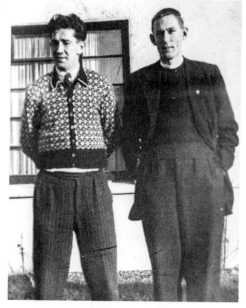

Joe and Brother Kelly

go the short distance from his flat to the Adelphi Hotel where Max, his wife Friede and their children stayed. Friede would prepare food and drink in the evenings as they relaxed and discussed their thoughts about living in Waterford. Although it was difficult adjustment in the early weeks, especially with the arrival of Christmas, Joe settled into the lifestyle and socialised with many of the young Irish workers in the various pubs throughout the city. The Irish culture of socialising in pubs was completely new for him, however he was soon playing cards and darts around the city every weekend. The young Irish workers would also bring him to dances at the local ballrooms every Friday, Saturday and Sunday night and he enjoyed this typical Irish social life as he was outgoing in nature, full of confidence and loved to socialise.

Josef's earnings at the factory in 1951/52 were multiples of the average Irish industrial wage which allowed him to lead a very comfortable lifestyle in comparison to most Irish workers. Also, unlike most of the other foriegn workers who had arrived in 1951, Josef was single and had no family or children to support with the money that he was earning. He was generous to the apprentices and young teenagers who worked with him in the blowing room. As apprentices they were only earning a fraction of his earnings and most of their earnings went back to their parents, leaving them with very little money for themselves. When on a night out in a local pub, whether socialising or playing darts, Josef would always buy them a few drinks and those who smoked would invariably smoke his cigarettes. The night would often finish when he would buy them a glass of whiskey as they prepared to walk home.

Some of the earliest apprentices who worked with him in the early 1950s included Sam Bible, Tony Galvin, Seanie Cuddihy, Johnnie Power, Paddy 'Biro' White and Michael Condon. Through working with the young apprentices in the factory and his busy social life, Josef's English improved steadily, faster than that of the other foreign workers. Soon he was able to communicate in English effectively, albeit with a strong foreign acccent. The apprentices in the factory shortened his christian name from Josef to Joe and, from that point in

time, Joe was the name that people in Waterford used when addressing him.

Joe became very popular with the local girls in the city with his striking good looks, thick dark black hair, sallow skin and foreign accent much loved by them and he always enjoyed female company. Whenever he had a relationship with a girl in the city he was always welcomed with open arms by her parents into their home, and he often recalled that during his early years in the city he was almost seen as a celebrity, because he was a foreigner in a city where many of the local people had never before met a person from mainland Europe. However, despite his popularity, he felt isolated in his flat on the Quay so he decided to rent a room with a family in the city. His *Certificate of Registration* booklet records an entry on 7 April 1952, by Sergeant Martin P. O'Reilly, recording:

> *Change residence on the 4ᵗʰ. April, 1952 to c/o Mrs. Power, 46, St. Ursula's Tce., Waterford.*

This change of address meant that he was now living within a short walking distance to the factory in Ballytruckle, but more importantly he was now living with an Irish family who provided some semblance of a normal family life. Although he was settling in well and adapting to the Irish way of life, he often thought of his siblings, in particular his sister Christine who was living in East Germany. He would regularly send her letters with photographs of himself taken in various locations around the city. He would write a short message on the back of each photograph such as 'a reminder of your brother Josef in Ireland', followed

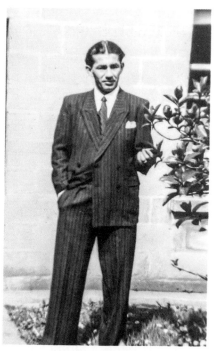

Joe on St Ursula's Terrace, 1952.

by the date the photograph had been taken. The thought of his sister being exiled indefinitely in East Germany was difficult for him to accept as he had a particularly strong bond with her. However, he was powerless to do anything about it, whether living in Ireland or West Germany. All citizens of East Germany were under the stringent control of the state police and there was no possibility of leaving East Germany under any circumstances.

On 7 October 1952, Joe's *Certificate of Registration* booklet recorded another change of address entry by Sergeant Martin P. Reilly stating:

> *Reporting change of address to No. 7 Cork Rd. Waterford on the 3rd October 1952*

Peg (née Power) rented out rooms at the family home at 7 Cork Road to support herself and her four children, Joe, Maeve, Paddy and Eamon. Her husband, Eddie Gavin, a Londoner of Irish parents, worked for the Electricity Supply Board (ESB) but had died after a battle with cancer at forty-six years of age leaving Peg to support four young children, the youngest, Eamon, being only four months old. The couple had been married for only seven years. There was no contributory pension provided by the ESB as he was short two weeks service on his pension contribution when he died. The family did receive a non-contributory pension of £29 and sixpence, and this was supplemented by an employment pension from England of 30 shillings and sixpence, giving Peg an income of £3 per week to pay rent on her house and raise the four children. Although initially nervous about taking a foreigner into the family home because of the language issue, Peg agreed to take Joe as a lodger.

Peg's daughter Maeve, only seven years old at the time, clearly remembers the first day Joe arrived at the house on the Cork Road:

> *He was a very distinctive looking man, dark hair and good looking. I clearly remember him standing at our front door on the day he arrived telling my mother that he was a good man, and that he was twenty-seven years old. His English was not very good but he*

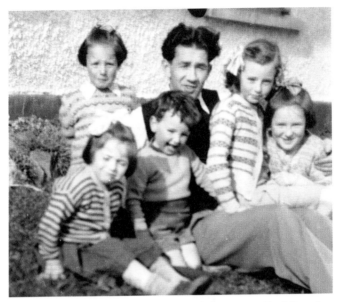

Joe with local children at Gavin's home on Cork Road

settled into family life and adored the company of the children in the house. He was particularly fond of Eamon, who was the youngest of the Gavin children. Whenever he went to Germany to visit his family and friends he would always bring back gifts for the children. He bought back cardigans and Lederhosen (short leather German pants with braces) for Eamon, and he brought me a Bavarian doll. He taught all the children on the road how to count in German and we helped him with his English. He was very good to all the children on the road and they all loved him.

In the evenings he would eat with the family and very often he jokingly suggested to my mother, Peg, who was eighteen years older than him, that they get married. Peg would point to the photograph of her late husband sitting on the mantelpiece and say, 'my husband is looking down on you Joe', to which he would stand up and turn the photo around to face the wall and say, 'but he is dead'. He often spoke about his sister in East Germany and how much he missed her. I remember on one occasion coming home from school to find him crying in his bedroom holding a photograph of his mother close to him asking her to help him. His face had been burned while at work that day, and although he was surrounded by our family, our family was not his family. It was the only time I ever saw him crying.

There must have been a feeling or loneliness and isolation here in Ireland and I think it all surfaced on that day after his accident.

Maeve's recollection of Joe was of a kind, generous and lonely man, and a man who had a huge effect on her young life growing up:

I remember that during the 1950s it became fashionable for young girls in Waterford to get their ears pierced. All the girls in my class were having their ears pierced but my mother wouldn't allow me to have mine pierced. They used a wooden cork and a darning needle to pierce the earlobe. Joe knew through conversations at our house that I wanted to have my ears pierced and he of course knew my mother wouldn't allow it, primarily on the basis that she felt it was child abuse to use a needle without any pain relief or proper hygiene. Joe brought me into town one afternoon and I asked him if he would get my ears pierced. He knew what my mother's feelings were about it so he brought me into Kniesel's jewellery shop to have them pierced professionally. He bought me a pair of gold sleepers and a pair of gold drop earrings that were to be used for special occasions. He was so generous to me.

During the years that he stayed with us in the Cork Road the highlight of my week was always Saturday afternoon. Every Saturday without fail, he would bring me into town, holding my hand as we walked through the town, and he would always bring me into the Granville Hotel. It was very posh to go into the Granville Hotel at that time, and my mother would never have been able to afford to bring me there. I remember being shocked at the sight of priests drinking whiskey while sitting at the bar there. Joe would have a bottle of beer and I was always given a treat of my choice, normally a bottle of orange while I watched the priests drinking their whiskey. He would often buy me a gift in one of the shops on the way home. Joe Cretzan was so different in every way to any other man I have ever known. I'm sure his kindness and generosity must have been a reflection in some way of his own childhood and the experiences he had through his life, especially surviving the war. Every day with Joe was like Christmas Day. Today as I look back on the time that Joe Cretzan spent living with my family on the Cork Road, I can say without doubt that he brought light into our lives.

Chapter 7

A Different Class

The number of apprentices at the factory was increasing throughout the early 1950s. Most of those who became apprentices at that time would start in the blowing room as unskilled workers, normally carrying in the glasses that the blower had just made to the lehr where they would cool down over a three-hour period. Others would hold the mould for the blower or knock off the glass from the blowing iron. Joe at this stage had established a reputation among the company directors, senior management, his co-workers and apprentices as a craftsman with unique ability. Even amongst the foreign glass blowers in the factory he showed a level of skill and craftsmanship that they all aspired to, even though he was the youngest.

At that time Sam Jacob was blowing balls for another German by the name of Hitze, who was one of the foreign craftsmen working in the blowing room. He remembers watching all the foreign glass makers in the factory but Joe more than any other.

Joe was a genius, he was gifted, he could do anything with glass. If the company directors wanted any special pieces of glass made it was Joe who had to make it, that was their instruction. He was completely different to the other foreign glass makers, at a different level to all of them. The way he would work the large gathers of molten glass, the sweat rolling down his face, steam rising off his back from the heat of the furnace, but it always seemed effortless for him. Many blowers tried to copy what he made, but nobody could match him.

The managing director of Waterford Glass, Noel Griffin, often came to Joe to ask him to make a special piece for him. Griffin knew that it would be a unique piece of glass and was guaranteed to be perfect.

Many of the other glass makers in the factory were envious of him, especially some of the other foreign glass workers, none of them had the skills that he had. Lots of the other blowers said he got a special bonus payment for making the larger pieces that he blew. I don't know if he was ever paid a special payment for that work, if he was, he deserved it, if he wasn't he should have been paid extra. Personally, I was never jealous of him in any way, for me he was a man to admire.

Joe blowing into the blowing iron

Joe with apprentice Charlie Maher

When he was making the large pieces of glass people would come from other parts of the factory to watch him at work. It was incredible to watch him making glass. The first group of Irish blowers – Tommy Nugent, Bobby Mahon, Johnny Power and Nicky Brennan – all learned glass making from Joe.

For me I can only describe him as a modern-day Beckham or Ronaldo, he was a man with unbelievable skill, great style and he was a showman. He was the man.

The factory continued to develop and, as planned by Bačik, the production of lead crystal commenced. The melting of the first batch of the raw materials for lead crystal was in 1952 and the first gather of molten lead crystal was made by Joe in the presence of all company directors and senior management. Because the pot of crystal was full to the lip of the pot it was not possible to gather a large amount of crystal, so to demonstrate his skill Joe decided to make cream jugs. He

gathered and blew the jugs, removed the cap from the jug and formed the spout before his apprentice handed him down the crystal to allow him make the handle. It was a masterful demonstration of his skill working with lead crystal. To mark the occasion, the Czech engraver, Miroslav Havel, took the first two jugs that Joe made and engraved them with Joe's initials, JC, with one jug engraved with a shamrock, the other with an Irish harp.

None of the Irish glass blowers had ever worked with lead crystal and it was to be several years before the factory moved to full crystal production. In the early to mid-1950s, the production of lead crystal was only undertaken by the foreign glass blowers. At that time a typical day of production on lead crystal started with the blowing of tumbler glasses up to the early morning break, thereby lowering the level of the glass in the pot to allow larger items to be gathered from mid-morning. All the large lead crystal items that the factory required were made by Joe as the profile and brand recognition of Waterford Glass was increasing across America.

First lead crystal jugs made at Waterford Glass, 1952, with
Joe's initials, JC, engraved on them

The sales team at Waterford Glass wanted to showcase the crafts-manship through specially commissioned prestige crystal pieces. As a result, the design department set about designing spectacular chandeliers, trophies and centrepieces to highlight the skills of the workers at the factory. In January 1953, Joe made the first St. Patrick's Day bowl that was to be presented to the American President, Dwight D. Eisenhower, by Ireland's ambassador to the United States, John J. Hearne. It was the first of many crystal presentation pieces that Joe made for American Presidents throughout the 1950s and 1960s.

Part of Joe's successful integration into Irish life and culture was his command of the English language. Although not fluent, his spoken English was improving rapidly considering that he did not have a word when he arrived in Ireland. While improving his own English vocabulary, his fluency in German came to the attention of one local woman named Margaret Kehoe, who lived at 2 Keane's Road in the city. Margaret's daughter Kitty had an opportunity to work as an au pair in Switzerland, however she could not speak German which was a requirement for the job. Margaret asked Joe if he would give her daughter some basic lessons in the language. Margaret explained to him that it was a once in a lifetime opportunity for her daughter Kitty to work abroad and that she and her husband James would gladly pay if he would give her some basic lessons in German. Without a thought Joe agreed to give Kitty the lessons but there was one condition: he didn't want any payment for his time. He was happy to help Margaret and her daughter in any way he could.

The lessons started the following week and Joe would call to the Kehoe's house every week for a couple of hours, teaching the basics of the language to Kitty. The Kehoe family developed a close bond with Joe and appreciated his time and patience in giving their daughter the lessons. Because he wouldn't take any payment, Margaret insisted that Joe stay for dinner on the evenings that he came to the house. Kitty's basic vocabulary developed quickly over the months and soon she had a good level of conversational German that prepared her for

her trip to Switzerland. Kitty enjoyed the interaction that she had with Joe during the lessons, describing him as a generous, outgoing and warm-hearted man, who gave great reassurance to her parents about her trip to Switzerland.

Kitty finally departed Waterford and worked as an *au pair* for a Swiss family. When she returned to Waterford on her holidays she called to Joe, proudly conversing with him in German. While on one of her return visits to Waterford she met a young man from Clonmel named John Curtin. The couple fell in love but John had planned to emigrate to America to start a new life for himself. Kitty decided that instead of returning to Switzerland she would travel with John to America. John Curtin emigrated to Denver, Colorado, in 1952 and Kitty followed him out six months later, in early 1953.

Before she left Waterford, Kitty called to Joe for a final time to thank him personally for all the time and effort he had given her over the previous year. More importantly for her, on a personal level, she wanted to acknowledge his generosity in not accepting any payment from her parents at a time when money for the family was a scarce resource. Joe was surprised that she had changed her mind and was now emigrating to America; nevertheless, he wished her well in her new life abroad. As Kitty was leaving Joe's flat he went to the mantelpiece in his room and took down a 12-inch crystal vase. He handed the vase to Kitty and told her to take it with her to America. He said he didn't have anything else to give her and that the vase was a gift from him to her as she set off on her new life. He told her that if he could make a life for himself in a foreign country, then she could too, and that whatever she decided do, she would be successful at it.

The crystal vase that Joe gave to Kitty was one of the first pieces of lead crystal made in the factory, a Christmas piece that Joe had made for himself. Because the vase was Joe's personal piece, Miroslav Havel had engraved the perimeter of the base with the inscription, *Happy Christmas 1952*, with Joe's initials, JC, engraved into the centre of the base. Kitty brought the vase with her to America.

Later that year, on Thanksgiving Day 1953, Kitty married John Curtin in Denver, Colorado. The family later relocated to Salt Lake City, Utah, where they owned and operated a successful printing business for many years. Forty-four years later, in the spring of 1996, at a Waterford Crystal signing event at the Z.C.M.I. department store in Salt Lake City, Kitty Curtin arrived at the event proudly carrying her Waterford Crystal vase that Joe had given her. She told the story behind the vase to Joe's son, David, who was undertaking the signing event for Waterford Crystal. She explained that the vase was a most treasured possession of hers, reminding her of her hometown of Waterford, but more importantly it was a reminder of a man that she had never forgotten, Joe Cretzan, a man whose character and generosity she described as 'remarkable'. Today, the vase is still in the possession of the Curtin family, having been passed down to Kitty's son, Dr. Michael Curtin, following her death in 2015.

Kitty Curtin with David Cretzan in Salt Lake City
with the vase Joe gave to her in 1953

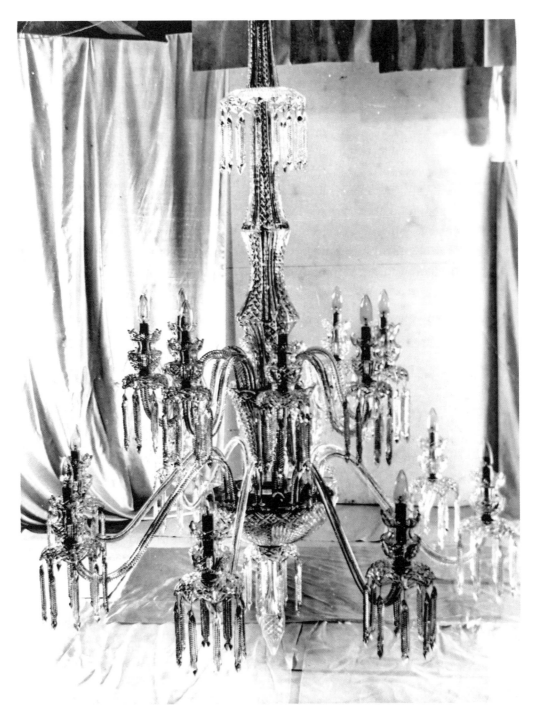

Chandelier for Ambassador Cinema in Dublin

Chapter 8

Love and Loss

In 1953, a new general manager was appointed in the factory. His name was Dr. Hans Winkelmann, the son of Franz Winkelmann, one of the company directors at Waterford Glass and the joint managing director of the Irish Glass Bottle Company in Dublin. At just 29 years of age, Dr. Winkelmann was given full responsibility for all production at the factory in Johnstown. Educated at Sandford Park School in Ranelagh, Dublin, he completed a science degree at Trinity College Dublin and then moved to England where he attended the school of glass technology at the University of Sheffield where he completed a Ph.D. in 1952. His Ph.D. thesis was titled 'Investigation of the colours of glasses containing various colouring agents and comparison of these colours with those of aqueous solutions of parts of these colouring agents'.

His background in glass technology gave him a theoretical expertise in all aspects of glass production, including raw materials, furnace construction, glass melting and glass colouring. Much of his practical knowledge relating to glass production was handed down to him from his father's experience in the glass industry, the majority of which had been gained while working in Europe. Dr. Winkelmann soon established a reputation amongst both management and the workers as a leader of people and a man with forthright views. Although he understood the principles of the glass making process thoroughly, he was not a glass maker and, therefore, when it came to the production of crystal he had to identify a glass blower he could go to for assistance with any

glass making issues or challenges. That person was Joe Cretzan. Dr. Winkelmann, like all others working in the blowing room, could see that Joe had a level of experience and skill that no other glass blower in the factory had, and he was determined that Joe's expertise was to be used for the benefit of the company.

At the end of every week Joe went to the dance halls around the city and met many girls, however his first serious relationship was with a young woman named Agnes Power. Agnes, who was known to her family as Una, was the daughter of city postman Thomas Power and his wife Annie. Una lived with her parents, at 29 Water Street, with her siblings Ann (Lal), Tessie, May, twin girls Joanie and Nellie, Irene, Nicholas, Billy, Tim and Sean. Una worked in the glass factory and it was there that Joe saw her for the first time in 1953 when Una was twenty-two years old. Una was tall with dark hair and for Joe it was love at first sight.

The couple started dating and soon a serious relationship developed. They socialised together every weekend and fell deeply in love. Joe would call to her family home each evening and Una's parents, although initially concerned about Una dating a man from a foreign country, a man of whom they knew nothing about, soon got to know Joe better through his broken English and were happy that Una had met a good man who could provide well for her. Joe often recalled how his father in the letters that he wrote to him from East Germany always advised him to find a good woman, a woman he could marry, a woman he could have a nice family with. Una Power was that woman.

Arrangements were made and a date was set for their wedding to take place, Saint Patrick's Day, 1954. The wedding ceremony was to take place in Saint John's church on Parnell Street followed by a party at Una's sister Tessie's house at Marian Park in the city. As the months passed by work at the factory continued and Joe made preparations for the wedding that would include German customs and traditions. All the other German workers at the factory were invited to the wedding and for those workers and their families the day was to be a

Joe and Una Power Cretzan, 1954

celebration of Joe and Una's wedding, but also an opportunity to show and celebrate their German customs and traditions of marriage, on Ireland's national holiday, Saint Patrick's Day.

As the New Year of 1954 arrived it was only a few weeks to the wedding day and final arrangements were made. Joe was still living with Peg Gavin and her family on the Cork Road and for the big day it was arranged that he would go to Max and Friede Göstl's house to get prepared for the wedding. Invitations were sent out to all of Una's family and Joe invited all the German workers from the blowing and cutting departments in the factory. Those German families included the Göstl, Vogel, Plattner and Muller families. Una's sister Tessie organised the wedding cake for the couple. Although the majority of people who were invited to the wedding were Irish, the German families made arrangement with Tessie to bring traditional German food and drinks to the party. They wanted the Waterford people to experience German culture on Joe's wedding day.

Joe wore a black suit with white shirt with a white dickie bow, with white hand gloves. The priest who celebrated the wedding ceremony was Fr. Raphael Power, the bridesmaid was Una's sister Joan, and the

Joe and Una's wedding

best man was the German glass cutter, Johann Muller. Following the
ceremony in the church all the guests went to Tessie's house where
the wedding celebrations started. The wives of the German workers
prepared traditional German food for the celebration – dumplings,
sauerkraut and a selection of meats that included pork schnitzel, and
for desserts they made apple strudel, black forest gateaux and black
cherry tarts, luxuries never seen or tasted before by the Irish guests,
but they were consumed easily, washed down with glasses of beer,
German schnapps and fruit punch. The richness of the foods and the
delicacies of the pastries and cakes made by the German families had
never been seen before in Waterford.

Particularly popular with the Irish guests were the large glasses of
fruit punch, made from cider mixed with black rum and sweetened
strawberries. The glasses were handed out to all the guests before
the main meal started and none of the Irish guests had ever tasted
a drink like it before, very sweet and sparkling which made it easy
to drink. After the meal the three-piece iced wedding cake was cut

and consumed with cups of tea and black coffee. Musical entertain-
ment was provided by a young German glass cutter, Heinz Plattner,
who played traditional German music on his accordion into the early
hours of the morning. Many of Una's sisters would recall in later years
the lasting impressions of the wedding day, in particular that of the
German women, tall and distinctive in appearance, wearing beautiful
long dresses, draped with fur stoles on their shoulders. It was a wed-
ding celebration incorporating traditional Irish and German customs
between one of the foreign glass workers who had come to Waterford
and an Irish girl.

Joe and Una took a short honeymoon following the wedding before
returning to Waterford. As a married woman Una had to give up her
job, and her Department of Social Welfare stamp book showed that
she paid her last contribution on 8 March 1954. The newlywed couple
lived together at 21 Lower Grange.

Shortly before their wedding, Una had been diagnosed with
chronic myocardial degeneration, a heart condition. It was not
affecting her day-to-day life but would require ongoing medical
monitoring. Unexpectedly, however, her condition soon created med-
ical complications that were not anticipated by her doctor. Una was
pregnant, which was a cause for celebration for all her family, how-
ever her recently diagnosed medical condition created problems for
the pregnancy and both the baby and Una were at an increased risk.
Tragically, her pregnancy became difficult to manage medically due to
her cardiac condition, and she became weak and tired easily. She fell
down the stairs at the house in Lower Grange and despite all medical
interventions available, a miscarriage occurred.

Una's condition did not improve after the miscarriage and she
became weaker. In order to allow her to recuperate fully she moved
back to her parents' home where her mother cared for her while Joe
was at work. At her family home her condition continued to deteri-
orate. Her parents and Joe tended to all her needs and she received
constant medical attention. She contracted a viral infection and after

weeks of gradual deterioration, she died in her parents' house in Water Street on 20 February 1955. Her certified cause of death was subacute myocarditis. She was 25 years old.

The news of Una's death was greeted with shock and disbelief by her family and friends and all the workers at Waterford Glass. They had only been married for 11 months. For Joe, her death and the loss of their baby several weeks earlier left him in a state of shock. The German workers who had celebrated their wedding only several months earlier were now providing support to Joe in his bereavement, as were the directors, senior management and other co-workers in the factory. The Power family made arrangement for Una's funeral to take place at Saint John's Church, site of their wedding ceremony less than 12 months earlier. The funeral mass was followed by burial at the Ballygunner cemetery on the outskirts of the city. The local newspaper reported the death officially:

Mrs. Agnes Power

The death took place at her parents' residence, 29 Water St., Waterford, on Sunday, at the early age of 25 years, after a protracted illness, of Mrs. Agnes ('Una') Cretzan, wife of Mr. Joseph Cretzan (Waterford Glass Ltd.), of Lower Grange, and daughter of Mr. Thomas Power (retired postman), and Mrs. A Power.

The widespread sympathy aroused by the deceased's passing was testified by the extremely large and representative attendance at the removal to St. John's Church (where they were received by Rev. J. McGrath, C.C.) and at the funeral which took place to St. Mary's Cemetery, Ballygunner, after Requiem mass celebrated by Rev. P. Power, C.C., who also officiated at the graveside.

The chief mourners included: Mr. J Cretzan (husband); Mr. and Mrs. T. Power (parents); Messrs. Nicholas, William, Tom and Sean Power (brothers); Mrs. D. Wyse, Mrs. J. Phelan, Mrs. M. Walsh, Barracks Street, Mrs. M. Walsh, Marian Park, and the Misses Irene, Joan and Helen Power (sisters).

The general attendance included Cllr. P. Browne (Mayor), Ald. W. Kenneally, T.D., Mr. N. M. Griffin (secretary), and Mr. M. W. Dolphin (Staff), Waterford Glass Ltd.

Wreaths:- From her loving husband; From Blowing Dept; Waterford Glass, Ltd.; From Anne and Aurelian, Limburg, Frankfurt, and from Minnie.

Telegrams:- From Christina Cretzan, Erfurt, East Germany; from Sullivan & Keena, Limerick; from Julia and Sid, Grensnorton; from Nancy and Tess Coghlan, New Ross.

Numerous Mass cards were also received by the bereaved husband and relatives.

Chapter 9

Setting the Standard

The shock and grief that followed Una's death affected Joe deeply. Before the first anniversary of their wedding day on Saint Patrick's Day 1955, he was a widower, living alone in the house where they had planned their future life together. His brother Aurelian had suggested that he return to West Germany, but he had now established Waterford as his home. He decided to move from the house at Lower Grange as it held too many painful memories. He didn't want to move back into a flat or house where he would have to live alone again. He wanted to move into accommodation where somebody would prepare his food and laundry for him.

Joe's former landlady Peg Gavin told him that she knew a woman who could offer him a room to rent and provide him with his food and do all his laundry for him. Chrissie Power was a friend of Peg's who lived at 41 Grattan Terrace, Francis Street in the city. Chrissie was a spinster who lived alone and had never married. Joe met with Chrissie and she agreed to take him in as a lodger, but strictly on her terms and conditions. Although she was a woman of small stature, she had a reputation of being domineering at times. Joe agreed to her conditions and took the room she was renting. His move to Chrissie's house was recorded in his *Certificate of Registration* booklet on 25 July 1955, by Inspector McMahon:

> Changed residence to No 41, Grattan Terrace, Francis St., Waterford, on the 12th July 1955.

While lodging with Chrissie Joe enjoyed her company and although she was many years older than him, they became good friends. Chrissie would listen to his stories of life in Romania and West Germany and his years serving as a soldier during the war. They were stories that had never been heard before in Waterford and seemed almost fictional to Chrissie. Every weekend she would have his clothes washed and ironed ready for the weekend when he played cards and darts in the pubs around Ballybricken. He particularly enjoyed darts and played in local competitions every weekend.

A well-known darts pub in Ballybricken was Robert Grace's, and he was a member of the darts team there playing in the inter pubs competitions. Traditionally, the prize for the winning team was a large perpetual silver cup, with runner up prizes of small silver cups for the losing teams. Robert 'Bobby' Grace asked Joe if he could make a Waterford Crystal trophy for the 1956 darts competition instead of presenting a silver perpetual cup. Joe spoke to Havel about having a vase engraved for the competition. Joe and Havel had a close professional relationship as all the commissioned pieces that Havel designed

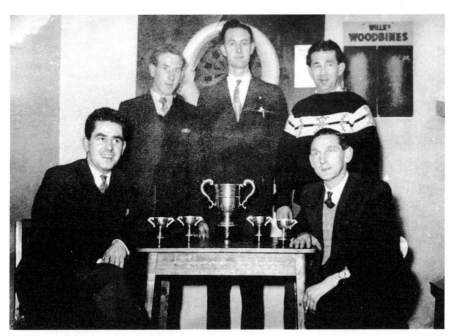

The darts team from Robert Grace's pub – Joe is standing on the right

were made by Joe. Havel told Joe that he would engrave whatever motif or emblem he wanted onto the vase for the darts competition trophy. Joe made a 10-inch footed vase which Havel engraved with a set of darts. Above the darts was the inscription Robert Grace, and below the darts the year was engraved, 1956. The Robert Grace darts trophy was the first of many glass trophies that was presented to local sporting clubs and organisations at prize giving ceremonies over the next 50 years in Waterford. Today the original engraved trophy is still in the possession of the Grace family in Waterford.

On a grander scale, 1956 saw the largest crystal sports trophy that Waterford Glass had ever designed being made by Joe. The trophy was for the Waterford Golf Club Senior Cup and was made from three separate parts, the base, the bowl and the lid. Tony Galvin was Joe's apprentice in 1956 and he remembers the day the moulds for the trophy were brought up to the blowing room:

Havel and Kurt Berger came into the blowing room both pushing a four wheeled trolley with the wooden moulds sitting on the trolley. The moulds were so big it wasn't possible to lift or carry them manually. They were the biggest wooden moulds made by Kurt Berger at the factory up to that time. When I looked at the moulds I didn't think it would be possible to gather enough glass by to fill them and that the opening on the pot would be too small to allow Joe to gather enough glass over the ball and then lift it out of the pot.

All the blowers in the blowing room gathered around to look at the moulds as Joe spoke with Berger and Havel. He would speak in English with Havel but always in German with Kurt Berger. They discussed the thickness of glass that was required for each part of the trophy and how much solid glass was required for the point on the lid on the trophy. Word spread from the blowing room down through the factory about the trophy that was being made. Most of the workers in the factory were now in the blowing room to watch Joe making it.

Joe told me the exact size of the glass ball he wanted me to blow for him and there was so much glass in the ball that another apprentice had to twist the iron for me as I was making the ball. The size

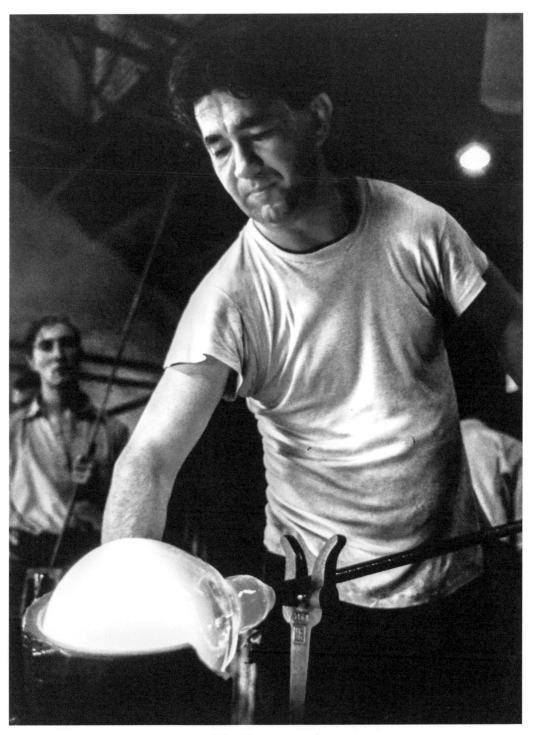

The Master at work

and the weight of the glass ball was incredible and of course it was on the end of the five-foot blowing iron.

There was an air of excitement among everyone there watching as he took the ball and walked over to the pot. Looking into the pot of glass, he lifted the ball into the pot and pushed the blowing iron forward, submerging the ball into the molten glass. With his right hand he began to twist the iron, slowly at first, but increasing the speed as he started to take the glass ball out of the molten glass. With the blowing rod bending under the weight of the glass he had gathered, he lifted the gather of glass out of the mouth of the pot. As he carried the gather of molten glass to the tank, the blowing iron bent with the weight of the glass, but there wasn't a grimace or any expression of effort on his face, just sweat running off his forehead, down the sides of his face. I twisted the iron for him as he blocked and shaped the glass with his wooden block and divider.

As he stood over that huge gather of orange molten crystal, cooling and shaping it, he was a master at work. Because he worked the glass so hot it wasn't difficult for me to twist the iron. He worked the glass into the shape he required before placing it into the wooden mould, where he blew it out to its final shape, filling the blowing room with smoke as the mould burned out. The tap of his foot on the platform signalled to the mould holder to open the mould and the base of the trophy appeared. It was perfection. Everybody there clapped and cheered him. It was a masterful demonstration of heavy glass blowing.

Throughout the 1950s the design department at the factory designed endless high profile prestige pieces to create a wow factor with the American crystal buyers in America. Sales manager Con Dooley travelled to America on extended tours using these prestige pieces of crystal as examples of the craftsmanship and quality of the crystal. Dooley knew first-hand every detail of the production stages of the crystal pieces he brought with him. On a weekly basis he went to the blowing room to watch Joe making the pieces of glass that he was bringing with him to America so that he could answer any questions about how the piece of crystal was made. He developed a close

relationship with Joe through his frequent visits to the blowing room watching him at work, understanding what was involved in the craft of glass blowing. Many of the prestige pieces were photographed in the factory before they were brought to America with Dooley and copies of these photographs were then signed by Joe at Dooley's request. When Dooley got to America he would exhibit the glass pieces to arranged groups of crystal buyers and give the signed photographs of the pieces to the buyers at the various department stores. On his return to Ireland he always brought back a gift for Joe from the cities or states that he had visited.

One of the most distinctive pieces that was made at Waterford Glass at this time was the Romanoff chandelier. Prince Michael Romanoff was a Lithuanian-born restauranteur who had opened a high-profile restaurant on Rodeo Drive in Beverly Hills in 1940. The restaurant became the favourite dining place for Hollywood's film stars including Jayne Mansfield, Humphrey Bogart, Sofia Loren, Groucho Marks, Cole Porter, Frank Sinatra and Alfred Hitchcock. The famous clientele enjoyed the finest food and dining experience surrounded by lavish furnishings and fixtures. Romanoff commissioned Waterford Glass to produce a crystal chandelier that would suitably impress his distinguished clients at his restaurant. The Romanoff chandelier would be an example of a truly unique Waterford Glass handcrafted chandelier that would be on display at one of the most prestigious celebrity restaurants in America.

The chandelier was a most unusual design and nothing like it had been made in the factory before. It comprised a large dome-shaped central body with long solid straight glass arms extending upwards at various angles from the base of the glass dome. Chains of glass drops hung downwards from the glass arms. Four large solid glass R letters for Romanoff hung from the lowest point of the chandelier at a 90-degree angle to each other. On the direct instruction of Bačik, every individual piece of the Romanoff chandelier was made by Joe with the help of his apprentice, Tony Galvin.

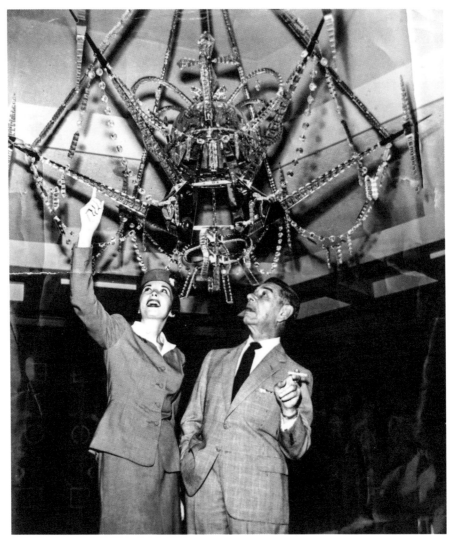

The Romanoff chandelier

It was a difficult chandelier to make, in particular the large R let-ters that hung from the base, however the chandelier was success-fully completed to schedule. Joe and Tony always believed that the chandelier was made for a palace in Arabia because they had been told by Bačik that it had been commissioned by a Prince. However, Prince Romanoff was not a prince at all, nor did he have any connec-tion to royalty. His real name was Hershel Geguzin, a Lithuanian-born national who gave himself the title of Prince, claiming to be a member

of Russian royalty. The photograph of the installed chandelier with Prince Romanoff admiring its features while smoking a cigarette was brought back from Los Angeles for Joe as an acknowledgement of his creation. Romanoff's restaurant closed its doors for the last time on New Year's Eve 1962. Today the location of the Romanoff chandelier is unknown.

Every day the pieces of glass that were made by Joe were placed into the lehr or kiln to cool down gradually over a period of hours. Having been taken from the lehr the glass pieces would be inspected for quality purposes to ensure they met the required standard and were free from impurities such as seed (small air bubbles) and cord (fine hair like filaments running through the glass). The next phase of production was the removal of the cap from each piece of glass. This involved rotating the glass against a fine abrasive wheel to scratch the circumference of the glass and then an intense flame was applied to the line of the scratch, causing the glass cap to crack off and detach from the body of the glass, leaving the finished blank glass. Every day Joe would inspect his work that had been cracked off to check the wall and rim thickness of each glass.

Based on the quality inspection at this point his wages would be calculated on the glasses that passed inspection. A young office clerk named Billy Power recorded the number of glasses for which Joe was to be paid for each day, thereby calculating his wages for that day. Billy remembers that Joe inspected his work every day without fail, and that he made all the special pieces of crystal that the factory needed at that time. Billy's interaction with Joe in the 1950s created a lasting impression on him, and decades later, as general manager of the company, he was to personally recognise and acknowledge Joe's contribution to glass making at Waterford Glass.

As the months passed by following the death of Una the loneliness and isolation remained. For Joe her death was difficult to accept at such a young age, and he was now, once more, a single man in a country where he had no direct family to support him at a time of

bereavement. One of the young teenage workers in the blowing room at the time was Vincent Dunphy who remembers clearly his first days working in the blowing room watching Joe blow a large globe of the world. When he had finished making the globe Vincent recalls that Joe sat down on the steps onto the blowing platform and started to cry uncontrollably, holding his face in his hands. Vincent had never seen a man cry like that before or since, but didn't realise at the time that Joe had just lost his wife and their unborn baby in the weeks beforehand.

Una's death of course also brought immense distress and grief to her parents and siblings. Joe remained in contact with them in the months and years following her death and they supported him in every way that they could. Una's sister Tess remained particularly close to Joe and he would often call to her house to talk about Una and what he should do with his life following her death. She encouraged him to get on with his life and live it as Una would have wanted him to. He promised Tess that we would make a special piece of glass for her, for all the help that she had given him after Una's death. He kept his promise and made her a footed centrepiece with a waved rim. The centrepiece took pride of place on the dining table in Tess's house, a reminder of her sister Una and the life that she had with Joe until her untimely death. The centrepiece is still in the possession of the Walsh family today and has been passed down to the next generation of the family, Kit Flynn née Walsh.

Chapter 10

Turbulent Times

Every photographer and film crew that came to the factory during the 1950s were brought to Joe's shop. He was a fantastic craftsman to film or photograph, not just because of his skills as a blower but because he was an exceptional showman. He would work the glass in a way that was wonderful to watch. As he attached the handle to the jug he would cut the molten glass from the iron and then rotate the jug, once, twice, three or four times, before dropping the handle on to the bowl of the jug, attaching it perfectly in line with the lip of the jug. Any important visitors to the factory were brought to watch him working because he was usually making the intricate or large items. Thousands of photographs and countless short films were taken of him and his photograph featured in a variety of national and international publications, including an article entitled the 'The Magic Road Round Ireland' which featured in the *National Geographic* magazine in 1961.

Throughout the late 1950s the demands on Joe continued to increase as the senior management, including

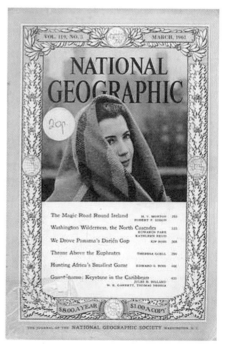

Cover of National Geographic which did a feature on Waterford Glass

105

Noel Griffin, insisted that he made all the specially commissioned crystal pieces. Along with the pressure of general production he was always called on when a young blower needed help on how to blow any particular item. When blowing the special pieces or teaching the Irish workers he was paid a fixed rate per hour, known as an average payment. The average payment system didn't suit Joe because he was able to earn more money when working on the piece rate system. The blowing room supervisor at the time was a German named Rudolf Mulac, who had come to Waterford with his wife and daughter in 1950 to work at the factory as a glass blower but was soon promoted to the position of blowing room supervisor.

Not happy with the situation whereby he was losing money when making samples or teaching other blowers, Joe went to Mulac to tell him that there were too many demands placed on him in relation to glass blowing at the factory. He told Mulac that he only wanted to work on a piece rate whereby he would be paid for what he produced, and that we wouldn't make any of the large items or help train any of the Irish workers unless he was paid properly for that work. His normal weekly earning ranged from £25 to £30 in the late 1950s.

Mulac had a fearsome reputation amongst the Irish apprentices working in the blowing room, and most were afraid to talk in his presence or even make eye contact with him. Mulac often threatened workers with dismissal if he saw them talking or singing while working on the platform. His philosophy was that when you came to work, you were paid to work, not to talk or sing.

Despite his fearsome reputation Joe had no hesitation in confronting him about any matter, including his wages. Both men had strong personalities and their allegiances to the company lay on opposite sides of the fence. Mulac was committed to the company, and he had little time for any of the workers in the blowing room, while Joe's loyalty and commitment lay with the workers, especially his apprentices and the general workers in his shop. At their meeting Joe told Mulac that he wanted to be properly paid for the work he was doing. Mulac

laughed at the suggestion and told him there was no possibility what-soever of being paid more money for the work he was doing and that he was in fact lucky to have a job with the company. Joe left the office telling Mulac that he meant everything he had said and that he would only work on piece rate until the issue was resolved.

Mulac met with Dr. Winkelmann every day to discuss the produc-tion requirements for the blowing room. He discussed with him the meeting he had with Joe and the demands that he was making. Dr. Winkelmann controlled every aspect of production and finance in the factory and the news that Joe was looking for an increase in wages could not have fallen on more unsympathetic ears. Dr. Winkelmann must account for every penny of expenditure and the idea of giving a wage increase to any worker was out of the question. Although he undoubtedly recognised Joe's ability and his importance to produc-tion in the factory, that ability was not to be rewarded or recognised through a wage increase. Mulac felt that other foreign glass blowers in the factory would be able to make the large pieces that Joe was making, if given the opportunity to do so. As far as Mulac and Dr. Winkelmann were concerned, Joe was overstepping the mark in terms of his demands.

Their apparent confidence in the ability of other glass blowers to replicate Joe's work was put to the test when Waterford Glass designed the 'Flame of Faith' presentation trophy for Olympic gold medallist Ronnie Delany following his success at the 1956 Olympic Games in Melbourne, Australia. The trophy was an eighteen-inch high lidded trophy which depicted an engraved image of Ronnie Delany kneeling on the ground in prayer following his victory at the Olympics Games. If Mulac and Dr. Winkelmann believed that other glass blowers were as good as Joe, this was the perfect opportunity for them to show their confidence in that particular glass blower by selecting him to make the piece. However, the truth was that they did not have the confidence in any other glass blower and the trophy was

The Ronnie Delany Trophy

made by Joe. The trophy remains one of the most iconic sport presentation pieces ever made by Waterford Glass.

Because of the incredible heat in the blowing room many of those who worked there took every opportunity to go for a drink in one of the two pubs in Johnstown, Kenneally's or Canty's. Those who went there frequently returned to the blowing room late, and in some cases never returned to work at all. Mulac's frustration with this problem grew deeper and deeper and he made the decision to open a bar in the blowing room to sell alcohol and cigarettes to the blowers. Kenneally's bar in Johnstown supplied the beer and Tom 'Clydie' Power, who worked in the factory, supplied the cigarettes from his small family grocery shop in Tramore. Mulac appointed Danny Waters as the barman, and he was instructed to only serve beer to the master blowers. Each blower was allowed a maximum of three large bottles of beer per day and payment for the beer had to be made at the end of each week. However, problems did occur because some of the blowers went to Canty's pub on their break to drink more beer. Inevitably, this led to drunkenness on the blowing platform, particularly among the younger Irish apprentices, and within two years of the bar opening Mulac made the decision to close it permanently.

As noted earlier, as the profile of Waterford Glass continued to grow there was a constant flow of photographers and film makers that came to the factory to capture the craftsmen at work. One of the many short films made about the factory was an Eamonn Andrews presentation, *Crystal Clear* [see www.youtube.com/watch?v=IMxP5QFwe4w]. The eleven-minute-long film describes the history of glass making in

Waterford. It begins with a general view of the blowing room showing five stemware shops at work before moving to record Joe at work. The footage shows Joe taking a handkerchief from his pocket to wipe the sweat from his brow, picking up a large bottle of beer and pouring a glass of beer for himself, which he duly drinks. Andrews describes the scene where Joe is making twelve-inch candlestick:

It is not every craftsman who has the privilege of drinking beer on the boss's time but here is one who has. For the master glass blower, because of the rigours of his craft and an old tradition in the trade, is permitted this pleasant way of slaking his thirst during working hours and preserving what bankers and accountants call liquidity, and he certainly merits this unique and ancient dispensation, for glass making is very hot work indeed, the furnace temperature for instance is in the range of 1,400 degrees centigrade and although the molten glass is slightly cooler when the blower gets to work on it, it is still several times as hot as comfort. It looks easy but then so does playing the trumpet, and this Louis Armstrong delicacy of touch is the result of long dedicated years.

Crystal decanter

The film shows several examples of Joe's work from that time including a Claret 'Bristol' decanter, a three ring neck decanter, chandeliers, a tripod, a world globe, a sports trophy and a footed turnover bowl. The apprentices who feature in the film were Johnny Power and Seanie Cuddihy, with Jimmy Kinsella as the general operator in the shop.

Whenever possible Joe would return to West Germany for a holiday and in the summer of 1956 he met his former girlfriend, Gretel Breugmann, the girl with whom he had been in a relationship before he came to Ireland in 1951. It was clear that there were still strong feelings between them but Gretel was hesitant about re-starting a relationship with Joe as

she was unsure whether or not he would move back to live in West Germany again. Despite his feelings for Gretel and the fact that they were both now single, no relationship was rekindled between them during his holiday. Shortly after he returned to Ireland and, much to his surprise, Joe received a handwritten letter from Gretel addressed to him at the glass factory in Waterford.

Greimersburg, 9th Sep. 57

Dear Sepp!

Greetings from Greimersburg from Gretel. You will be very astonished to receive post from me, you won't be pleased. I know you are angry with me and that you cannot forgive me. I can understand all that, if you could have read between the lines in the past you would not have left me alone for 8 days, but you misunderstood a lot.

I went to Winningen again for the wine festival, hoping secretly that I would see you again there, but Anni and your brother were alone. Your brother told me that you wanted to come to Greimersburg. But your boss wrote that you would not come.

Dear Sepp! I want to ask you why you are not coming back ???

Dear Sepp! If you are no longer angry with me and you can forgive me, then do come back.

We can discuss everything else in person. Hopefully soon.

Cordial greetings from Gretel

The content of letter clearly shows that there was a still a connection between Joe and Gretel despite their relationship ending six years earlier in 1951. When they met during the summer of 1957 neither was prepared to commit to the other. For Joe he was at a point in his life where he was unsure about where his future was to be, Ireland or West Germany. Further letters were exchanged between them over the following months however their romantic relationship never rekindled.

Chapter 11

Resignation

In 1956 a young girl named Kitty Buckley was working in the blank finishing area in the factory. Kitty was the youngest of the three children of James and Roseanne Buckley, and the family lived at 25 Tycor Avenue. Kitty had two older brothers, Bill and Dick. Her father James, a cabinetmaker by profession, worked at Hearne's furniture factory in the city, and her mother Roseanne, a confectioner, worked at Greer's cake shop.

Every morning Joe went to examine his work in the blank finishing area. He was very well-known to all the women who worked in the area, including the area supervisor Mary Prendergast, Mary Power and Kitty Buckley. Joe was thirty-three years of age and a widower, but for the first time since Una's death he was deeply attracted to another woman, Kitty Buckley. When he asked her out on a date to the Olympia ballroom she immediately accepted, somewhat to his surprise as he was almost ten years older. For Kitty the age barrier was not an issue, and soon their relationship developed, and they became inseparable as a couple.

On the weekends they would go to all the ballroom dances and party into the early hours of the morning. On weekdays after work, Joe would call to Kitty's home and her parents would insist that he stay for his tea. Kitty's father was an avid gardener and beekeeper, and during the summer months Joe, a lover of gardening and the outdoor life, would spend hours with him in his small garden. Kitty's mother was in poor health and gangrene had developed in her lower leg which

Kitty Buckley

required it to be amputated. Her older brothers Bill and Dick had left the family home so the care of her mother lay primarily with Kitty. Her relationship with Joe and the social life that they enjoyed together provided a welcome release from the everyday strains of caring for her mother.

As Joe's relationship with Kitty grew stronger and stronger, his relationship with management in the factory continued to deteriorate over the issue of wages. Mulac and Dr. Winkelmann made no genuine effort to deal with the issue, but Joe was not prepared to let the matter go unresolved. He decided to escalate the situation by refusing to make the large samples, but he knew he would be threatened with disciplinary action if he refused to work. Contrary to his work ethic he said he could no longer make the large items due to pain in his shoulder and arms, as a result of the physical effort required. Joe told Mulac and Dr. Winkelmann that if they didn't believe him they could buy him his tickets to return to West Germany.

Kitty pleaded with him not to leave and reminded him that he was earning more money than any other worker in the factory. Dr. Winkelmann had to make the decision on whether to pay Joe the extra money he was looking for or call his bluff and see if he would really go back to West Germany. Mulac did not want Joe to be paid anything extra and told Dr. Winkelmann that he would never leave because he was now in a serious relationship with a girl who was working in the factory. More importantly, Mulac was of the belief that if he did decide to leave Franz Hoffman would be able to replace him. Having carefully considered everything Mulac had told him, Dr. Winkelmann made the final decision on the matter.

In December 1957, Dr. Winkelmann asked Joe to come into his office for a meeting to discuss the issue. At the meeting Dr. Winkelmann told Joe that he was not being reasonable in his demands for more money and that the factory could not afford to pay him more than what he was already earning. He told Joe that he should go back to work and be happy with what he had and realise that he had a good future for himself in Waterford. Joe asked if that was the final answer in relation to the matter and Dr. Winkelmann said it was. The meeting ended in a heated argument between the two men, a clash of two uncompromising personalities. As Joe walked out of the office he told Dr. Winkelmann to get his travel tickets ready and prepare the necessary paperwork required for him to leave the factory. Dr. Winkelmann was stunned by his decision. He never believed he would actually leave over the issue. But his bluff had been called and there was no option for him to reverse his decision as his credibility would have been damaged amongst the other workers.

Joe didn't return to work that day but he did go to the blowing room to tell his apprentice, Tony Galvin, what had happened and that he was leaving. Tony was shocked that the factory would allow him to leave over a small sum of money. That evening Joe went to Kitty's house to tell her that he was leaving. Her parents pleaded with him to stay as he had so many friends here now, and they were thinking of the effect it would have on Kitty. Despite the best efforts of Kitty, his closest friend Max Göstl and other friends, there was no changing his mind. He contacted his brother Aurelian to organise accommodation for him. Everything was in place for his return to Limburg an der Lahn.

The following week he went to the factory by appointment to collect his wages and all his personal belongings. Dr. Winkelmann met him and asked him to reconsider what he was doing, but there was no changing his mind. He asked Dr. Winkelmann for an official work reference, to be written in German, on Waterford Glass letterhead. Dr. Winkelmann called Mulac into the office and dictated the content of the reference directly to him.

Our Ref RM/FM.

18.12.1957

Reference

Mr. Josef Cretzan, born 14/04/1924, was employed from 1.11.1951 until today as a master glass maker in our factory.

He worked mainly on large piece, such as plates, bowls, vases, jugs etc with lead crystal. Besides that he made parts and arms for chandeliers.

We are pleased to confirm that Mr. Cretzan is a good glass maker and that we were very satisfied with the quality of his work.

Mr. Cretzan is leaving us on his own account as it is his intention to return to Germany.

We wish him the best for his future.

Waterford Glass Ltd.

(Dr. H. Winkelmann) Director

The decision to allow Joe to leave the factory created a nightmare for production in the blowing room. They now had to identify which blower would take over from Joe to make the large vases, bowls and specially designed pieces that were being brought to America. The person they selected was Franz Hoffman. He had years of experience in jug-making and heavy blowing, so he was the only realistic option. This was now an opportunity for Hoffman to be the main glass maker in the factory and blow all the large heavy items that the factory needed.

On the day Joe was leaving Waterford his work colleagues, including Tony Galvin, Paddy White, Seanie Cuddihy, Michael Condon, Johnny Power and Max Göstl, organised a farewell party in one of the city centre pubs. The young apprentices who had worked with him had grown to love him and he was almost a father figure to them because he had looked after them so well. They had smoked his cigarettes,

ALL COMMUNICATIONS TO BE ADDRESSED TO THE COMPANY

TELEPHONES:
WATERFORD 4921-2

TELEGRAMS:
"GLASSFACTORY." WATERFORD

RECD.

Waterford Glass Limited

DIRECTORS:
JOSEPH McGRATH (CHAIRMAN)
JOSEPH GRIFFIN
FRANZ WINKELMANN (FORMERLY GERMAN)
B. J. FITZPATRICK
NOEL M. GRIFFIN, A.C.A.
PATRICK W. McGRATH
H. WINKELMANN, M. SC., PH. D.

WATERFORD. IRELAND

YOUR REF.

OUR REF. RM/FM.

den 18.12.1957

<u>Zeugnis.</u>

Herr Josef Cretzan, geb. 14.4.1924, war vom 1.11.1957 bis heute
als Glasmacher-Meister in unserem Werk taetig.
Er wurde hauptsaechlich auf Grosszeug, wie Teller, Schalen, Vasen,
Kruege etc. in Bleikristall beschaeftigt. Ausserdem hat er Kron-
leuchter- Teile und Arme angefertigt.
Wir bestaetigen gern, dass Herr Cretzan ein guter Glasmacher ist,
und dass wir mit der Qualitaet seiner Arbeit sehr zufrieden waren.
Herr Cretzan verlaesst unseren Betrieb auf eigenen Wunsch, da er
die Absicht hat, nach Deutschland zurueck zu kehren.
Wir wuenschen ihm das Beste fuer seine Zukunft.

Waterford Glass Limited

(Dr. H. Winkelmann)
Direktor.

Reference letter signed by Dr Winkelmann

drank his Russian tea and beer while working with him. None of the
other foreign glass makers had treated the young Irish workers so well.
As they drank together in the pub Joe bought them rounds of beer and
many of them got drunk. When they couldn't drink anymore beer he
gave them glasses of rum and orange and insisted on them drinking it
with him as it would be their last time together.

As the time for the evening sailing approached, they made their way down to Adelphi Quay. Kitty was there with her father. Some of Una's family had come to say goodbye, Margaret Gavin from the Cork Road had come with her children, and his landlady Chrissie Power was there. He was emotionally overcome as they all gathered around him to say goodbye. There was one further surprise in store for him as he said his final farewell to everyone there. The apprentice Michael Condon, who lived in Glen Terrace, had organised for him to be waved off to the sounds of the Yellow Road Fife and Drum Band, and as he boarded the *Great Western* the band began to play. It was an incredible farewell to the man they respected and loved so much, and many tears were shed as the steamship pulled away from its berth and steamed its way down river and out of sight.

Chapter 12

In Absentia

As Joe's journey to Limburg an der Lahn began, arrangements had been put in place for Hoffman to start blowing all the heavy items. As Christmas approached, there was a backlog of items to be blown as Joe hadn't worked at the factory for over a week. There was some urgency as they had to be shipped to America for the New Year. The responsibility to make these pieces now rested on Hoffman's shoulders, and Dr. Winkelmann needed the backlog of work to be completed before the Christmas holidays. From the first day that Hoffman took over Joe's production schedule it was clear to everyone in the blowing room that despite his experience, Hoffman was never going to be able to make the large heavy items that Joe made. The consequences of Dr. Winkelmann's and Mulac's decision had now materialised, and a serious production problem had been created by them. The factory had now lost over one week's production on heavy items required for the America market in January.

On the lead-up to the Christmas holidays it was a tradition that directors of the company would come to the factory floor to meet the workers before they took their holidays. Con Dooley came to meet the workers but more importantly to check on the progress of the pieces that he and Noel Griffin were bringing to America in early January. As he walked through the cutting department he was told that there were no large vases or centrepieces available to be cut. Surprised and somewhat concerned, he went to the blowing room to find out what the problem was.

As he entered the blowing room he met Tony Galvin and asked him where Joe was. Tony told him that if he wanted to find Joe then he would have to go to West Germany because he had left the company a few days earlier. Dooley stood back in disbelief and asked him what he meant. Tony told him that he should go to Dr. Winkelmann and ask him why Joe had left the factory.

Dooley went straight to the blowing room office to find out for himself what had happened. Dr Winkelmann told him that Joe had left the company of his own free will and that he had tried to change his mind on the matter, but to no avail. The problem, he told Dooley, was that nobody else could make the pieces that Joe had been making for years. Dooley asked why he had decided to leave and that there must have been a reason for it. Dr. Winkelmann said there was an issue about his wages and that he would not give into his demands as he was confident other blowers would be able to replace him. However, he now realised that wasn't the case.

Dooley told Dr. Winkelmann to sort out the mess he had created, get in contact with Joe and get him back to the factory. Dooley told Bačik and Griffin later that morning about Joe's departure and that it was as a direct result of a decision made by both Dr. Winkelmann and Mulac. The urgency of the situation was realised when Winkelmann's father, Franz Winkelmann, arrived at the factory several days later for the sole purpose of finding out the circumstances of why Joe had left. Danny Waters had been instructed to clean up and prepare the blowing room for the arrival of Franz Winkelmann and he recalls the occasion.

Franz Winkelmann was not a regular visitor to the factory as he lived in Dublin. When he arrived at the factory by chauffeur driven car, we knew something serious was happening. It was the only time that anybody ever saw father and son, Franz and Hans Winkelmann, together in the factory. The fact that he had come down from Dublin for that meeting was an indication, if ever one was needed, of how important Joe Cretzan was to Waterford Glass.

At the meeting Dr. Winkelmann and Mulac were reminded that they had no authority to make any decision that would allow Joe Cretzan to leave the company. They were instructed to contact him immediately and get him back as soon as possible, giving him whatever wage increase he was looking for. That instruction had come from the senior directors in the company and Franz Winkelmann delivered it in person to his son and Mulac. After the meeting Mulac went straight to Kitty Buckley to tell her that he would be immediately contacting Joe asking him if he would return to Waterford.

One of the Irish blowers who was working in the blowing room at the time was Henry Moloney. Although Henry didn't work directly with Joe he did twist the blowing iron for him occasionally. He remembers the effect of his departure in December 1957 for both the workers and the factory.

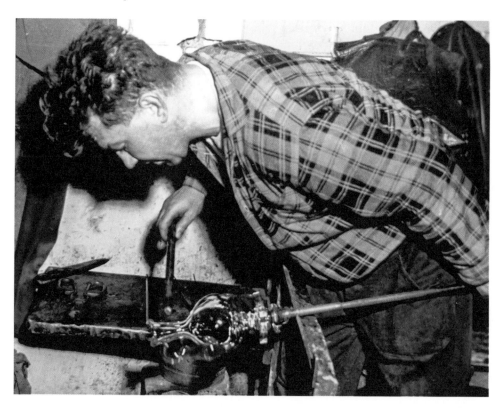

Forming the handle on a claret decanter

The whole factory looked up to Joe, he was the blower everyone wanted to be. Everything that had to be made in the blowing room at the time, he had to make it, and anything that Griffin wanted for America, or for himself personally, Cretzan had to blow it. They made moulds so big for him to blow that they had to be brought up on a truck to the blowing room.

He made glass blowing look good and he had a pair of hands that I would describe as, as good as the Pope's hands. He was very fair to all the workers in the factory, in fact I would say he was the fairest man I ever knew. He treated all his workers very well, even the boy who held the mould for him, he would always buy him a drink. When my sister was sick in Ardkeen Hospital with tuberculosis he sent me out to the hospital with fruit and bunches of flowers for her. He never met her, but he insisted I give her the gifts.

None of the other foreign blowers could hold a candle up against him in terms of glass blowing. He was the greatest glass blower I have ever seen in my life. He could blow anything, you name it, he could make it. Bačik, Griffin and the McGraths would come to see him at work, they knew how good he was. He could gather half a hundredweight of molten glass in a single gather and the blowing iron would bend as he worked with the glass. On the day he left Waterford in December 1957 I was working on the evening shift, so I couldn't wave him off, but I had tears in my eyes that night as I worked in the blowing room. When he left nobody could replace him. Hoffman was given the responsibility of blowing all the large items, but he was thirty years behind him in terms of glass blowing, so they had to get him back as soon as they could. The blowing room was Joe Cretzan, and I will never forget that man because he was the greatest glass blower I have ever seen and, he was good to me.

As Christmas approached Joe arrived in Limburg and stayed at Aurelian's house with his wife Anni and their two children, Peter and Gabi. He was happy to be with them and he spent many nights over Christmas with old friends. Over the Christmas and New Year period Kitty and Joe wrote to each other every week. All the workers in the factory asked Kitty to send their regards to him and they hoped that

he would return to Waterford at some stage. The letters and cards that Kitty sent to Joe were all dictated to and handwritten in German by Mrs. Weber, wife of Karl Weber, a German glass worker who lived on the German Road. On 10 January 1958 Kitty sent the following a letter.

Waterford

10.1.58

Dear Joe!

I have received your letter dated 6.1 and I thank you. I was very happy about it. I still think you will come back to Waterford. All the girls and boys in the factory are asking about you and they send their greetings. I will tell them all you asked about them.

Joe in Germany with his brother Aurelian, wife Anni and their children Peter and Gabi

Unfortunately, I have to inform you that your friends lost the darts match. And I am sending you the picture of Tramore. I think you are like the big chief sitting bull. Tony Galvin will write a letter to you within the next few days. Maybe you have got it already. And he would be delighted if you would reply. Nobody can forget you and they like you very much. The boys told me that Mr. Dolphin will write to you too. I heard Mr. Hoffman's work is not supposed to be very good. Mr. Griffin has gone to America for 3 months. He will have a nice holiday there. And Marchwald is travelling to Germany today. I will tell your sister-in-law she should send you the money. And I will tell Tommy Power all about the camera. And I will send greetings to all the boys and girls in the factory from you. They are all asking about you. I will send you the newspaper and cigarettes next week. Please tell me if you found another good factory and if you are happy with your work and wages. But it would be better for me if you were back here again. My Mother is ill. The weather is very bad. Everyday rain and storms. My Mother has bad feet and has to stay in bed. I hope it will improve soon. Heinz Plattner asked me for your address. He wants to write to you. He wants to go back to Germany. Christie Kennedy and all the others are asking what you are doing and how you are keeping. The darts players lost the match 2–0. Kings and Scanlons are in the final on Monday evening.

I have written enough for today. I hope you will write to me again soon, as I am always waiting for mail from you.

Loving Greetings and Kisses

From your loving Kitty x x x x x x x x x x x

All my love

Please come back quick.

Write soon.

The content of the letter gives an insight into the issues that had arisen as a result of Joe's departure from the factory, but it also high-lights personal issues between Joe and Kitty. The letter shows the regard that Joe was held in by the workers and it clearly identifies the production issue that Dr. Winkelmann and Mulac had created for the

factory. Noel Griffin had travelled to America in the New Year of 1958, but without any of the special order pieces that were to be used in his promotional tour of the major retail stores across America. Staff supervisor Bill Dolphin had also been instructed by Noel Griffin to write to Joe in an attempt to speed up his return. The Tommy Power referred to in the letter worked in the quality control department in the factory and was better known as Clydie Power. He had asked Joe about photographic equipment in West Germany and the letter suggests that Joe had identified the camera he was looking for. Glass cutter Heinz Plattner was not happy in Waterford at that time and the letter states that he wanted to return to West Germany. The darts players referred to in the letter played for Robert Grace's pub and they had been beaten in the semi-final of the Waterford pub darts competition. The finalists in the darts competition were Sean King's pub from Lombard Street and Scanlon's pub from Military Road. The letter was signed off with greetings and best wishes from Kitty.

Chapter 13

Delicate Negotiations

The process of posting letters to and from West Germany was slow and the situation was developing into a crisis for the factory as orders were not being fulfilled. Kitty was the point of contact for management in relation to communication updates from Joe. She wrote to him at least twice every week in the hope that she could entice him to come back as soon as possible. On 13 January 1958 she wrote:

13-1-58

Dear Joe,

I am sending you the sports page but I am very sorry about the cigarettes. It is not allowed to send them out of the country, you know I would send them if I could. If you can think of any other way of getting them to you let me know and I will send them. Mammy is still in bed with her leg and daddy is not well either so you can see I have my hands full, I wish you were here, I am very lonesome without you and I am always thinking about you, and love you as much as always, please come back as quick as you can, though it will not be quick enough for me. I am just writing this note to you before I go to bed, you will have had my letter before this and I hope you write me a long letter. I want to know everything that you are doing, I do not go out much and I cannot go out because of all the things I have to do when I come home. I hope you understand this printing, I did not have time to go out to Mrs. Weber, I will write you a long letter the next time.

All my Love

Kitty x x x x x x x x x x x x x x x x

I am very sorry about the cigarettes.

In early January, under the direct instruction of Dr. Winkelmann, Mulac posted a letter to Joe confirming that he would receive an appropriate wage increase if he returned to Waterford immediately. However, the wage increase was not quantified, and Joe wanted clarification on what he would be receiving before he would commit to returning. He was now determined to negotiate the best deal possible for himself. Dr. Winkelmann would not commit in writing any detail of the wage increase he was prepared to give him. In the blowing room the workers knew that efforts were being made to get Joe back because Kitty was updating the workers on her contact with him.

The production backlog continued in the blowing room as dozens of presentation pieces that were due to go to America had not been blown. Eventually, Noel Griffin lost patience as there was no progress being made in getting Joe back to the factory. Griffin contacted Con Dooley and told him to take charge of the situation and do whatever had to be done to get Joe back. Dooley decided that the only way to deal with the matter was to go to West Germany himself. He got Joe's address from Kitty and told her that he was flying to West Germany to meet with Joe and that he would be making the necessary arrangements with him to bring him back as soon as possible. Neither Dr. Winkelmann nor Mulac were informed about Dooley's trip to Germany.

On 25 of January 1958 Kitty posted a letter, handwritten in German by Mrs Weber, to Joe:

Waterford 25.1.58.

Dear Joe!

Thank you for your letter which I received in good health. I am always delighted to receive a long dear letter from you. And many

thanks for your small picture. I am sending you a photograph from the newspaper of the social sports club of the glass factory today. There was a dance again last week. It was quite nice. Only I missed you a lot. Tony Galvin will send you the union card himself, he told me so. Tom Power told me he will wait about the camera till you are back here or he will go to Germany himself. He thinks £15 is too much customs duty. Scanlon's won the darts match. And Chrissie told me he had a good time. We are telling everyone that you will be back here on the 9th of February of this year. I hope that you are really coming. Everyone is asking about you and they are looking forward to your arrival. Mother is still ill. This is bad for me as I have to work a lot at home. I cannot go out much. She says she will always think of you. I will also send you the sports paper today. I will send you the other newspapers next week. I will also send you cigarettes. Dear Josef I do miss you a lot. And I hope and wish you would come back soon. And, dear Joe, I have one favour to ask, please don't drink too much in Germany. I have not seen Chrissie yet, as I don't get out very often now that my mother is sick. I hope you enjoy your holiday. I hope you won't forget me when you are out dancing and meeting the nice girls.

Well, I have written enough for today.

Thinking you will write to me soon.

> *Greetings and kisses from my heart*
>
> *All my love*
>
> *Kitty xxxxxxxxx*

I miss you & love you very much, and I will wait until you come back

Because of Dooley's intervention and his planned trip to Germany, it was now hoped that Joe would return to Waterford on Sunday, 9 February 1958. Throughout January 1958, Joe corresponded by letter and telegram with the factory, in most cases with Mulac, but on at least one occasion with Bill Dolphin. The content of Joe's correspondence with the factory is not known as his letters were not retained

by the company, however Joe kept the letters he received from Mulac from that period. On 27 of January, Mulac posted a handwritten letter in German to Joe:

Rudolf Mulac Monday 27.1.1958
Waterford – Ireland
Waterford – Glass L.T.D.

Dear Josef!

Many thanks for the record you sent me. I can imagine how you often cried crocodile tears over this. But otherwise quite nice melodies. Dolphin also thanks you for your letter, which you should have sent directly to the company.

Dr. Winkelmann instructed me to answer your letter. If I was convinced that a reasonable Josef Cretzan would return, I would say for your sake – yes. You know that nobody sent you away from here. You know that you said at least 100 times 'give me the tickets' and you know dear Josef, unfortunately, what you got up to in this company. It beggars belief. The example you set was terrible, because it was then said that this was how the Germans behaved.

Well it was often too much – And therefore I am very worried about you coming back here. A man cannot just let himself go and do whatever he likes. We are all subject to unwritten law and that is called conduct.

Quite often other people too had reason to despair, take my word for it. You are no exception. You always referred (and I want to tell you this clearly) to your work. Okay, when you didn't act the crazy and wild man you did your work. But shouldn't mankind be grateful to God that he gave the gift to use his hands so he can work well? Is it ok if someone misuses this gift and then brags about it? Dear Josef, I am of the opinion that one should not tempt faith, it will not end well. One should always try to adapt and fit into a community. This applies to human communities as well as the community at work. Then everything will be ok and you will see that I am right – And now consider whether you find this to be the right way, and if you can live and work under different circumstances,

that is a different Josef than in the past. If you can do that then take your stuff and come immediately. Your work permit has not gone to Dublin yet. It might not be noticed. The majority of the workers have nothing against you, you should just be reasonable, nobody is asking any more than that. – Send me a telegram to tell me when you will arrive.

You should marry a German girl. A woman who sticks with you not in only good times but also in bad times, and who would, above all, lead and guide you (and sometimes give you a kick up the arse).

Many greetings to you and your brother,

Yours R Mulac

I have never let you down and now you should finally try and be reasonable.

The tone and content of Mulac's letter gives an insight to his own personality and character. Joe had written to staff supervisor Bill Dolphin because he had received a letter from Dolphin on Noel Griffin's instruction, asking him to return to Waterford. Malac's letter admonishes Joe over his behaviour and this referred specifically to his refusal to blow large items for the company. Mulac never referred to Joe's demand for higher wages and he never acknowledged his own error of judgement that resulted in Joe's departure from the factory. Mulac's opinions on the issue had become irrelevant as Con Dooley was travelling to meet with Joe later that week.

In January 1958, Joe met Con Dooley to discuss his return to Waterford. Dooley had gone with an offer which he believed would guarantee his return to the factory. The offer included a guarantee of a special average payment, a premium payment that would be paid when making any type of non-piece rate items, the full payment of his wages for the period that he had been in West Germany, reimbursement of all the travel expenses he had incurred and, perhaps most significantly, the factory would make arrangements to assist him in the purchase of a house in Waterford. The gamble he had taken in leaving the

company had paid off. The offer which Dooley had presented, which had been approved by Noel Griffin, was an acknowledgement of Joe's unique importance to glass making at the factory.

When Con Dooley returned to Waterford he told Dr. Winkelmann that he had met with Joe and that Joe would be confirming to him his return date to Waterford by telegram. Dooley told Dr. Winkelmann to orga-nise and pay for all the required travel documents as soon as he received the telegram. He also informed him that the arrangement that had been

Joe in 1958

made to secure Joe's return to the factory had been authorised by Noel Griffin. Dr. Winkelmann was furious that he had not been informed about Dooley's trip to Germany and he felt that his authority in the factory had been damaged by the whole affair. Dooley's trip to West Germany had, however, saved Dr. Winkelmann and Mulac the humil-iation of having to acknowledge to Joe personally their error in allow-ing him to leave the factory.

On 4 February, Dr. Winkelmann received a telegram from Joe informing him that he wanted all his travel documents posted to his brother Aurelian's house at Franz Schubert Strasse in Limburg and der Lahn. Mulac immediately set about making his travel arrange-ments. He sent a telegram to the Thomas Cook travel agent office in Frankfurt informing them to arrange all the required travel tickets for a journey to Waterford. The tickets were delivered by registered post to Joe on 10 February and his journey back to Waterford was to begin on 12 February 1958. The two-day period before he started his journey

back to Waterford allowed Joe time to say goodbye to his friends, and to spend time with his nephew Peter and niece Gabbi.

Mulac's letter of 4 February 1958 was posted from his home address, Mount Carmel, which was located in Lower Grange, not far from the factory in Johnstown. Mulac confirmed that he had received Joe's telegram which detailed the date he wanted to return to Waterford and that his travel tickets for his return journey would be sent by the end of the week. The tickets were not received by Joe until one week later, 11 February, due to the complexity of organising the journey back to Waterford.

In the telegram that Joe sent to Mulac he asked him if he wanted anything to be brought back from West Germany for his family. Mulac took the opportunity to send a long list of German household foods and delicacies that he wished for, which of course were not available in Ireland. Very specific in the detail of exactly what he wanted, and the price of the goods, the letter highlights the everyday German foodstuffs that were not available in Ireland and, in Mulac's case, it included his wife's very specific requests. The letter finished with the detail of how two of the former German glass workers at Waterford, Karl Vogel and H. Urbaneck, both of whom had already left the company and returned to West Germany, had now changed their minds and wanted to return to work at the factory in Waterford again.

R. Mulac *4/2. 1958*
Waterford – Irland
Mount Carmel

Dear Josef!

I have received your telegram. Your ticket will be sent to you on Tuesday or Wednesday. You will receive same by the end of the week.- I'll send it to your address £2-0-0 and I am asking you to bring me a few things.

You will certainly have time and I ask you not to forget anything.

1. *For 2 DM (Deutsch mark) camoline tea*

2. *For 2 DM herbal tea (for infection of the respiratory tract)*

3. *For 2 DM Peppermint tea*

4. *For 1 DM a tea which is given to small children in cases of mouth ulcers (or herpes simplex virus). I believe it is called alum? Ask the pharmacist please*

5. *For 3 DM Wybert pastilles (they are to protect the voice box)*

6. *A small bottle of valerian drops.*

Monica asks you to bring 1 pound (500 grams) of Russian bread. Your sister in law will know what this is.

Anyway they are a sort of biscuit in the shape of letters. Like A or B or C. And 1 pound sprinkled chocolate biscuits.

You can get all this in a good confectioner.

My wife asks you to get her a tin of fish mayonnaise from a department store or a fish shop and a tin of meat mayonnaise.

She has been looking forward to this for the last 3 years. You know what it's like here, you can't get these things here.

Dear Josef, buy me some good chocolate and Cognac-filled chocolates for the rest of the money. As I have no other way of getting these things from Germany. I hope you will get me these. Stuff all this deep into your suitcase so that you won't get into any trouble.

Many greetings from all

R. Mulac

K. Vogel and H. Urbaneck wrote today. They too want to come back to Ireland.

Joe had written to Kitty confirming that he was returning and he asked her to ask his former landlady, Chrissie Power, if he could stay with her again. Kitty had arranged that he could stay with her brother Billy if Chrissie didn't have a room available for him. A letter sent on 8 February detailed the arrangements she had put in place for his return. The letter is signed by Kitty. However, before it was placed

into the envelope, Karl Weber wrote a short personal message to Joe, signing the message with his signature.

Waterford *8.2.58.*

Dear Joe!

Thank you for your letter which I received in good health. I thought you would be here with me by now and therefore I didn't want to write to you. I thought you might not get this letter. But today I will post this letter. I do hope that you will be here by Thursday. I am so looking forward to your arrival. And I agree with all the things you wrote. I did ask Chrissie about you staying but she didn't say either yes or no. But I think she will do everything for you again. Do come over first and then ask her yourself. But I will keep searching for you. I will try and find a good place for you. When you arrive next week go to Billy. You can eat there and arrange everything in peace. Billy will put you up for a couple of days until you find something suitable. My Mother is in hospital. She asks about you every day. I will finish off now as the letter mustn't get too heavy for airmail. Send me a telegram to tell me when you will arrive. I am so looking forward to your arrival.

That is all until I see you, come quick,

All my love

Kitty x x x x x x x x x x

Josef you old dope, I am already drinking a small bottle to your health today. I hope there will be a strong storm when you cross over from England. Hope you get well shaken.

Karl Weber

Kitty's letter dated 8 February was the last letter she sent to Joe before his return to Waterford. She received a telegram from Joe confirming that he would be returning to Waterford on 15 February 1958.

Chapter 14

Return of the Exile

The travel tickets were sent to Joe by registered post on 10 February from the offices of Thos. Cook & Son, Kaiser Street, Frankfurt Am Main. The journey to Waterford was complicated and long, but Joe arrived as scheduled in Waterford on Saturday, 15 February 1958. On Monday morning he arrived at the factory to loud cheers from all the workers in the blowing room. Dr. Winkelmann met him and welcomed him back. Everything had been prepared for his return, all the wooden moulds that needed to be blown were on the blowing platform waiting for him. Dr. Winkelmann had prepared the pot of glass to allow him to start blowing large heavy items from 8.00 am. For Joe's ball blower, Tony Galvin, it was one of his greatest days in the factory because the man he believed he would never see again had returned.

Before he left the factory that day Dr. Winkelmann called Joe into his office. He told him that the company had devised a new payment scheme for him called the 'special average payment'. The payment would be made when making samples, trophies, centrepieces or any other type of item that was not suitable for piece rate work. It was a premium payment that would guarantee him no loss of earnings in comparison to piece rate production, and the payment would recognise the effort and skill required to make those items. The new payment system resulted in his weekly wage increasing to over £30 pounds per week. However, he was not the only person to benefit from the 'special average' payment system. The apprentices in his shop,

much to their delight, also reaped the benefits of the payment as they were paid a percentage of his wages resulting in a significant increase for them also.

On 20 February 1958, an entry into the *Certificate of Registration* booklet by Garda T. Burke recorded:

> *This alien reported that on the 14/12/57 he was returning to Germany on that date. He returned to Waterford on the 15/2/58 – reported to Dept. on the 20//2/58.*

There was another commitment that the factory had made to Joe for his return to Waterford: the promise to facilitate and arrange the purchase of a house for him. The factory had been involved in the building of the houses in Saint John's Park for glass factory workers, and the German Road was named because of the number of German families, such as Göstl, Weber, Vogel and Berger, who lived on that road. Many of those families came to Waterford with their children, so it was important that suitable homes were provided for them. However, Joe had come to Waterford as a single man so there was no urgency on behalf of the company to find a home for him. Noel Griffin wanted to ensure that all the workers in the factory would be able to purchase their own homes and made arrangements with the local banks to provide lending facilities to ensure it happened. Griffin was now anxious to fulfil the commitment he made to Joe, but that commitment now was not based solely on goodwill; it was a strategic decision made by him. He knew Joe personally and he believed that if he had his own house it would increase the likelihood that he would settle in Waterford permanently, thereby eliminating the chance that he would consider leaving Waterford Glass again.

In 1958, the majority of glass being made in the blowing room was still soda glass which was mainly used in the pub trade. All the Italian glass makers who came to Waterford in the 1950s were soda glass workers who specialised in the gentile style of glass blowing. There were only two pots of crystal in the factory at that time and most of the crystal was made by Franz Hoffman and Joe. Glass making

in crystal required a greater level of skill than soda glass as the shaping, distribution and control of the molten crystal required greater technical ability. Max Göstl was the first glass maker in the factory to make stemware items, such as champagne, martini and liqueur glasses, in crystal. Max introduced the use of the wooden divider into the production of crystal stemware. The wooden divider would allow the glass blower to control the walls in the glass to ensure that there was enough thickness in the body of the glass for glass cutters to cut the required depth, while at the same time having a rim thickness of between 2 to 2.5 millimetres. The use of the wooden divider was not required when making soda glass, and many of the Irish apprentices found the transition from soda to crystal production difficult. Under the guidance of Max Göstl, the first group of Irish stemware blowers perfected the use of the divider to allow them to produce the complete range of stemware glasses.

The use of colour in glass blowing was introduced into the factory by Joe, and he would use the colour sticks that he sourced from the glass factory in Limburg to make fish, baskets, horses and other non-production items. The coloured pieces were usually made at the end of the working day if there was enough glass left in the pots. The colour glass sticks, usually white, blue, green or red, were broken down into small pieces and then melted into the molten glass giving a mixed colour appearance to the finished piece. These novelty items were never production pieces and, in later years, many of the blowers made coloured fish for their own friends and families.

The most technically difficult examples of colour glass making that Joe made were the footed centrepieces. The bowl of the centrepiece was a single colour, usually green or ruby red, and a clear foot was attached to the bowl. The process of creating the coloured bowl involved making a cup from the stick of coloured glass and then inserting the clear molten crystal into the coloured cup. The distribution and thickness of the colour had to be perfect so that when the centrepiece was hand cut, either wedge or flat cut, the cut into

the bowl exposed the clear glass on the inside. Dr. Winkelmann had a particular interest in coloured glass as the Ph.D he completed in 1952 related to coloured glass, and he watched in amazement at the technical understanding that Joe demonstrated in fusing together perfectly the coloured and clear glass. So impressed was he with the finished piece, he asked Joe if he would make one of the coloured centrepieces for him as a Christmas present for his father. It was the start of a tradition that would last many years whereby every December a special request would be made for colour centrepieces to be made by Joe for Dr. Winkelmann, Noel Griffin, Charles Bačik and other senior members of the management team at the factory.

Those colour centrepieces were made for only a handful of people and they were recognised as unique examples of the technical skill and craftsmanship of Joe Cretzan. A set of six green tumblers and a matching water jug made by Joe were donated by Waterford Glass to the National Museum in Dublin in 1958, and they are still in the possession of the museum today.

Photograph courtesy of Archives Department, National Museum of Ireland

National Museum green jug and tumblers

Joe's relationship with Mulac and Dr. Winkelmann remained tense, mainly due to the clash of personalities between the three men. All were experienced glass specialists but had differing opinions on how glass could and should be made. This inevitably led to disagreements and Joe was never prepared to change his opinion. He respected Mulac's and Dr. Winkelmann's views, however he rarely agreed with them.

In June 1958, Joe refused to cooperate with instructions given by Dr. Winkelmann, and his refusal to cooperate led initially to a verbal threat of disciplinary action. That threat further deepened Joe's resolve not to cooperate and he reminded Dr. Winkelmann of the errors he had made in the past, referring specifically to his departure from the factory only a few months previously. This reminder infuriated Dr. Winkelmann as he felt his credibility had been tarnished over the affair. In an attempt to distance himself from the situation and diffuse any future potential blame that might occur, Dr. Winkelmann arranged that Joe was called to a meeting with staff supervisor, Bill Dolphin, over the issue. No discussion was held at the meeting, instead a letter of suspension was handed to Joe by Dolphin:

BY HAND: *24ᵗʰ June '58:*

Joseph Cretzan Esq.,

Dear Sir,

As there is the possibility that you may not have clearly understood the instructions given to you today, I wish to inform you that you are suspended for three days i.e. Thursday, Friday and Saturday. The arrangement to call to see Dr. Winkelmann on Thursday still stands but you are not to work until next Monday. Also - drei Tage beurlaubt von morgen.

> *Yours faithfully*
> *Waterford Glass Limited:*
> *W. B. Dolphin, Staff Supervisor.*

ALL COMMUNICATIONS TO BE ADDRESSED TO THE COMPANY

TELEPHONES:
WATERFORD 4921-2

TELEGRAMS:
"GLASSFACTORY," WATERFORD

RECD.

Waterford Glass Limited

WATERFORD. IRELAND

DIRECTORS:
JOSEPH McGRATH (CHAIRMAN)
JOSEPH GRIFFIN
FRANZ WINKELMANN (FORMERLY GERMAN)
B. J. FITZPATRICK
NOEL M. GRIFFIN, A.C.A.
PATRICK W. McGRATH
H. WINKELMANN, M. Sc., PH. D.

YOUR REF.
OUR REF. WBD/SH.

BY HAND:

24th June '58:

Joseph Gretzon Esq.,

Dear Sir,

 As there is the possibility that you may not have clearly understood the instructions given to you today I wish to inform you that you are suspended for three days i.e. Thursday, Friday and Saturday. The arrangement to call to see Dr. Winkelmann on Thursday still stands but you are not to work until next Monday. Also— drei Tage beurlaubt von morgen.

Yours faithfully,
WATERFORD GLASS LIMITED:

W. B. Dolphin,
Staff Supervisor.

Joe's official Letter of Suspension

 The last line of the letter, which was written in German, confirmed that he was suspended for three days. The suspension was implemented on the instruction of Dr. Winkelmann, but he had distanced himself by instructing Dolphin to issue the letter. It was a futile suspension as it was never going to change Joe's opinions, behaviours or beliefs. It was ironic that the loss of earnings for Joe that resulted from the suspension paled into insignificance with the production loss that the company suffered as a result of the three-day suspension.

Throughout 1958 Joe and Kitty made their wedding plans and the wedding date was set for Easter Monday, 30 March 1959. The close working relationship between Joe and Con Dooley over the years led to a personal bond of friendship between the two men, which resulted in Con Dooley accepting Joe's request to act as his best man at his wedding. As the wedding approached, the factory had still not organised a suitable house for Joe to buy as had been promised. Noel Griffin reconfirmed his commitment and told Joe that the purchase of the house would be facilitated through the company and a local bank.

In January 1959 final plans were put in place for the wedding. The ceremony was to take place at the Holy Family Church, Ballybricken, followed by a reception to be held in the Bridge Hotel. Wedding invitations were sent to Kitty's family and friends, and likewise Joe invited many of the German glass workers from the factory and his Irish co-workers and friends. Only one invitation for the wedding was declined. Tony Galvin, his apprentice ball blower for many years, declined the invitation to the wedding for himself and his fiancé, Bonnie McCarthy. There was no malice behind the decision, it was

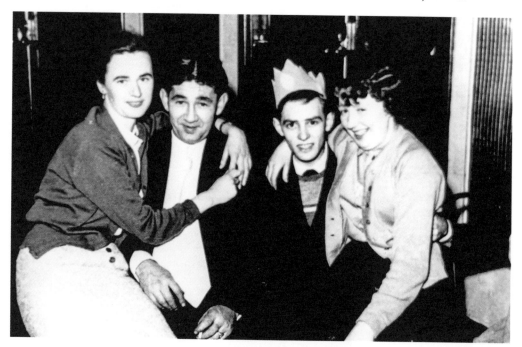

Kitty Buckley, Joe, Tony Galvin and Bonnie McCarthy

139

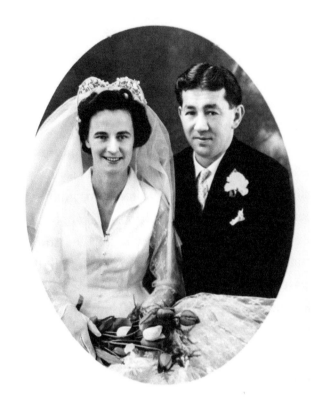

Joe and Kitty's wedding photo

purely a logistical matter. Tony and Bonnie had coincidentally organised their wedding on the same day, in the same church and both receptions were being held in the same hotel.

The Waterford News & Star newspaper reported on Joe and Kitty's wedding on 31 March:

> *The wedding took place with Nuptial Mass and Papal Blessing of the Church of the Holy Family, Ballybricken, yesterday between Mr. Joseph Cretzan, Waterford, son of the late Mr. and Mrs. Cretzan, 12 Five Alley Lane, Waterford, and Miss Catherine (Kitty) Buckley, daughter of Mr. and Mrs. James Buckley, 25 Tycor Avenue, Waterford.*

> *Rev. Fr. Mulcahy, C.C., performed the ceremony.*

> *The best man was Mr. Con Dooley, sales manager of the Waterford Glass factory and the matron of honour was Mrs. William Buckley (sister-in-law) of the bride.*

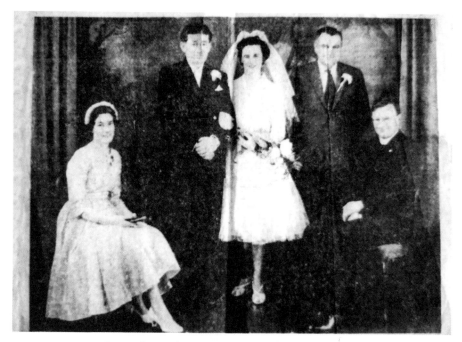

Joe and Kitty's wedding, Con Dooley best man

The bride was attired in a white ballet length frock with matching head-dress and carried a bouquet of flowers.

The matron-of-honour wore a pink ballet length frock with accessories to tone and also carried a bouquet.

Following the reception, which was held in the Bridge Hotel, Waterford, the happy couple left on their honeymoon, which is being spent in Dublin. About 30 guests attended the wedding.

The groom is employed at the Waterford Glass Factory as a glass blower, while the bride prior to the wedding was also employed in the factory.

The newspaper incorrectly names Joe's parents as Mr. and Mrs. Cretzan and refers incorrectly to them as late of 12 Five Alley Lane, Ballybricken, which was the home address of Kitty's brother, Bill Buckley. Before departing Waterford on the morning after the wedding, Joe and Kitty had breakfast in the Bridge Hotel with Tony and Bonnie Galvin. After breakfast both couples took the short walk across

Redmond bridge to Plunkett Station to Dublin for their respective honeymoons.

Following their return from honeymoon in Dublin, Joe went to live with Kitty at her parent's home at Tycor Avenue. An entry was recorded to the *Certificate of Registration* book on 16 April 1959, by Sergeant Con Crowley at Waterford Garda, recording the marriage and change of address for Joe.

> *Married to Irish National Catherine Buckley, of 25 Tycor Ave, Waterford on 30/3/59; changed residence to latter address on the 30/3/59*

At the time it was not uncommon for married couples to move in and live with their parents while they saved for a deposit for a house. However, for Joe and Kitty this was not the reason. Joe wanted Waterford Glass to honour their promise to him regarding the provision of a suitable house, and it was not long before that promise was fulfilled.

In 1959, Rudolf Mulac decided to return to West Germany with his wife and daughter. The exact reasons for his return were not clear. The content of the letter he had sent to Joe in January 1958 indicated that his wife and daughter were finding life in Ireland difficult as they longed for even the most basic everyday German foodstuffs which Mulac had asked Joe to bring back to Waterford. Waterford Glass had provided Mulac and his family with a house, a detached three-bedroom bungalow named Mount Carmel which was located in Ballytruckle. The house was used by Waterford Glass to provide housing for members of management. Bill Dolphin previously lived in the house before the Mulac family.

When Mulac informed the company that he was leaving Noel Griffin made the decision to offer the house to Joe. The offer was accepted by Joe and Kitty and arrangements were made by them to move from Tycor Avenue to Ballytruckle. For Noel Griffin the promise he had made to provide a suitable house had now been fulfilled, and for the company it meant that Joe now had his own house in Waterford.

Griffin thereby felt assured that Joe would remain in Waterford for the rest of his working life. The change of address was recorded in the *Certificate of Registration* booklet on 13 November 1959 by Sergeant Con Crowley:

> *Changed residence to 'Mount Carmel', Ballytruckle Road, Waterford on 1-11-1959*

For the first time since leaving his home in Putna almost twenty years earlier, Joe had an address that he could call home. The three-bedroomed bungalow with a garden was a dream come through for Joe and Kitty. Now they could plan their future together with the security of having their own home.

Chapter 15

Westminster Abbey Chandelier

In 1959, Joe's apprentice Seanie Cuddihy left the factory to work in England. There was now an opportunity for one of the apprentices to work as a heavy ball blower with Joe. There were very few who had significant experience of working with crystal but there was one, a teenager from Graiguenamanagh, County Kilkenny, named Bobby Mahon. Bobby had come to work at the factory in Waterford because there was little work available in rural Ireland and most young men of his generation were forced to emigrate to England or America to find employment. For Bobby the opportunity of working with Joe Cretzan was a dream come true and the experience of working directly with Joe would become a career-defining moment.

Although Joe was only responsible for his own work in the factory, Dr. Winkelmann always asked him to guide the young Irish glass blowers in the best methods for working with crystal. Gerry Cullinane, who was one of the young glass blower in Johnstown who Joe had trained, attributes everything he learned about glass blowing to Joe. Gerry recalls vividly one of the many occasions when Joe helped him.

Joe was walking through the blowing room, maybe ten metres away from where I was making a decanter, when he walked over to me. He told me the shoulder on the neck of that decanter that I was making was going to be too thin. He could see from the way I had been working the glass that there was going to be a problem with it. There wasn't enough thickness in the shoulder of the decanter, and that meant the decanter would be rejected at quality control. But

144

he didn't walk away. He stayed there and talked me through how I should work the glass and of course when I followed his instructions on the next decanter that I made, it was perfect. He made it seem so easy, but of course it wasn't like that at all, working hot molten glass is so difficult to do. He showed me everything that I know about glass making and he would always help anyone who needed help. For me he was not only the greatest glass blower I have ever seen, I would say he was the greatest craftsman I have ever seen.

One of the many high profile presentation pieces made by Joe in 1963 was the Kennedy Commemorative Cup. The New Ross Harbour Commissioners asked Waterford Glass to create a special piece to be presented to President John F. Kennedy after his speech on the quayside in New Ross, County Wexford, on 27 June 1963. The Kennedy Commemorative Cup had four engraved panels depicting the Kennedy homestead at Dunganstown, the White House, an immigrant ship of the type that President Kennedy's great grandfather had sailed in from New Ross and the New Ross coat of arms. The 19-inch-high cup is a superb example of Joe's work illustrating his skills as a glass blower, foot maker, and centrepiece master. Today, the Kennedy Commemorative Cup is on display at the John F. Kennedy Presidential Library and Museum in Boston.

As technical director at Waterford Glass, Dr. Winkelmann coordinated every aspect of production and, as such, he wanted to

Photograph courtesy of the John F. Kennedy Presidential Library & Museum. Photography credit, Joel Benjamin

Kennedy Commemorative Cup

utilise every resource and skill that was available to him. He would regularly call Joe to his office to discuss new ideas that he had for production. During the summer holiday shutdown periods he asked Joe to work through the scheduled holiday period and defer his holidays until late summer or earlier autumn. The reason he wanted him to work then was that it was the only time he could provide Joe with two full pots of crystal, one in the morning and another for the afternoon. The physical effort required to empty two pots of glass every day over a three-week period was huge, but Joe never complained as he was always at his happiest when making glass. His effort didn't go unrewarded as his wages doubled during that holiday period. Despite their disputes and grievances in the past, Dr. Winkelmann always paid him a substantial bonus in recognition for his cooperation in working during the holidays. Initially, Bobby Mahon didn't receive any additional bonus payment as he was only the apprentice in the shop, however Joe intervened and told Dr. Winkelmann that both Bobby and Jimmy Kinsella were part of his team and that if they didn't receive the additional bonus payment he wouldn't work the holiday period again. Both Bobby and Jimmy received the bonus payment.

In 1965 the Guinness family commissioned Waterford Glass to create sixteen chandeliers to mark the 900th anniversary of the foundation of Westminster Abbey. Because of the significance of the commission, the production of the chandeliers was managed directly by Dr. Winkelmann. To ensure that the chandeliers were made to the highest standard, Joe was asked to make them. Each of the individual sixteen chandeliers was made up of almost 500 pieces which when assembled were ten feet in height and three feet wide. The chandeliers were hung in the central nave and in each of the four transepts of the Abbey. They are regarded as one of the most prestigious lighting-ware projects ever completed by Waterford Glass. The Westminster chandelier project was significant from a personal perspective for Joe because it was the last project that he and Dr. Winkelmann worked on together.

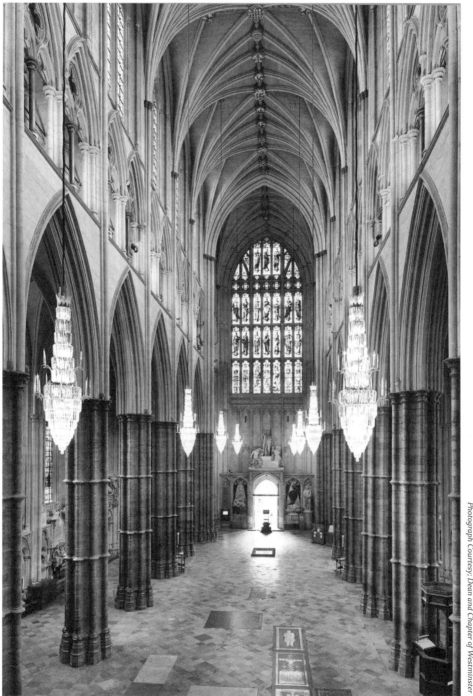

Nave looking west, Westminster Abbey

Photograph Courtesy: Dean and Chapter of Westminster

During the summer shutdown of the factory in 1965, Dr. Winkelmann managed the maintenance program that was undertaken in the factory and worked with Joe on his production schedule for that two-week period. When the factory reopened and production returned to normal, Dr. Winkelmann took his holiday leave. A keen and experienced sailor, his yacht *Iolanthe* was berthed at Dunmore East. Dr. Winkelmann had planned to sail the yacht from Dunmore East to Baltimore in County Cork, where maintenance work was scheduled to be carried out on it over the winter months. In mid-September he set sail from Dunmore East and berthed in Kinsale overnight from where he then set sail on the final leg of the journey to Baltimore. He never reached Baltimore and, after several days of no contact, concerns were raised for his safety, as a series of heavy storms had battered the Cork coastline.

For the management and workers at the factory the news that Dr. Winkelmann had been reported missing while at sea raised concerns, and after two weeks of no contact it was presumed that he had been lost at sea. Fears of his demise were confirmed when on Wednesday, 29 September, a body discovered by a fishing vessel off the Cork coast

*Apprentice Joe Williams, Charles J. Haughey and
Dr Winkelmann in the blowing room*

was identified as that of Dr. Winkelmann. The news of his death was communicated to all workers in the factory and was reported upon in the national newspapers on 1 October 1965.

Director's body found at sea

Gardai at Kinsale were not worried two weeks ago when they discovered a car owned by Dr. Hans Winkelamnn, 41-year-old technical director of Waterford Glass. For they knew that he was on a two-week holiday and that he was a keen yachtsman.

But the body discovered by a Skibbereen trawler crew a few miles off Baltimore on Wednesday has now been identified as Dr. Winkelmann's. Gardai have discovered that he had sailed his yacht from Dunmore East to Kinsale and had planned to lay it up for the winter in Baltimore. It is thought that his boat may have overturned in one of the heavy gales on the coast during the past fortnight. Dr. Winkelmann came to Ireland from Belgium in 1932 and has been attached to Waterford Glass since 1953. He is survived by his wife and son. His father, Franz Winkelmann, is a retired joint managing director of the Irish Glass Bottle Company.

Following his funeral mass at Saint Finian's Lutheran Church in Dublin, Dr. Winkelmann was buried in Deansgrange cemetery on 2 October 1965. He was survived by his wife Niamh, his son Karl, his parents Franz and Anna and his brother Franz.

Dr. Winkelmann's death was deeply lamented by the workers and management in the factory. Although he rarely conversed with the workers on the factory floor, his leadership, commitment and dedication to the company were recognised by all, and his technical understanding of glass production was unparalleled. Joe's relationship with him had been tense and difficult at times, and their personalities clashed, however they had a deep mutual respect for each other. The two men shared much in common and their glass making careers were influenced by their respective fathers, both of whom had worked in the European glass industry. During the 1920s, the Winkelmann family lived in the city of Aussig in northern Bohemia

(renamed Ústí nad Labem after the Second World War) which is where Hans Winkelmann was born in 1924. The family moved to Belgium in the late 1920s before arriving in Ireland in 1932 where Franz Winkelmann, a glass engineer by profession, went on to become a director at Irish Glass Bottle Company and Waterford Glass.

Waterford Glass now faced the challenge of finding a suitable replacement for Dr. Winkelmann, but they were unsuccessful in finding a candidate with his technical knowledge and experience. The company instead made several internal appointments from its existing staff to cover the roles that Dr. Winkelmann had carried out. Within a period of months there was a change in management's approach to glass blowing. The new approach now focused solely on production capacity and output. There was little interest in the philosophy that had been in place to further develop the skills of the Irish workers, which was of deep concern to Joe. For Joe, this introduced a threat for the future development of glass blowing in the factory, and it was a fundamental change from the approach led by Dr. Winkelmann whereby the opinion of the most experienced glass makers in the factory had always been sought, considered and appreciated.

Chapter 16

Commission for Jacqueline Kennedy

On 30 November 1965, Joe's *Certificate of Registration* booklet, which had been issued to him on the 14 November 1951, had its final entry made by Superintendent J.P. McMahon. The handwritten entry stated:

> *The alien is permitted to reside in Ireland without condition at this time.*

In total, twenty-four entries were recorded in the *Certificate of Registration* booklet and all were made by or on behalf of the regional Garda Superintendent, as required under the Aliens Order Act 1946. No endorsements were recorded in the booklet over the fourteen-year period. Although he was now legally permitted to remain in Ireland without condition by the Department of Justice, he never pursued the option of applying for an Irish passport or citizenship. He decided instead to maintain his citizenship of the Federal Republic of Germany.

Joe and Kitty never had children of their own, but did adopt two children, the first of whom, David, was adopted on St. Patrick's Day 1967. The arrival of a baby boy into their lives fulfilled their wish to start a family of their own and provided some focus and meaning. In keeping with tradition, Bridie Buckley and Con Dooley, who acted as matron of honour and the best man at Joe and Kitty's wedding, stood as godparents for David.

During the summer of 1967, Jacqueline Kennedy was holi-daying in Waterford with her two children, Caroline and John, at

Woodstown House. While walking back to his car after a day's fishing in Woodstown, Joe accidentally met Jacqueline while she was taking an afternoon walk. Joe greeted her with a handshake and introduced himself. Jacqueline commented on his unusual accent and a conversation began about Joe's past and how he had come to work at the glass factory in Waterford. She spoke with him for over ten minutes, fascinated by his life story and the circumstances that led to him coming to live in Ireland. When their conversation ended, she wished Joe and his family the very best for their future.

The following Monday Joe went to work telling his friends about his conversation with Jacqueline Kennedy in Woodstown. After the morning tea break a large group of people arrived into the blowing room including security personnel from the factory, company directors and members of the Garda Siochána. Nobody had said anything to Joe about what was happening, however workers were told to move to certain areas in the blowing room and a clear pathway was set up directly to where Joe was working. Then through the crowd which had gathered, Jacqueline Kennedy appeared. As she was guided towards Joe's shop she immediately recognised him and walked straight towards him and said, 'it's you Joe, it's so good to see you again'.

The directors of the company, who were about to explain the process of glass making to her, stood open mouthed in disbelief as Jacqueline extended her hand out to Josef. Jacqueline then watched in fascination as he worked with the molten crystal. Before leaving the blowing room she asked Joe if he could make something special for her children, Caroline and John, and he said he would make a fish and basket for them. Jacqueline was delighted and one of the company directors said that Waterford Glass would arrange to have the fish and basket delivered to her home address in America.

The fish and basket were made later that day, flown to New York and delivered by courier to her penthouse apartment on Fifth Avenue. Although Jacqueline and her children were still holidaying in Ireland, her New York-based staff informed her that the fish and basket had

Jacqueline Kennedy
(postage & fees Paid)

AIR MAIL

Mr. Joseph Cretzan
Fairy Hill
Waterford,
Ireland

MRS. JOHN F. KENNEDY

June 30, 1967

Dear Mr. Cretzan:

Mrs. Kennedy has asked me to write express-
ing her deep appreciation for your thoughtful-
ness in sending Caroline and John the lovely
fish and basket which you made specially for
them.

She would like you to know that both her children
are so pleased to have such special presents and
that the fish and basket will serve as constant
reminders of the happy days spent in Ireland.

Along with her gratitude, Mrs. Kennedy sends
you her very best wishes.

Sincerely,

Nancy Tuckerman

Nancy Tuckerman
(secretary to Mrs. Kennedy)

Mr. Joseph Cretzan
Fairy Hill
Waterford, Ireland

Envelope (top) and letter sent on behalf of Jacqueline Kennedy

arrived. Jacqueline immediately contacted her personal secretary, Nancy Tuckerman, and asked her to write a letter of acknowledgement to Joe thanking him personally. On the 30 of June the letter was posted by air mail from New York.

It was almost sixteen years since Joe had arrived in Waterford and many of the Irish glass blowers had developed into master glass blowers in their own right. The skills that Joe possessed had been handed down to the workers in the blowing room and they could now make all of the items required for production. With this in mind, Joe was asked to join the management team so his experience could be used in a management capacity. From the company's perspective, it meant that he would have greater flexibility and time to help those blowers who needed it, and of course when required he could always be called upon to make any samples or special pieces as needed. There was much to consider as he had a deep loyalty to those working with him, including Bobby Mahon but also Jimmy Kinsella, who was the general operator in his shop. After several weeks of consideration, Joe accepted and was appointed to the position of blowing room supervisor.

Bobby Mahon, who had worked directly with Joe for eight years, a longer period than any other individual blower, took over the role as heavy blower and master of the shop. Bobby was the natural choice for the position as he had worked closely with Joe and he had learned greatly from that experience. That knowledge, combined with his own ambition to succeed, ensured his success in the role of master of the centrepiece shop.

The influx of apprentices into the factory that started in the early 1960s required further training to develop their skills in specific areas. As well as having to manage the blowing room, Joe had to teach blowers such as Joe Williams, Dick Evans and George 'Saoirse' Morrissey the skill of jug-making. It wasn't a difficult task for him because of their willingness to listen to his instructions and watch him as he demonstrated how a jug was made. The apprentices who went on to become blowers and jug-makers had learned the basic skills by taking

advantage of an old tradition in the craft, whereby the master of the shop would leave the last ball or jug before each break for the apprentice to gather on, or in the case of jug-making, to form the spout and handle. This informal system of progression had produced a crop of talented glass blowers in the factory. Alas, this century-old tradition in glass blowing came to an end in Waterford Glass when it was replaced by the seniority system, negotiated between management and the trade union.

The seniority system allowed for any glass maker to apply for a position in the blowing room, however the appointment was based on years of service within the blowing section and took no consideration of an individual's ability, skill, aptitude or experience. Joe's opinion on the introduction of the seniority system into the blowing room was never sought by the management team who had negotiated it. For Joe, the seniority principle was fundamentally wrong for two reasons: it allowed blowers to take up positions for which they were unsuitable, but more significantly, it discarded the most talented younger blowers who had the ambition and potential to become masters of their craft. The seniority system never allowed them to reach their potential in a timely manner and, in many cases, never at all.

In 1970 Joe and Kitty adopted their second child, a baby girl. With her arrival they now felt that they had a complete family. They decided to name their daughter Christine after Joe's sister, who was still living in East Germany and whom he had not seen since 1950. Of his three remaining siblings he thought most often about Christine and worried about her wellbeing living under the restrictions of communist rule. Throughout the 1960s he had returned to West Germany several times and stayed with Aurelian and his family, but he was never able to make contact with Christine. There was a facility to apply for an entry visa to visit East Germany, but he chose not to because in many cases persons who travelled into East Germany were detained when they tried to leave, and this was a risk he wasn't prepared to take.

Joe with children David and Christine

In contrast, his younger brother Mirtscha had decided that he wanted no contact with any of his siblings including Joe. His decision seemed bizarre, particularly in relation to his stance with Joe, since during their teenage years while living with their father in East Germany, it was Joe who sent the weekly parcels of food that kept them alive during the bleakest years of communist rule in the late 1940s. It may have been understandable that as a teenager he never fully understood what Joe had done for him, but as a middle-aged man it was regrettable that he never acknowledged what Joe had done and chose to turn his back on him completely.

During his holidays in Limburg an der Lahn, Joe would always arrange to meet with his former work colleagues and friends in the restaurants and bars in the old town of the city. When he met his friends they spoke mainly about glass making and new procedures

they had developed in their factory. One of those new procedures was a method they had introduced for removing the excess glass, known as the cap, from a piece of heavy glass. A German company had developed a mechanical saw that allowed the cap to be cut straight off, using only water as a coolant. This method had replaced the old traditional system of using a diamond wheel and a gas flame to remove the glass cap. Joe visited the factory to see how the saw was used. His friend removed the manufacturer's label from the saw and gave it to him, telling him that he could contact the company directly using the information on the label if he thought it might work at Waterford Glass. Before leaving the factory he went to the blowing room to meet all his former colleagues he had worked with twenty years earlier. The tradition of beer drinking while glass blowing was still preserved, and while Joe enjoyed a bottle of beer his friends put together a collection of colour glass sticks and cups for him to bring back to Waterford. All the colour items that he made in Waterford came from the coloured glass that he sourced from the factory in Limburg an der Lahn.

By the early 1970s, the early Irish apprentices had established themselves as highly skilled glass blowers who could now make anything from a tumbler to a chandelier. Their commitment to their craft was unquestionable. The first generation of glass blowers had given their sweat and blood for the company, and that commitment was acknowledged through the excellent terms and conditions that they enjoyed. In 1965, the company began construction on a new factory at Kilbarry on the outskirts of the city. The factory was designed and built specifically for glass production. No other department in the factory benefited more in terms of the improvement of working conditions than the blowing department. The new factory provided the blowing rooms with raised ceilings, high velocity fans, natural light and proper welfare facilities which included shower rooms, all of which was in stark contrast to the conditions that the workers had endured in the Johnstown factory for over twenty years.

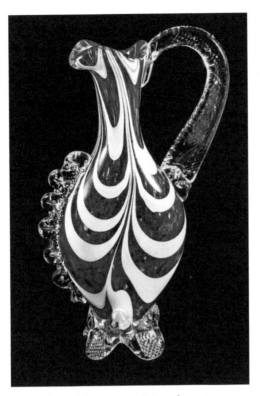

Blue with white striping decanter

The closure of the Johnstown factory brought an end to soda glass production and the Kilbarry factory, which had eight multi-pot furnaces, produced lead crystal only. The increased capacity contributed to another surge in apprentices joining the factory and, as a result, a training school was established. The school was set up not only to train the new apprentices, but also to train the existing blowers in the factory who now needed additional training. The cessation of soda glass production required all the soda blowers to transfer to crystal production. The skill levels required for working with crystal were much greater, so a training programme was put in place to give every soda blower the opportunity to re-train for crystal production. The commencement of the training school also introduced a formalised system of training for glass blowers for the very first time.

One of the apprentices who progressed through the system was Ray Cullinane. Ray started in the blowing room in 1962. Within a period of two years he was working as a blower on crystal making tumblers and stoppers, following in the footsteps of his older brother Gerry. Ray went on to become a heavy blower in the 1970s and eventually reached the pinnacle of the craft when he became master of the centre piece shop, featuring in many of the company's promotional videos during the 1980s and 1990s, including the acclaimed video, *Story of Waterford Crystal.* When he reflects on his career of over thirty-three years as a glass maker, he emphatically acknowledges that Joe Cretzan was the most important and influential individual.

On the very first day that I started work in the factory I still remember that I couldn't stop watching Joe blowing glass. He came over to and asked me why I was I watching him so much and I told him it was because I admired the way he worked with glass. All through my career he showed me how to make everything, he always helped me, and he believed in me because he knew I wanted to learn everything that he knew. It was his direct input that resulted in me becoming master of the centrepiece shop, and of course he taught me how to make everything including claret jugs and decanters, turn-over bowls and tripods. I admired him greatly in every way, both as a craftsman but also as a person.

Throughout the 1960s there was a continuous stream of new supervisors, engineers and managers who had come to work in the blowing room. They possessed a range of educational qualifications, but they had no knowledge of the glass making industry and no appreciation or understanding for the craft of glass blowing. Their sole purpose was to maximise output at any cost. In a haze of management blindness, they organised research and development trips to West Germany where they hoped to identify new production methods that would enhance production at the factory.

As far as Joe was concerned the organised trips to West Germany were a complete waste of time. The individuals who travelled included blowing room management, union shop stewards and individually handpicked glass blowers. No one who travelled to West Germany had any knowledge of the glass industry in Europe and none could speak German. The glass factories that they visited never shared any information on their glass making processes or techniques, and those who travelled never had the ability to identify anything of any relevance during the visits to the factories. Ironically, Joe and Max Göstl were never asked to go on any of the trips despite being masters of the German glass industry. Their exclusion wasn't accidental. It was a deliberate decision by management to exclude them because they knew that in their presence their incompetency would be exposed.

*Top: St Patrick's Day 1965 piece presented by Irish Ambassador
to President Lyndon Johnson. Above: Coloured basket*

The research trips to European glass factories continued for many years but they never resulted in a single change to the glass making production techniques that had been introduced by Joe and Max in the early 1950s. The disregard that was shown for the expertise of the pioneering foreign glass blowers was in stark contrast to the trust held by the original founding directors of the company.

Some of the finest and most elaborate examples of Joe's work were the non-production pieces that included fish, horses, paperweights and baskets, which he usually made in the late afternoon when all the blowers had gone home. There was a small group of blowers, including Michael Connolly and Dick Hannigan, who helped him make the pieces and they would follow his exact instructions on what he needed them to do. They would usually gather the small amounts of glass that were used to decorate the handles on the baskets or to make the bridle, saddle or stirrups for the horses. The skills involved in the making of those pieces originated from the factory in Putna where he was mentored in the most elaborate glass making techniques.

Joe with apprentice Michael Connolly preparing to make coloured fish

Undoubtedly the most sought after piece that he made was the coloured basket, which required every aspect of the glass maker's skills to be used. Over the years as many as three hundred baskets were made by Joe and they were mainly given to workers in the blowing room, often on the occasion of their weddings. Less frequently baskets without any colour were made. These were smaller in size and more refined in their

intricacies, in particular the detail of the decoration along the handle of the basket, which was pinched and squeezed when the glass was very hot, resulting in remarkable indentation detail running along each side of the handle. A small gather of molten glass was placed on the highest part of every handle and a small decorative feature was then created. Some of the workers who assisted Joe in making the baskets tried themselves on many occasions to replicate the baskets he made, however they were never successful. One of those blowers who did get a basket was John Sinnott, and for John the basket is his most valued piece of Waterford Glass.

I have centrepieces, lamps and ceiling fixtures in my house but the only piece of glass that I value is the basket made by Joe. Only those who saw a basket being made will appreciate the skill that goes into making one. The biggest trophies and chandeliers made in the factory can be replaced, but a Joe Cretzan basket is irreplaceable. The amount of work that goes into making a basket is incredible. Each basket was made free hand, no mould was used. He made the body of the basket and then his apprentice dropped a gather of glass onto the base to form the four feet. He stuck the punti onto the base and then cracked off the blowing iron. The weight of the basket on the end of the iron made it difficult to control but he played with it in the gloryhole and on the chair as if it was weight-less. He then had to make the coloured handle with the correct thickness to match the basket and then he had to attach it evenly to the basket before he eventually decorated the handle pinching the hot glass that was dropped onto the handle. There was never a piece of glass produced in the blowing room by any other blower that required so much skill. You can take away all the glass that I have in my house, every piece, it doesn't mean anything to me, but you will never take that basket from me.

The European glass workers had assimilated themselves into the Irish way of life, some more so than others, but they had never forgotten their homelands and in many cases the families they had left behind. For most it was possible to return to their native countries on occasion and reunite with families and friends. However, for Joe

Crystal basket

and Miroslav Havel that option did not exist as their home countries, Romania and Czechoslovakia, were under communist rule since the end of the Second World War. Neither held citizenship of their respective countries and there was no process available for them to apply for citizenship of the countries where they were born. Both men shared more than their passion for glass, both were exiles from their places of birth. Almost every day Joe would meet with Havel in his small office and they would sit together smoking cigarettes, often recalling their childhoods and their early years training in the glass industry. Havel always brought his glass designs and production ideas to Joe for his opinions on how they could be best produced in the blowing room. By the 1970s, their collaborative work had produced a vast array of handmade crystal products that had established Waterford Glass as the premium handmade crystal producer in the world. Despite the fact that he was no longer a production worker, Joe continued to make many of Havel's special commission and design pieces.

Chapter 17

Tragedy Strikes

In June 1977, Joe suffered a heart attack while working in the blowing room, primarily as a result of the stress and demands of his job. He was hospitalised, made a full recovery and was released from hospital under the care of Dr. Tom Keogh, Waterford Crystal's occupational health advisor. Dr Keogh told him to take several weeks off work and advised him to take a family holiday to help recuperate. Joe reflected on his general health and the demands of his job. He deeply regretted his move from production into management for several reasons. If he had remained in glass blowing, he would have maintained his special average payment which guaranteed him a premium payment every week, while working between ten to fifteen hours less. He would have had no responsibility in relation to the day-to-day management of the blowing room and the added pressure of training blowers who always came to him for help. But his greatest anxiety was for the future of glass blowing in Waterford under the direction of the management team because they were making decisions that he believed would in time lead to the death of the craft in Waterford.

In July, Joe travelled to Limburg an der Lahn for a family holiday with Kitty and their two children. It was his first time there for almost ten years and it was the first time that he brought Kitty and his children with him. During the two-week holiday the family relaxed while staying with Aurelian and his family at their family home. On a personal level Joe wanted to meet with his younger brother Mirtscha who hadn't spoken to him for almost thirty years. Aurelian had no contact

with Mirtscha despite the fact that they both worked as glass blowers in the same factory. Aurelian made contact with Mirtscha and told him that Joe wanted to meet with him. Mirtscha agreed and arrangements were made for them to meet in the town of Bad Schwalbach near Weisbaden. When they met Joe asked Mirtscha why he was isolating himself from his family. As the youngest child everybody had helped him in the past and Joe reminded him of what he had done for him when he was living in East Germany and how he had smuggled money to him that allowed him to cross the border and escape. It was clear that Mirtscha had no desire to rekindle the relationship with his family and, after less than thirty minutes together, their meeting ended. As Joe left the room he felt disappointed but not surprised by Mirtscha's decision. It was the last time the brothers were to be in each other's company.

As the end of the holiday approached Joe and Aurelian would sit together every evening on the patio sipping beer and smoking cigarettes, reflecting on their childhood years in Putna, their service in the German Army during the war and their glass making careers. They spoke a lot about Christine's family in East Germany and they wondered about their wellbeing as they had little contact with them. They discussed their own plans and wishes for the future. For Joe his greatest wish was to return to Putna with his children to show them the village where he was born, but he was resigned to the fact that it would never become a reality. On the last night of the holiday, Joe's nephew Peter and niece Gabi arrived at Aurelian's house along with their families. They celebrated through the night the meeting of the family members for the first time.

On their return to Waterford there was still a week remaining before the factory reopened. Making the most of the remaining holiday time Joe and Kitty went out every night to play cards in the pubs they frequented in Tramore and Dunhill. While playing cards in Tramore on Thursday, 9 August, Kitty felt unwell and asked Joe to bring her home. She believed that tiredness related to their holiday

was responsible for why she felt so unwell. However, her condition deteriorated and she was admitted to hospital in the early hours of the morning.

The following day Joe and the children visited Kitty and she spoke to the children as they sat beside her on the bed. She told Joe to bring them out to Tramore for the afternoon. She didn't want the children to be upset over the fact that she was in hospital and felt that an afternoon at the seaside would distract them. Joe took the children to Tramore and they spent time playing on the amusements before going to the beach. When they returned to the house later that evening a group of friends and neighbours had gathered outside waiting for Joe. As soon as he got out of the car they told him that he was to go to the hospital immediately as Kitty's condition had deteriorated. The children were taken to Kitty's sister-in-law Bridie Buckley in Ballybricken. They stayed there with their cousins to allow Joe to go straight to the hospital with Bridie. At the hospital the doctors told Joe that Kitty was in critical condition. Later that night she suffered a cardiac arrest and died. She was forty-five years old.

The following morning when the children awoke Joe had to tell them that their mother had died. He could not hide his grief despite his best effort, and he held his children as they cried uncontrollably in his arms. At fifty-four years of age the tragedy of the unexpected death of his second wife was compounded by the fact that he now had the sole responsibility to raise his two young children. The days and weeks following Kitty's death were most difficult and plans had to be put in place to get the children to school every morning when Joe returned to work. Noel Griffin told him not to return until he was ready to do so, and not before suitable arrangements had been put in place regarding the care of his children. Family, friends, neighbours and work colleagues helped in every way possible, particularly his sister-in law Bridie Buckley, who comforted the children in every way possible in the immediate aftermath of their mother's death and for many years after.

Joe had no idea how he would be able to guide David and Christine through the emotional challenges that they would experience as a result of their mother's death at such a young age. He had to face the challenges as they arose, and he did everything to support and protect the children over the following weeks and years as they finished in primary school and moved on to secondary education. It would have been an easy option to bring David into the factory as an apprentice glass blower, just as his father had done with him following the death of his own mother, but he was adamant that he would give him every opportunity to finish his secondary education and go to university to get a professional qualification. Although he had received very little formal education himself, Joe understood fully the value and importance of education for his children's future.

As the children returned to school in September it was difficult managing the house, looking after the children's needs and then supervising the blowing room with all the extra demands that were placed on him. When he finished work every afternoon, he went straight home to prepare and organise everything that needed to be done in the house and for the children. As the months passed by and Christmas approached the children had slowly adapted to life without their mother. Not wanting to break with Christmas morning tradition, Joe called to the Göstl and Berger families with the children. The German families supported Joe in every way they could and ensured that the Christmas morning tradition was never lost because it was a day to celebrate their German heritage and culture.

Joe's contact with his sister had been infrequent and all letters to and from East Germany were screened by the police authorities there. On 29 August 1979 he received a telegram from Christine's husband, Edwin Schulz:

Christine is dead. Funeral 3.9.79 at 14.45

From 2.9. until 4.9.79. you are entitled to a visa for entry to the German Democratic Republic using public transport.

Peoples' Police Regional Office

Christine had died on 28 August. At the request of Edwin, the East German police authorities issued an entry visa allowing Joe to enter East Germany from 2 September to 4 September 1979 to attend Christine's funeral. The news of the death of his sister was unexpected and although he had not seen her since their father's funeral in 1950, his emotional bond with her had never been broken. He wanted to attend her funeral, but the risks associated with travelling into East Germany were too high because people who crossed the border could be detained for questioning for an indefinite period. Reluctantly, he made the decision not to travel to her funeral.

In October 1979, he received a letter form Edwin detailing the background and official cause of Christine's death. The content of the letter gave an insight into the emotional distress that she had suffered for years under the rigours of communist rule, including her disappointment at Joe never returning to East Germany to meet with her, her unfulfilled wish to revisit her birthplace of Putna one last time, and the compulsory conscription of her son, Georg, into the East German Army.

October 25th, 1979

Dear Josef and family,

Today I would like to thank you for your telegram of condolences, also on behalf of the children Renate and Georg. We also thank you for the flowers sent by Fleurop. We used the flowers to adorn the resting place.

I enclose a copy of the death and thank you notice, which we inserted (in the newspaper), also with your agreement we hope.

As you well knew, Christine had been ill for many years. Due to her heart ailment, she was receiving constant medical treatment. Therefore, she had not been able to do any heavy jobs for some time. Due to pains in the abdomen, Christine had to be admitted to the hospital in Ilmenau. The treatment and results led to her admission to the Women's Clinic of the Medical Academy in Erfurt for in-patient treatment. She could not be operated on. From 27th Feb.

to 4thMay 1979 she received at total of 40 radiation treatments. All our hopes for recovery were in vain despite good care. Everything was too late, and she could not recover. The death certificate states uterine cancer.

Christine loved you very much, she could not understand that you didn't visit her even once. Her greatest wish was to travel to Putna one more time. I would have loved to grant her that wish, but because of her severe illness it was not possible to undertake this journey.

All this time I was alone in the flat. Georg is now coming home as his service with the NVA Nationale Volksarmee, (National Army) is finished, I am very happy about that.

Best wishes

Edwin and children

Shortly after Christine's death Max Göstl was diagnosed with leukaemia and despite all medical interventions he succumbed to his illness on 4 June 1981. He was seventy-one years old. In later years during conversations about the factory and its foreign workers, Joe always remembered the contribution and influence that Max had made to stemware glass blowing in Waterford. Wiping tears from his eyes on many occasions he recalled that Max was the only person out-

Max Göstl and Joe

side his direct family for whom he had shed tears, such was the bond of friendship that had developed between the two men.

Chapter 18

A Bond of Friendship

During the summer of 1984, while having a drink at the bar in the Granville Hotel in Waterford, three generations of an American family holidaying in Ireland sat at the table beside Joe. A conversation began and the American family explained that they had come to Waterford to take a tour of the glass factory. Recognising that Joe's accent was not Irish the family asked him where he was from, and so the story of his connection to Waterford Crystal was revealed.[3] When Joe mentioned his involvement in the Second World War it brought an immediate reaction from one of the American visitors, Bradford Evans, who had been a pilot with the American Air Force flying a B-17 bomber on bombing missions across Europe. It soon became apparent that both men shared much in common and although they fought on opposing sides during the war, there was no resentment or animosity between them.

At the insistence of Evans, Joe returned to the Granville Hotel that evening for a meal and a chat about their involvement in the war. Both had fought at one of the most disputed events of World War II, the bombing of the Benedictine Abbey of Monte Cassino in Italy. Evans informed Joe that he was the mission leader of the thirty-seven B-17

[3] In 1981 Waterford Glass was converted into a holding company, Waterford Glass Group Limited and Waterford Crystal became a separate company within the group. Waterford Glass and Waterford Crystal were interchangeable names to describe the product since 1950, from 1982 the product was referred to as Waterford Crystal.

bombers and that he led the mission in his plane, Bomber 666, which dropped its bombs on to the Abbey, destroying it completely. Joe, who was part of the German forces based in Monte Cassino under General Frido von Segner, was returning gunfire at the American bombers as they flew over. Evans was a contributor to a book about the bombing of the Benedictine Abbey and he promised Joe that he would send him a copy as soon as he returned to America. True to his word, the book arrived at Joe's house four weeks later. Written by David Hapgood and David Richardson, *Monte Cassino: At Last the Full Story Behind One of World War II's Most Disputed Events* gave an in-depth account of the destruction of the Abbey at Monte Cassino. The inside page of the book contained a personalised handwritten note to Joe from Evans:

> *To Joe Cretzan,*
>
> *On February 15, 1944 there we were just 17,000 feet apart. So close yet so far caused by a cruel war. Now, as a result of the beauty of Waterford Crystal and an evening meal, a bond of friendship, one which I hope will long endure.*
>
> > *Bradford Evans*
>
> *July 17, 1984*

Throughout his lifetime Joe often talked about his involvement in the war and the occasion of his enrolment into the German Army in the city of Erfurt where he was given bars of chocolate to welcome him into the army. For many Waterford people he was the only person they had met personally who had fought in the war. His stories gave them an insight into the reality of war, but he never discussed the war in detail because he believed that only those who lived through it could understand what war really meant. The meeting with Evans and the friendship created between the former adversaries reinforced his belief, as the men had the utmost respect for each other despite the fact that they were once deadly enemies.

In 1984, David completed his Leaving Certificate and went to study in college in Dublin. However, by Christmas 1984, he decided

that he didn't want to pursue his studies and intended to find a job in Waterford. The only realistic option open to him was to join the factory, and in 1985 he became an apprentice in the blowing room, much to Joe's disappointment. He told David that he accepted his decision to become a glass blower but his regret was that he didn't make that decision several years earlier. If he had, Joe could have had a direct input into his training. He told David, 'everything that I know about glass making I could have passed on to you, I would have shown you everything, everything that I know about how to make glass. But it's too late for that now, the system in the factory would never allow it, and I'm too old for all of that now'.

As David started in the factory Joe was comforted in the belief that he would have a job for life there and he could watch over him as he learned the craft. At this time his health began to deteriorate, and his doctor felt that he was at risk of another heart attack due to hypertension. Joe was told to step back from work and take some time away from the blowing room. He was sixty-one years of age. During his time off work he had time for himself that he never had before. Every weekend he met with his friends in the pubs and enjoyed a few drinks without having the pressure or responsibility that work had placed on him for all the years beforehand. On Sunday nights he played cards with Paddy 'Biro' White who was the blowing room supervisor in the stemware section in K1 blowing. Biro told Joe about everything that was happening in the blowing room and he pleaded with him to stay out of work for as long as he could for his own benefit because he had given more than enough service to the factory. He did return to work several months later but only on a casual basis.

After the Whit weekend holiday break in June 1987, Joe walked into the blowing room on the Monday morning shortly after 7.00 a.m. As he made his way towards the training school he stopped in disbelief at what he witnessed. A supervisor was skimming the pots of molten glass, but not in the way that it had been done for almost forty years. Wearing a three-quarter length brown coat, a tinted full-face

visor, full length foil arm coverings and gloves, the supervisor was pulling scoops of molten glass from the pot using a metal ladle. It was supposed to be glass skimming, but it was anything but that. It contradicted everything that glass skimming was meant to be – the precise removal of surface impurities from the molten glass that had formed during the melting phase while causing minimum disruption to the molten glass. In disbelief he watched and remembered how Max Göstl had skimmed the pots for years on that same furnace. It was a defining moment for Joe. That single event crystallised years of frustration and it occurred to him that his time with Waterford Glass had come to an end. At 9.30 a.m. that morning he left the blowing room for the last time as an employee of the company. As he walked out the doors, he knew that he would not be returning. But there was no sadness in that decision; ironically, he felt relief for the first time in many years. His years of frustration at the mis-management of glass blowing in the factory were not his concern anymore.

The rationalisation programme that was introduced in 1987 provided a generous financial package that was designed to entice as many craft workers as possible to leave the company. For Joe, the package on offer had come at the perfect time. The culmination of his frustrations working in the factory along with the gradual decline in his own health reinforced his decision to retire. Over several weeks he finalised the details of his pension package before eventually signing up to the offer. On the day he signed his retirement papers he asked David to go with him when he was signing the contract. After doing so he went to the main office block where he took the elevator to the top floor to the office of the general manager, Billy Power. Billy had worked in the Johnstown factory and knew Joe from his time working as a clerk in the finishing department during the 1950s. It was Billy's job during the 1950s to calculate Joe's earnings based on the quantity of his work that had passed quality control checks. Billy congratulated him on his decision to retire and asked him if there was anything he could do for him.

Joe said,

I want a chandelier from the factory as my retirement present.

Billy shook his head and said he couldn't do that because, if he did, everybody would want a chandelier. He said the company would be presenting all retirees with an inscribed footed bowl as a retirement gift. There was silence in the room for a minute as Billy waited for a response.

Do you think that I am the same as all the others who are retiring here? You know who trained the blowers here, you know who made all those special pieces that went out to America every year, you know who it was Billy. Do you think I deserve a footed bowl as a retirement present?

Billy knew that every word Joe had spoken was true. He turned to David and told him go downstairs to the showrooms and pick out whatever chandelier you want for your father and come straight back up and tell me which one you chose. Within minutes David had returned to the office and two days later the chandelier was delivered to Joe's house. His contribution to glass blowing at Waterford Glass had been recognised in a small, but nevertheless important, way by Billy Power.

Chapter 19

The End of a Remarkable Life

With retirement Joe finally had the time he needed to do all the things he enjoyed most. He spent hours every day working in his garden where he would later sit and relax, often deep in thought. He remembered all the significant events from his past, his training as a glass maker in the factory in Putna, the death of his mother and the civil unrest in Romania that he had experienced as a young child. The war, and his survival of that war, had the greatest impact on his life. He remembered in particular his time on the Eastern Front in Russia, where he fought on the front line in the cities of Leningrad, Minsk, Smolensk, Gomel, Oryol and Vyazma. He was one of only thirteen soldiers from his regiment who survived that campaign, over 487 were killed there, all young men, many were friends of his. His military service had brought him across Europe and finally to North Africa, where he served with the Desert Corps under Field Marshall Erwin Rommel at Tobruk in Libya. In a speech given by Rommel near Tobruk he often quoted the advice he gave to the young German soldiers on that day:

Joe in his Desert Corp uniform

> *Young soldiers, listen to my advice carefully, mind your own cross, not the Iron Cross.*

Josef, third from left, with Regiment Captain and fellow soldiers, 1944

The statement made by Rommel of course related to the soldiers' own mortality, and it was the only time during the war that Joe felt his life had any meaning or value. For him there were no winners in the war, everybody lost, especially the soldiers and their families and, of course, the civilians whose lives were destroyed by the depredations of war. He had defied the odds and survived, but he never forgot those who had died, especially his older brother, Octavian.

Working in the U.S. and British zones in Germany provided him with limitless opportunities in the glass industry and he earned enough money as a glass maker to lead a comfortable lifestyle. Those earnings also allowed him to provide support to his father and younger siblings with weekly supplies of food, clothing and money, ensuring they never experienced hunger or cold under the rule of the occupying Russian forces. He always acknowledged the wisdom of the advice his father had given to him: be hardworking, be fair and honest, be generous to others. But it was his advice and insistence that he move to the West that had the greatest bearing on his life, paving the way for his eventual move to Ireland.

Enjoying the benefits of his retirement, he went for a drink every evening with his friends and when closing time came it wasn't always necessarily the end of the night. When in Tramore with his friend Bobby Power, having spent the night in Rockett's bar in Westtown, they often made their way down to the pier in Tramore where they fished until daylight. During the early autumn months after they had

fished throughout the night, they would go to pick mushrooms in the fields around Westtown, before finally making their way home. Retirement had indeed provided Joe with the opportunity to do the things he wanted to do, whenever he wanted to do them.

Throughout his life he recalled all the details of his past to David and told him that a book would be written about his life someday. He told David that he would face challenges during his own life, but they would never be anything like the challenges he had faced and overcome. He reminded David that when he came to Waterford he had nothing more than a suitcase of belongings, and two hundred pounds. He said that he was happy in the knowledge that whenever he died, he would leave behind more than the contents of a suitcase to secure his children's future.

He never forgot about the life he had lived in Europe and his decision to come to Ireland was one that he never regretted. He had never intended to stay but his outlook on life and his personality endeared him to the Irish way of life. More so than most of the other emigrant glass workers who came to work in Waterford, Joe had assimilated himself into the Irish way of life completely. He connected fully with the people of Waterford and the customs and traditions of the city. He never distanced himself from those who worked for him in the blowing room and his loyalty was always to his co-workers. He was proud of what he had achieved with the glass blowers in Waterford and he regarded them collectively as the greatest group of glass workers he had ever worked with.

He took particular care of the new apprentices and his presence was a welcome reassurance for them when they entered the hostile working environment of the blowing room. Noel Phelan, who joined the factory in 1970, was a nephew of Joe's first wife, Una Power. On Noel's first morning working in the factory Joe came over to him and said in broken English with a German accent: '*You're one of the Powers, I know by your face, your Lal's son are you? No worry, I will look after you in here.*'

Noel didn't know who Joe was, but when he went home asked if anyone knew Joe Cretzan. His Aunt Tess told him that Joe had been married to his Aunt Una, who had died in 1955. For Noel, who was 15 years old at the time, it was reassuring to know that there was somebody there he could turn to, as the blowing room had a reputation for being a difficult and sometimes hostile place to work. Many others who worked in the factory benefited in a similar way.

In 1989, the fall of the Berlin Wall and the subsequent collapse of communism in Eastern Europe was an event that Joe never believed he would witness. The collapse of communism opened the possibility for him to return to his birthplace in Romania and visit the family of his late sister Christine, who were still living in East Germany. It had been almost forty years since he had last been in East Germany on the occasion of his father's funeral, but the possibility now existed for him to return to meet his niece and nephew, Renate and Georg. Unimaginable opportunities that he never believed would materialise during his lifetime had become a reality. His greatest wish however was to return to his birthplace, Putna. It held so many memories for him. The graves of his mother and brother were there, unattended for almost fifty years. He never knew what had happened to the family home and the glass factory, or if they still existed. They were all unanswered questions and, for the first time, there was the possibility that he could return to Putna to find the answers.

On 8 September 1990, Joe's daughter Christine got married in Wales. Her wedding day was one of the proudest days of his life. As her father and the grandfather to her two daughters, Cathy and Natasha, he now felt that his direct responsibility for Christine and her two daughters had been passed over to her husband, David. The challenges and responsibilities of being a single parent had come to an end as Christine embarked on married life. The previous twelve years since Kitty's death had been difficult. He had reached a point in his life for the first time where he had no responsibilities to anyone but himself, and he looked forward to a life of leisure and enjoyment.

Father of the bride

On the evening of Saturday, 29 September 1990, as was his normal routine, he prepared to go out to play cards in Walsh's pub and meet with Paddy 'Biro' White. With time to spare, he sat down to watch television with David. As he sat smoking a cigarette he suddenly slouched over on to the arm of the couch. There was no warning, no pain, no distress – Josef Cretzan's remarkable life had come to an end.

His plans for retirement, which were richly deserved, were never fulfilled. He had lived a remarkable life and travelled an incredible journey from his birthplace in Romania through a worn-torn Europe to his adopted homeplace of Waterford. Life had presented him with many challenges from an early age: the death of his mother, the loss of his brothers Georg and Octavian, the years of fighting and the effects of war, the separation from his father and younger siblings and the premature deaths of his wives Una and Kitty. But he never despaired,

and throughout his life he gave of himself in both a professional capacity as a glass blower and in a personal capacity as a friend and work colleague.

The news of his unexpected death saddened all those who knew him. For many his death was a time when they reflected upon his influence on their lives. For master glass blower Ray Cullinane, who had followed in his footsteps to become master of the centrepiece shop, his death conjured up mixed emotions and memories:

I never have, and I never will speak about glass making in Waterford Crystal without speaking about Joe Cretzan. From the very first time I met Joe I knew he was different to everybody else. You didn't need to know anything about glass blowing to know he was an exceptional craftsman, the way he worked the glass, there was nobody like him. He was in a different class to everybody else and he taught and showed us everything that we know about glass blowing. He never sought recognition and he never received recognition, but he deserved it. Those at the top knew how good he was and what he done for Waterford Glass, but they never wanted to recognise that. His skill and expertise was squandered by senior management. If they had any foresight at all, they would have allowed him to select a small group of blowers, a group that he could have taken under his direct control, and he would have taught them everything he knew about glass making, in his way. That would have been something special. I told them that for years, but they never listened to me. They showed no respect for the man who in my opinion was the greatest glass maker in the history of the company, the man that every glass blower looked up to. But it's too late for that now, that is all in the past now, but his influence and his memory will live with me forever.

The sadness of his death amongst the mourners was mixed with laughter as personal experiences and memories of him were recalled. Glass blower Dick Hannigan, who started his apprenticeship in 1961, remembered one personal story in particular.

On the day my son Richard was born I met Joe near his house at the Sacred Heart Church. He asked me what I was doing out this way and I told him I had visited my mother to tell her about the birth of my son Richard in Airmount hospital that morning. 'Ahh, come into the house for a drink of schnapps,' he said. He opened a bottle of schnapps as I was looking at all the coloured glass pieces he had in the house.

'No, no, no, no, you're not getting none of them Hannigan,' he said.

I must have been in the house for a good hour or two drinking schnapps and looking at the collection of glass that he had. I had to go straight back to the hospital to Dorothy when I left his house, I was there so long.

'Where were you?' Dorothy said to me when I got back to Airmount.

'Oh, you won't believe it,' I said. 'I met Joe, he said to come on in and we wet the child's head.'

Oh, we wet it alright, we drowned it. He got me into a lot of trouble that day. I'll never forget that day and I'll never forget him. He had to make a basket for Dorothy after that because he was afraid

Dick Hannigan and Joe at the Blowers Dinner Dance, 1986

Joe in his front garden, 1989

that she wouldn't talk to him again over what happened that day. I still have that basket and my daughter said it is the only piece of glass that she wants from the collection that I built up over thirty years working in the factory. She is moving to Canada now so Joe's basket will be leaving Morrison's Avenue after fifty years and going with her to Canada.

Joe's funeral mass was celebrated by local priest Father Milo Guiry and by Father Dan Ryan, P.P. from Cashel, County Tipperary, who was a personal friend of Joe's. As his coffin arrived at the Sacred Heart church, it was carried to the altar by Bobby Mahon, Paddy 'Biro' White, Max Göstl Jnr, and his nephew Jim Buckley. Joe was buried in Saint Otteran's cemetery with his wife Kitty.

Chapter 20

The Views of Joe's Colleagues

The glass making skills that Joe Cretzan possessed can be seen in the pieces that he made in Waterford dating back to his arrival at the factory in 1951. Those early examples, including the Romanoff chandelier and the Waterford Scratch Golf trophy, are some of the finest examples of his work from that period. The ability to produce such intricate pieces of glass demonstrates the skill and technical ability that he possessed as a young man.

All of the glass makers who worked directly with Joe Cretzan testify to his craftsmanship. Individually, each of those men has his own memories of their times working with him. To analyse the factors that distinguished Joe from all other glass makers at Waterford Crystal it is necessary to hear from one who had experience in the industry and had the ability to technically analyse the knowledge, skills and experience of Joe Cretzan. Without question, the most competent person to undertake that evaluation is Joe Williams.

Joe Williams is a glass maker with over sixty years of experience in the glass industry who began his career as an apprentice glass maker in Waterford in 1960. By the mid-1960s he was blowing tumblers and light heavies and later progressed to jug-making and heavy blowing. In the early 1970s Joe joined the management team and became a training instructor in the blowing room. Over the next twenty years he held several managerial positions including Technical Manager, Technical Operations Manager and, in 1986, he became General Manager of the blowing section. His contribution to training, development and

research at Waterford Crystal lasted over twenty years and he implemented some of the most significant projects introduced into the glass making department during that period. His commitment and passion to Waterford Crystal was without question, and the skills he acquired during his time working there are still utilised in the glass industry today.

In 1990, Joe Williams established himself as a consultant in glass manufacturing and marketed himself across the world through contacts he had previously made. He worked extensively across Europe, primarily as a technical advisor to the glass manufacturing industry. In particular, he worked closely with the Turkish glass company, Pasabache, spending extended periods in Turkey helping the company improve its glass manufacturing capabilities. He established his own glass factory in Waterford, which was to operate as a teaching and research facility for his international client base. However, the economic uncertainty created by the Gulf War in 1990 changed the course of those plans. The planned research facility changed to a manufacturing facility named Heritage Crystal, producing traditional hand-crafted crystal products at its factory located in Bilberry, Waterford.

In appraising Joe Cretzan as a glass maker, Joe recalls the thirty years spent working closely with him in the Johnstown and Kilbarry factories.

Joe Williams Remembers Joe Cretzan

As a young glass maker my earliest memories of Joe Cretzan go back to the early 1960s when he was making jugs, heavy items and centrepieces. I clearly remember him making the 10-inch, 207 vase with Bobby Mahon as his apprentice in the shop. Joe was making all the heavy items at that time, and he was also showing the young glass blowers how to make glass, properly. Although his English wasn't perfect, he was well able to communicate and he would give out to you, but he would always show you how to do everything properly, how to hold the mould for him, how to lift and lower the mould when he was making footed items so that the foot would be

fully pressed out. He did everything properly. He had an uncanny and unique ability to manoeuvre glass through his hand and finger dexterity as he would roll, turn and twist the blowing iron with his fingers and hands.

On a technical level it was incredible to watch him making any-thing, but in particular it was fantastic to watch him making any item with a long neck. In the Crystal Clear film in which he can be seen making a 10 inch candlestick, his technical knowledge and skills are demonstrated perfectly. The way he uses the wooden divider can be seen perfectly in the film. The smoke and ash rising from the divider shows that he used a dry divider, and that was not by accident. The dry divider ensured that he did not chill the glass too much and he played with the glass as he dipped the divider into the water for a split second when he had finished using it. He had the finger and hand movement to do everything with glass and everybody learned that directly from him. On a personal level, he taught me the importance of hand movement when working with molten glass and he was brilliant in how he controlled the glass. He was a great teacher in his own right, and he passed on his skills more through demonstration than explanation. He had a unique ability to make you feel comfortable when he spoke to you. He showed you, and he talked to you, in his own unique way, and he explained what you needed to do, but more importantly, what not to do.

I started making jugs in the factory with George 'Saoirse' Morrissey, and of course it was Joe who taught us. He had an incredible ability to make jugs and he could play with the handle on the jug, swing-ing it three or four times if he wanted to, before rolling it into the jug perfectly. In the late 1960s he taught me how to make claret decanters, but the way he could make a claret decanter was never matched by any other glass maker in the factory. He was a big man as he sat into the chair and as he cut into the neck he was always looking directly down into the decanter. He had his own way of making the cuts into the neck of the decanter using his shears, and when he formed the lip, it matched perfectly with the location for the handle at the back of the decanter. From a dimensional point of view his claret decanters were perfection. George Morrissey and

I struggled to emulate his work, but he had the skill, he had the edge, he had the experience. Nobody ever had the experience that Joe Cretzan had, and he made everything so naturally. I had great personal ambition for myself as a glass maker and if you looked to anyone to emulate in the blowing room, you looked up to Joe. He had the skills, the experience, the knowledge, the ability and the knowhow, and the knowhow was his greatest attribute. He could work with hot and cold glass. I remember him making a 23-inch fountain base, gathering the molten glass on a three-gather ball. He gathered a massive amount of molten glass and had the ability to take that gather out through the 9 inch opening of the pot, on the end of a five foot blowing iron.

Nobody ever matched the way he could take a large gather out of the pot, it was as if he stopped turning the blowing iron for a split second as he lifted the gather out of the pot. I watched him again and again taking those large gathers out through the pot opening, and even today, almost sixty years later, I cannot do it the way he did it. No job was too big or too small for him, he could do every-

'... I have never seen another glass maker like Joe. He was simply in another league ...'

thing with glass, and I never once heard him complain about the heat or the horrendous conditions that he worked in during the 1960s in Johnstown.

Millions of tumblers were made in the blowing room through the 1960s and 70s and they are a basic glass for any glass blower to make, but even the tumblers that Joe made were unique. He was able to stretch and divide the glass with the divider and the rim thickness and wall thickness of his tumblers was pure perfection. It was never matched by another glass maker in the factory.

Mary Pender and Mary Power were the two ladies who removed the caps from all the tumblers when they left the blowing room and they always spoke about his tumblers. They always told me they could

distinguish Joe's tumblers from all others in the factory. They said that his tumblers required one single rotation on the diamond wheel for the cap to remove itself; all the other blowers' tumblers required multiple rotations on the diamond wheel to remove the cap because the thickness on the rims was never perfect. But there was another element to his tumbler making which distinguished his from all others, it was the wall and base thickness. He made a tumbler with enough wall thickness to allow the glass cutter to cut any type of wedge or flat cut into the body. He never compromised on quality and his tumblers were a delight for the cutter to work with. His tumblers felt beautiful in terms of weight and balance as you held one in your hand. His work colleague, Max Göstl, was also a fantastic tumbler and wine glass maker, and he also had a unique ability to distribute glass thickness on stemware items like nobody else. Both Joe and Max defied logic when working with molten glass.

Throughout my career I have worked with glass makers across Europe and I have analysed their skills and their work, but I have never seen another glass maker like Joe. He was simply in another league compared to any other glass maker I have ever seen. He could make anything from glass. Great credit should be given to those craftsmen who trained Joe as a glass maker, they obviously identified something special in him as a young boy and they maximised his natural ability to its limit. Everything that I know about glass making came from Joe, he taught me everything. We should have recorded and analysed his work in detail because when he left the factory, we lost that incredible wealth of experience that he possessed. Only those who worked with him will truly understand how special he was.

Over fifty years later now, as I recall my time working with Joe, it brings back wonderful memories for me. Joe Cretzan made a unique and immense contribution to glass making in Waterford, and he transferred his skills to the Waterford workers who had the ability to use those skills. Waterford Crystal, and all those glass blowers who worked with him at the factory, including myself, owe him a great debt of gratitude. For me personally, Joe Cretzan was the master glass maker, in the true sense of the word.

Tony Galvin Reminisces

Tony Galvin from Sallypark in Waterford joined Waterford Glass in 1952. His first job was at the Ballytruckle factory working in the blowing room where he was holding the mould for Joe Cretzan. He recalls his time working with Joe.

I remember clearly my first day in Joe's shop and that Sam Bible was the apprentice blowing balls for him. There were no crystal pots in the factory so Joe was blowing soda glass, mainly half pint, pint and pilsner glasses that were used for the bar trade. At that time every Sunday morning, Joe would go to the factory and train any of the young boys who were working in the blowing room if they were interested in becoming apprentice blowers. He never got paid for that training, he did it to help the boys get up onto the platform so they could start as apprentices as soon as the opportunity arose. I was one of those boys who he trained on Sunday mornings. Although he had very broken English at that time, he could get his message across as he showed us how to gather glass from the pot and then how to blow balls or bit gather. He would stand beside you and show you exactly how to do it, and if you didn't get it right the first time, then he would show you again and again until you were finally able to do it. If you showed an interest in glass making he would do anything for you. Everything I know about glass blowing I learned from him.

I was surprised when Sam Bible, his apprentice, left the factory to go to England at the end of 1952 and because of that Joe needed a ball blower in his shop. At that stage I was still holding the mould in his shop but I was able to blow balls because he had been training me on Sunday mornings. Joe spoke to Mulac who was the general manager in the blowing room and told him that he wanted me to be the apprentice in his shop. Although Mulac was a very dominant and difficult man to deal with, he would not have stepped in the way of Joe picking the apprentice for his shop. Joe was not a shy man, and he had a strong personality too, so when he decided who he wanted to work in his shop nobody on management was going to disagree with him. So, when Sam Jacob left the factory, I became the apprentice in Joe's shop.

Crystal pots were introduced into the blowing room shortly after I started working with Joe. Working with crystal is much more diffi-cult than working with soda so he had to train me again in how to work with crystal. At this stage in the early 1950s my parents were worried about the glass factory and my future there. When I told Joe that my parents were worried about me working in the factory he said he would go over to my house to talk to them, which he did. He explained to my parents all about factory life and glass blow-ing, and that really eased my parents' worries. He often came over to my parents' house in Sallypark for his tea and my parents were mad about him because he looked after me so well.

With the introduction of crystal pots all the large and special pieces of glass that were designed by Havel were made by Joe. He was the only man who could make the large pieces of glass. At that time the Hoffmans, Franz and Alfonz were also working in the factory, but they were making jugs. For the very large pieces of glass that had to be blown I would blow the ball for Joe and there was enough glass in the ball to make a centrepiece. He would then gather over that ball to get the required amount of glass to make the piece. For some of the largest pieces that we made, Dr. Winkelmann organ-ised for the mouth of the pot to be knocked out by the furnace men so that he had a bigger opening to get the glass out of the pot. The blowing irons that we used were probably two inches in circumfer-ence and as Joe gathered the glass from the pot the iron would bend slightly from the weight of the glass.

I wasn't long in the shop when we made a very special chandelier, one that I will never forget, the Romanoff chandelier. It was prob-ably one of the first chandeliers ever made in the factory and it was definitely the most difficult to make in terms of its unusual features. It was a huge chandelier that had a massive bowl in the centre, large straight solid arms and four solid 'R' letters that hung from the bottom of the chandelier. Havel designed the chandelier, and he watched Joe making the individual pieces for it. There was a particular problem with the mould Havel had designed for the letter 'R' and it wasn't filling out fully. However, Joe had an idea and had the mould changed to a way he had used before, I presume in Germany. Using the mould designed by Joe and using the glass

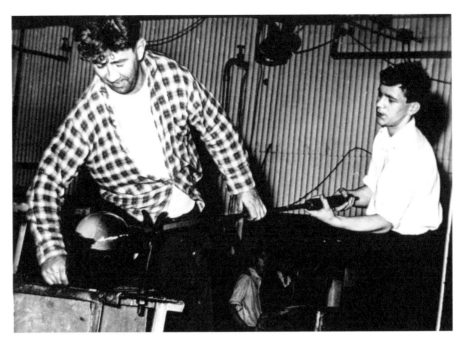

Joe with apprentice Dick Evans

hotter than normal, the four 'R' letters were made perfectly, and the chandelier was completed. That chandelier generated a huge profile for the company at that stage, and it led to a series of high-profile chandelier orders for company including the chandeliers at Westminster Abbey in London. He made every piece for that chandelier also, from the smallest to the largest. I have never seen the chandeliers in Westminster Abbey but they are and will remain a testament to his legacy and his skill in glass making. Other well-known pieces that he made while I was his apprentice included the presentation piece for Ronnie Delany after he won the gold medal at the 1956 Olympic games in Melbourne, Australia, and of course the Waterford Golf Club Scratch trophy which can be still be seen at the Waterford Golf Club.

During the 1950s many young Irish apprentices went on to become blowers and heavy blowers making basic items such as salad bowls and decanters. Although Joe was still a production worker at that stage, if there was ever a problem with a blower making an item Joe was always asked to help the young blower, and he always did that. Every blower in the heavy section was guided by him at some stage.

We could never have learned those skills without his input. Many of those Irish blowers who he taught went on to become very fine and skilful glass blowers in their own right.

But there was more to Joe than glass blowing. He was a great man to work with as he spoke to you in his broken English, with the strong foreign accent. My girlfriend at the time, and now my wife Bonnie, worked in the colouring department in the factory where they decorated and painted the soda glasses for the pub trade. Whenever Bonnie walked through the blowing department or came over to me on the blowing platform, he would start singing at the top of his voice to her, 'my Pony lies over the ocean, my Pony lies over the sea, my Pony lies over the ocean, oh bring back my pony to me'. He couldn't pronounce her first name Bonnie correctly, so he called her Pony instead. Although there was several foreign workers in the blowing room at the time he was different in every way to them all, he was more outgoing and he socialised with Irish people very well. As we worked together, he would often ask me to sing his favourite song 'Oh Danny Boy', while we were working on the platform. At the end of a week's work, he would often bring the workers in his shop out for a few drinks to Canty's pub in Johnstown, and every Christmas he would buy everyone in the shop a beautiful shirt and tie. He treated us as his family, and he looked after everyone who worked in his shop.

Because of his skills and work ethic there were a lot of demands placed on him by the company and I think he felt he was being exploited to some degree. Every single important piece of glass made throughout the 1950s was made by him and he was expected to teach the young Irish blowers also. Towards the end of 1957 he had and argument with Mulac and Dr Winkelmann over his wages primarily, as far as I remember. He wanted more money, pointing to the quality of his workmanship and the training of other glass blowers in the factory. But they did not want to give him a pay rise and they felt confident that the new generation of young Irish glass blowers that had emerged could replace him. He said he would leave the factory if they didn't give him the increase and they made the decision to not to give him the wage increase he was looking for. Because he was not a man for going back on his word,

he handed in his notice to leave the company in December 1957. They were wrong in that decision, and he was 100% correct, they should have given him the extra money that he was looking for.

We were shocked that he decided to go back to Germany, but there was no changing his mind once he had made that decision. The day he was leaving Waterford we had a party for him in Lawlor's pub on John Street. Max Göstl, Michael Condon, myself and a few others from the blowing room were there. Because he was so fond of my singing I made a vinyl recording of his favourite song 'Oh Danny Boy' at the music shops in John Street and I gave it to him as a going away present. He liked to drink dark rum with orange which I had never drank before so most of us drank rum and orange with him for the day. It was a late sailing of the Great Western that evening and when the time came for us to go down to Adelphi Quay with him, I had to be helped down by Max Göstl because I was very drunk. We all cried as we said goodbye to him, and as the Great Western departed for Fishguard I honestly believed I would never see him again.

In January 1958 Con Dooley travelled to Germany and met with Joe. I don't know what happened at that meeting but Joe did return several weeks later. It was the luck of God that he came back as soon as he did because nobody else was able to make the pieces that the factory needed. When he arrived back into the blowing room all the workers were delighted to have him back, but no one more so than me, because I was his apprentice. I worked with Joe until I got my own shop in the blowing room. When I look back at my time with him in the factory, I can say I owe everything to him. He taught me everything about glass blowing and more. In all of my thirty-five years as a glass blower in the factory I saw every blower that worked there. There is no question about it, he was the greatest glass blower in Waterford Glass. Nobody could come near him in terms of glass making ability. He was gifted, just gifted. He had his own ideas in his head about glass and he had the skill in his hands to make anything with glass. Nobody else in Waterford Glass ever had that level of knowledge and skill in glass blowing. As a glass blower, he was a genius. As a person Joe was the friendliest of all the foreign workers in the factory by a mile. He was like a

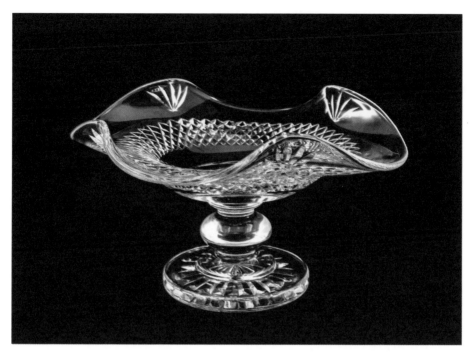

'As a glass blower, he was a genius ...' – Tony Galvin

second father to me. He fitted in with Irish people and the Irish way of life. He was a wonderful human being, a man with warm heart, and to this day, there is nothing I wouldn't do for that man.

Seanie Cuddihy Tells His Story

One of Joe's early apprentice ball blowers was Seanie Cuddihy. Seanie joined the factory in 1953 at fifteen years of age, following in the footsteps of his older brother, Tom 'Bongo' Cuddihy who was already working in the blowing room. Seanie's first job in the blowing room was 'carrying in'. The job involved carrying a piece of blown glass that the blower had made and putting it into the annealing lehr where the glass would cool down slowly over a period of hours. It was relentless and exhausting work for any young boy due to the extreme heat in the blowing room and the constant walking forward and back to the annealing lehr. Seanie remembers that 'carrying in' in the 1950s was seen as part of the apprenticeship journey and the only way to progress to become an apprentice glass blower. Although it is over sixty

years ago now, he can remember every detail about his apprenticeship and how he became Joe's apprentice.

Billy Power from Water Street was one of Joe's apprentices at that time and when I started working in the blowing room I would use his blowing irons to practice gathering glass whenever possible. At that time Rudolf Mulac was the general manager of the blowing room. Mulac had a fearsome reputation for managing the blowing room with an iron fist and was always monitoring workers' performances and efforts throughout the day as he passed through the blowing room. However, he would often send boys up on to the blowing platform where he saw them having an interest by ball blowing at break times or at the end of a shift. My enthusiasm didn't go unnoticed with Mulac and I got my first job on the platform when he told me to go to blow balls for Eagon Schoenberger who was an Austrian wine glass blower.

Joe's apprentice, Billy Power, left the factory and went to Scotland to pursue a different career in the mid-1950s. There was still only a very small group of apprentices in the factory and Tony Galvin then joined Joe as his apprentice to replace Billy Power. On a normal day starting at 8.00 a.m. the apprentice would blow balls for small items such as tumblers to allow the level of glass in the pot to drop to the required level so that larger items could be gathered from the pot after the tea break at 9.30 a.m. For these larger items an apprentice was required to twist the iron for the blower. Although I had never worked in the heavy blowing area, Mulac instructed me to go to Joe's shop to twist the iron for him on the larger items and finish off the large balls for Tony Galvin. Tony flourished as a ball blower in Joe's shop and now had experience working with crystal. A new wine shop was being created in the blowing room and Dr Winkelmann asked Tony if he would be interested in blowing wine glasses in that shop due to his experience working with crystal. Tony accepted and left to become a wine glass blower. When Tony left the shop Joe told me to start blowing the heavy balls for him. Dr. Winkelmann came up on to the blowing platform to talk with Joe about who was going to blow balls for him. Joe nodded his head in my direction identifying me as the apprentice he wanted.

Dr. Winkelmann was not happy with his choice and shook his head in disapproval. He believed that I didn't have enough experience or the physical strength to work in the shop, however Joe was not for moving on his choice. He let Dr. Winkelmann know in no uncertain terms that I was the person he wanted come hell or high water. Dr. Winkelmann chose not to argue with Joe and reluctantly conceded to his choice commenting, 'he would give the young boy a chance', but he was adamant to prove Joe was wrong in his selection of me as the apprentice in his shop. In order to do this Dr. Winkelmann told Joe that he wanted 16 inch square vases to be made urgently the following Saturday. For Dr. Winkelmann this was sure to be the way to prove that I was not the right choice for the shop, as those vases required a very large heavy ball to be made by the apprentice.

The following Saturday morning as we prepared to make those vases Joe handed me a wooden block he used for blowing decanters and told me to make sure I gathered enough glass to fill the block to ensure I had enough strength and thickness in the walls of the glass ball. Joe blew the first ball and he showed me how to gather, block and shape the molten glass so as to produce the perfect ball for him. After a couple of hours blowing the vases I remember vividly how Dr Winkelmann appeared out of nowhere on to the blowing platform with a smile on his face, giving the thumbs up hand signal to Joe indicating that all the vases were perfect. He had inspected the vases as they were being placed into the kiln. Joe's belief in my ability to do the job was vindicated and Dr. Winkelmann, although somewhat embarrassed by the episode, was happy as production of the vases had been completed successfully.

I had established my place in the shop with Johnny Power who was the other apprentice ball blower. I always remember the respect that Joe had for his apprentices, how he wanted to show and teach them his particular ways to work the molten glass. If you showed an interest in glass blowing then Joe had an interest in you and in developing your skill. He had a generous and kind personality and he never shouted at, or disrespected, any of the apprentices, unlike many of the other master glass blowers in the blowing room at the time who treated apprentices poorly. Joe gave you his time and he spoke to you if there was a problem.

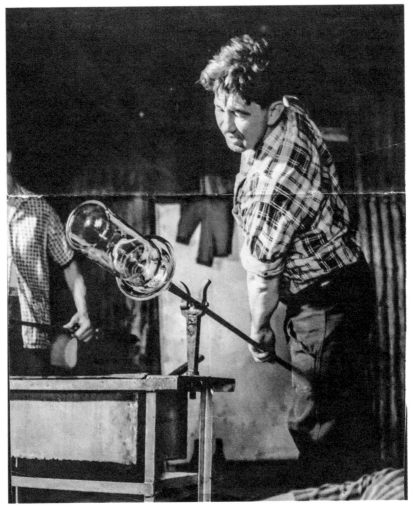

Photo of Joe that appeared on cover of Irish Life Assurance Annual Report, 1964

The young apprentices felt part of his team and they were proud to work with him.

We smoked his cigarettes and drank his Russian tea whenever we were thirsty. The management in the factory allowed Joe to maintain a well established German tradition in glass blowing, drinking beer during working hours, and therefore inevitably there would be a large bottle of beer on the water tank for him to kill his thirst. The apprentices were strictly forbidden from drinking alcohol in the blowing room as most were still only young boys in their teenage years, however the temptation was very often too great and

we would quickly take a mouthful or two of beer directly from the large bottle if he had his back turned while gathering glass from the furnace. As he returned from the furnace and finished making the glass he would go to pour the beer from the bottle into his glass to find, in many cases, the bottle was empty. Of course, he knew we were drinking his beer and he would often ask me to check and see if there is a crack in the bottom of the bottle.

Over the following years I gained invaluable guidance and skills in glass making from working directly with him. The factory benefited hugely not alone from his skills as a glass blower but also his knowledge of glass making in general and the many techniques he had been taught when he worked as a glass blower under his father's guidance in Romania, but also as a result the range of skills and techniques he had learned when he worked in the various glass factories in Germany after the war.

On one particular morning Dr. Winkelmann walked on to the floor with Kurt Berger, the wooden mould-maker pushing a trolley with the largest wooden mould I had ever seen. Dr. Winkelmann smiled at Joe as he pointed to the mould knowing well that it was going to be a very difficult piece for him to make. Joe placed the mould onto the platform and opened it up to see the exact shape inside the mould. He spoke in German to Dr. Winkelmann and Kurt Berger for several minutes and then came to myself and Johnny telling us exactly the way he wanted the ball made, the thickness in the walls and in this case to make sure not to round off the ball, but to make sure to make it a longer ball so it will be easier to get it out of the mouth of the pot.

When we made the ball he took a mouthful of his Russian tea before gathering over it, blocking and dividing the glass before blowing it out in the mould. After several unsuccessful attempts trying to make the piece he jumped down off the platform and lifted the mould on to the platform to look inside it to see where it wasn't filling out on the foot of the vase. After a few minutes he went to the small table close to the lehr and took a small piece from a wooden divider and inserted it carefully into the mould at the point where the bowl of the vase and the solid foot met. He then closed the mould tightly.

European Masters, Heinz Plattner, Joe and Kurt Berger

Much to Dr Winkelmann's surprise, he told us to make a smaller glass ball, indicating by hand how much smaller he wanted the ball. He gathered over the smaller ball and shaped the molten glass before carefully placing it into the mould making the body of the vase only. After taking it out of the mould he asked Kurt Berger to cut the mould in half and said that we would make it in two separate pieces and join them together. Both Dr Winkelmann and Kurt Berger were confused, however the mould was cut in half and he then made the vase in two separate pieces, the body of the vase and the foot, before sticking them together using the overnight crystal pot that was melting at the time to keep the blown pieces warm. Although stick-on items had been made before in the factory by him, nothing with a joining point as big as this piece had been made. That intervention by him opened up the possibility for a whole new range of larger items to be made in the blowing room. All samples and large heavy items that had to be made in the factory were brought to his shop and very often Havel would come up to the blowing room to talk to him if there was something particular he was looking for in a piece of glass.

On one particular occasion Charles Bačik, who was not a regular visitor to the blowing room, came on to the platform to watch him make a particular piece. I blew the ball for Joe and Bačik watched as he gathered over the ball and made the piece. The sheer weight of the glass on the end of the iron caused the iron to bend in the centre as he worked the glass beautifully. I twisted the iron using every ounce of strength that I had as Joe blocked and shaped the molten glass to the stage where it was ready to go into the wooden mould that was sitting on the floor. As he placed the wooden divider back into the water tank he stepped back to grasp the handle at the end of the blowing iron and then, incredibly, he reached down on to the platform and took a mouthful of Russian tea from his bottle, while at the same time controlling the molten glass with his other hand. As Bačik looked on with great satisfaction, I made eye contact with him and smiled, proudly saying, 'he's the greatest blower in the factory, isn't he?' Bačik stood back, frowned and shook his head from side to side and replied, 'no, he's not the greatest glass blower in the factory, he's the greatest glass blower in Europe.'

In 1958 an opportunity arose for me to travel to England to work as a glass blower in London. The lure of working in England brought my time as an apprentice in Joe's shop to an end, however it was not the end of our working relationship, as I returned to the factory in Waterford two years later. Again, Joe directed me successfully in my career path and he told me to go on the chair and become a stemmer in the wine blowing department. The workers in the factory were family to him and he looked after me and all his apprentices in every way he could.

There wasn't anything he couldn't do with glass. He could blow the largest vases and trophies all day long, and then one minute later, the smallest liquor glass. Nobody else could do that. He was incredible. Every blower in the factory wanted to blow glass like Joe Cretzan, but nobody could, or ever did. He was the greatest glass blower in Waterford Crystal and it was a honour for me to be his apprentice.

Bobby Mahon Describes Working with Joe

Bobby Mahon joined the blowing department on 24 October 1955 having successfully completed a blowing test with Dr Winkelmann several weeks earlier. Initially, he worked on soda glass with Christy 'Tanter' Brophy, before he progressed to working with Tommy Nugent on the night shift, making basic crystal pieces only, such as salad bowls.

The opportunity to progress and work with Joe Cretzan did present itself and he recalls how that opportunity arose and his time working with Joe.

In 1958 Joe's ball blower, Seanie Cuddihy, went to England and I realised there was an opportunity to get into Joe's shop as his apprentice because I was the only apprentice who could blow heavy balls at that time. To get into his shop you had to have some experience and he wouldn't take any joe soap as his apprentice. I approached Mulac not being sure if he would give me the job, but I figured he had to, as there was nobody else who could blow large heavy crystal balls. I went into Mulac one evening and asked him if I could get the job with Josef Cretzan when Seanie Cuddihy leaves?

Mulac replied in his strong German accent, 'Oh Robert, Mossie Kelly had asked about the job, and I agreed to give Mossie some training in heavy ball blowing in the evenings, but I will tell him I gave you the job.' I walked out of the office that day about ten feet tall with delight, and a week or so later I started working with Joe. It was magic for me because it meant that I had no night shift work as Joe didn't work nights and my wages increased from £7 per week to £13 or £14 per week which was massive, massive money at the time.

As I worked with Joe I began to blow balls initially for him and then over the years I progressed to blowing larger heavy items for his centrepiece shop, and then blowing jugs for him to put the spout and handles on. He was the most gifted glass blower, a man who had hands twice the size of mine, but he had the deftest touch, even when dividing a tumbler. Nobody could make a tumbler like he could, and nobody will ever understand that unless they

witnessed him making a tumbler. He would barely touch the glass with the divider to make the most beautiful tumbler you have ever seen, and I learned those skills from him. He could make the largest pieces of glass look so easy, the way he gathered the glass, and he could work and shape the glass so hot, nobody else ever worked glass as hot as he did. He made it look as if he was only using the strength and skills in the tips of his fingers as he made those huge trophies, vases, globes of the world, tripods and special one-off pieces. He taught every heavy blower in the factory at that time, from the early 1950s up to the late 1960s, including Nicky Brennan and Paddy Hannigan. However, I was privileged as I worked with him directly for eight years, and no other blower worked with him for that length of time. I learned everything from him, and from watching him work. He made glass blowing look so easy.

Each morning we would start off making tumblers until 9.30 a.m. and then start making heavy items such as decanters, vases, jugs or centrepieces. Every photographer or film crew that came to the factory had to come to his shop, to film or photograph us working together and we featured in magazines, newspapers and in one particular year, on national schoolbooks in Ireland. He had developed great experience from working in Europe and I recall him making very large chandelier arms on one particular occasion. The arms for the chandelier were over five feet in length and he told me to gather over the ball while he got a solid blowing iron that was used to make solid feet for the centrepieces. As I was pulling out the arm for him to stretch out, he simply stuck the solid iron to the end of the gather and we used a blowing iron each to stretch out the arm. He gave me directions on what exactly to do as we stretched out the arm to the thickness and length he wanted. I never saw anybody else do that before or since, but he had obviously done that and learned that skill before he came to Waterford.

On another occasion that I won't forget, Dr Winkelmann called Joe to his office which was located over Canty's pub in Johnstown. Joe always brought me to those meetings as he said I was part of his shop. Dr Winkelmann spoke to him in German but Joe insisted that he spoke in English so that I could understand what was being discussed. Dr Winkelmann explained that the factory had got a

huge order from America for centrepieces, and he wanted them completed as soon as possible. There was no other shop that could make them. The centrepieces had no piece rate price set for them, so Dr Winkelmann said we would be paid a guaranteed wage for the length of time it took to complete the order. After several weeks, when the order was completed, Dr Winkelmann called us up to his office to tell us he was delighted with our work and what we had done for him, and he wanted to compensate us for our loss of earnings for not being on piece rate for those weeks. Much to our delight he handed both of us several hundred pounds. Both of us were very happy leaving the office that day.

In 1959 I got married and of course Joe and his wife Kitty were invited and attended my wedding. My family were country people, very reserved and conservative, and knowing Joe's personality and how he loved to socialise with people, I had to ask him to go easy with my family and relatives as they would never have met a foreigner with his type of outgoing personality before. When I returned to work after my wedding, I was a fully qualified master blower, however, my wages were based on a 60/40 split in favour of Joe, so he was earning 50% more than me. One day I said to him that the 60/40 split was a hell of a gap and that was ok when I was an apprentice, but I was a married man now and need extra money, to which he replied, ah yeah, I suppose it is, so what about 55/45 from now on. Yeah I said, and I did get my wage increase the following week while he took the decrease in his wages. He was never mean towards to his workers, he was always fair to them.

Every summer during the holiday period in August when the factory would close down Joe was always asked to work the holiday period when there was no wine glass production in the crystal pot. That meant he had two full pots of crystal to work with. On one particular week during that holiday period in the late 1950s I remember clearly earning £32 pounds as the apprentice in his shop, which meant he had close to £50 for a week's work. That was a record week earnings for a blower and apprentice for years after until the twelve pot furnaces came into use. At the end of the two weeks working the holiday period he would bring the entire shop of seven or eight workers over to Canty's pub to buy us a few drinks.

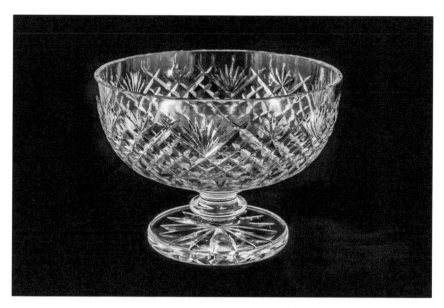

Green centrepiece

One particular year I remember that after two or three large bottles of beer I felt full and couldn't drink anymore beer, but of course Joe was very persistent and said to me, ahh Bobby you must have a whiskey. I said, Joe, I never drank whiskey, I don't drink it. Ah you have to have the whiskey, he said, So, I drank Scotch anyway, and I got pissed actually, and when I went back to my digs that night I got sick all over the room. Of course, the next day I got my notice to leave. Would you believe that I have never liked whiskey from that day to this, and never drank a drop of it after that day? He just wouldn't take no for an answer.

The bottle of tea that he brought to work was something that I had a mouthful of every day. He would leave it close to the furnace to keep it slightly warm. It was sweet and it tasted lovely and when he wasn't looking I always managed to get a mouthful. When you were tired and thirsty it kept you going.

I remember clearly in Johnstown how he would make fantastic coloured centrepieces, which he must have learned how to make when he worked in Europe. He always had coloured glass sticks which he got from Germany and he would heat the coloured sticks in the glory hole. He would work that stick of coloured glass into

a cup to the exact size and shape that he wanted. I would keep the coloured cup warm in the glory hole as he gathered enough glass to make the bowl of a centrepiece. He would then insert the molten glass into the coloured cup and then he would put it back into the glory hole so they would fuse together seamlessly. He made the bowl for the centrepiece from that piece of glass. A solid foot was then attached to the bowl to complete the centrepiece. The skill, the precision, and the expertise that he had in working with coloured glass was unbelievable.

When the centrepiece went to the cutting department the wedge cut would go through the outer coloured glass layer to reveal a clear crystal on the inside of the bowl. Those pieces were never a production piece but when Dr. Winkelmann saw him making those coloured centrepieces he was obviously impressed, and he showed them to the other directors in the company. They were magnificent pieces, a single colour, often green or deep red. They were very special pieces that I know he was often asked to make for the directors in the factory, particularly at Christmas time. They were very difficult pieces to make and you had to know precisely how to work with coloured glass, which of course nobody else in the factory could do. They were never made by anybody else, and that skill and knowledge was lost completely which was a great pity. It should never have been allowed to happen, the company allowed his skills to be lost forever.

In 1966 he went on management and never went back to blowing on a full-time basis so no other person ever had the experience of working with him for eight years as I did. I was privileged really to have had the experience of working with him for so long and I learned greatly from him and I developed into a good glass blower myself taking over his role as master of the centrepiece shop, but I would never ever say that I was equal to him in anyway in terms of glass making ability. On a personal level, what I experienced and learned from Joe was beyond precious and I'm proud to say that I worked with him. My whole life had changed positively as a result of working with Joe Cretzan.

Joe Cretzan's contribution to glass blowing in Waterford Crystal was phenomenal, absolutely phenomenal, not a shadow of doubt

about that. The skills that he brought to the blowing room had never been seen before, he brought glass making to a different level in Waterford. He made a huge, huge contribution, a bigger contribution than any other person ever did, or ever will make to glass making in Waterford, of that, I have no doubt.

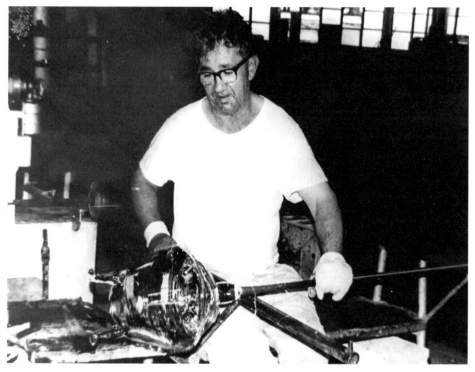

'The skills that he brought to the blowing room had never been seen before ...'

Epilogue

Joe Cretzan's Legacy

When Joe Cretzan arrived in Waterford he had no idea how long he would stay in the city or what his future would be, however he left a legacy to Waterford and its people in both a personal and professional capacity.

In a personal capacity, despite the fact that he could not speak English, his personality and character overcame the language barrier and he immediately assimilated himself into the local community in Waterford. People felt comfortable in his presence and he was welcomed into the families of those he befriended, including the Kehoe family from Keane's Road, the Gavin family from the Cork Road and the Galvin family from Sallypark. All these families recall the effect that his presence had on their lives.

> *He brought light into our lives (Maeve Gavin)*
>
> *He gave great comfort to my parents who were worried about my future in the factory (Tony Galvin)*
>
> *A man whose generosity and character was remarkable (Kitty Curtin)*

The personal contact that many of the Irish apprentices in the factory had with Joe gave them an insight into a way of life that was far from the experiences they had growing up in Waterford. Joe brought European culture directly into their lives through sharing the stories of his life in Europe, however it was his desire to transfer those skills to the apprentices in Waterford that was most remarkable.

From the mid-1960s he raised concerns in relation to the management of glass blowing in Waterford, but those concerns fell on deaf ears. Managers and engineers never wanted to understand that glass blowing was a craft that had to be carefully managed and developed to protect its future in Waterford. In the years that were to follow Joe's concerns about the future for glass blowing in Waterford materialised and the standard of craftsmanship and quality declined in the pursuit of mass production and reduced costs.

Ultimately, Joe's greatest legacy was his direct contribution to glass blowing in Waterford. Within weeks of starting work at the factory in Ballytruckle he was teaching the basic skills in glass blowing to Irish workers every Sunday morning at his own cost for the benefit of the workers who wanted to become glass blowers. During the 1950s and 1960s Joe guided the first group of Irish apprentices including Paddy 'Biro' White, Tony Galvin, Seanie Cuddihy, Johnnie Power, Bobby Mahon, Tommy Nugent, Gerry Cullinane, Paddy 'Whacker' Hannigan, Michael Condon, George 'Saoirse' Morrissey, Joe Williams, Pat Aylward, Ray Cullinane, Nicky Hannigan and Dick Hannigan. That group of glass blowers went on to produce the world's finest hand-made crystal that established Waterford Crystal as its finest producer.

Undoubtedly, the greatest way to appreciate his legacy as a glass blower is to view the individual pieces of crystal that he made. These include the numerous centrepieces presented to American presidents on behalf of the Irish government, sports trophies presented to Irish and international sporting champions and chandeliers which adorn the most prestigious buildings in the world. The most comprehensive collection of Joe's work remains in the possession of his family, however examples of his finest work are on display at the Masterpieces in Glass exhibition at the Bishops Palace, Waterford.

In 2018, former glass cutter and academic John M. Hearne published the most comprehensive history on glass making in Waterford, *Waterford Crystal: The Creation of a Global Brand, 1700-2009*. Hearne details the growth of Waterford Crystal under the guidance of the

skilled European glass workers, and he details the critical contribution that they made to the success of glass making in Waterford. Hearne recounts the contribution that Joe made to Waterford Crystal during his 37 years of service at the factory:

> *Joe Cretzan was a big man with a pair of big hands and an equally big heart. But few would ascribe dexterity, deftness and a delicate touch to his physique. But nothing could be further from the truth. He was a master craftsman responsible for some of the most prestigious and innovative Waterford Crystal commissioned and presentation pieces during the 1950s, 1960s and 1970s, such as the Romanoff chandelier (1953), the first St. Patrick's Day Waterford Crystal presentation to President Eisenhower (1953), the unique eighteen-inch lidded trophy presented to President Kennedy (1963), the Flame of Faith lidded trophy presented to Ronnie Delany (1956), the aesthetically beautiful chandeliers commissioned by the Guinness family to mark the 900th anniversary of the foundation of Westminster Abbey in London (1965), the bicentennial vase marking the 200th anniversary of the American Declaration of Independence presented to President Ford in 1976, and many more. These were among the most important crystal pieces that elevated Waterford Crystal to the vanguard of crystal manufacturers in the world during the latter half of the twentieth-century. It was fortuitous for both, as the wealth of the McGraths enabled Cretzan to display his enviable skills as he created exceptional pieces that evinced favourable critical comment, especially in the USA.*

> *But Joe Cretzan was much more than just a gifted craftsman. He was a loyal and loving family man who had to deal with his own personal tragedies and he had to carry the burden of raising his two young children by himself. It was a burden that he would carry with dignity as he crafted masterpieces for the rest of his working life. He also empathised with his apprentices and helped them improve their skillset, both professionally and socially. He set the bar high, and many became exceptional craftsmen in their own right which was a testament to the rigorous standards Joe Cretzan set. And it was those exacting standards that set Waterford apart from its competitors. But like most of the foreign craftsmen who*

came to Waterford in the late 1940s and 1950s, Joe brought not only his disparate skills but also his individual traditions thereby creating a melting pot for innovation and creativity.

When Josef Cretzan, the master of masters, retired in 1987 he was one of the few foreign craftsmen who had remained in Waterford and one of the last to leave the company. Unfortunately, he did not live long to enjoy his richly deserved retirement as he died in 1990. But his legacy remains in perpetuity in the iconic crystal pieces he created that adorn some of the world's most prestigious buildings and museums. It is, I am sure, what he would have wished for.

Although Joe's life was glass, his love was his family. He worked tirelessly throughout his life for his family, and he was determined that his children would never have to live the life he had lived. He provided them with education and opportunities that he had never received, and his wish was that they would have better opportunities in their life than he had in his. He didn't live long enough to witness in full the success that his children and grandchildren achieved, however his legacy lives on in them today.